Color Photography

A WORKING MANUAL

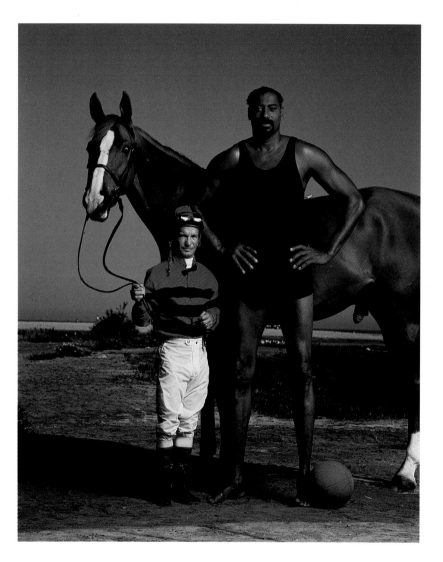

Annie Leibovitz, *Wilt Chamberlain and Willie Shoemaker*.

Leibovitz photographed these two great athletes as a part of her award-winning American Express print campaign in the 1980s. In many ways it's typical of her highly influential style: familiar subjects, dazzlingly rich colors, and a strong sense of both irony and humor. Leibovitz's trademark technique—mixing natural light with studio strobes—has been widely copied, but it's her understanding of her subjects, attention to detail, and drive for perfection that sets her apart. This photograph took a full day to complete.

Color Photography

A WORKING MANUAL

Henry Horenstein

with Russell Hart

Drawings by Tom Briggs

LITTLE, BROWN AND COMPANY

Boston New York London

Also by Henry Horenstein

Technical
Black and White Photography
Beyond Basic Photography
Computer Wise
The Photographer's Source

Photo Essays
Racing Days (with Brendan Boyd)
Thoroughbred Kingdoms (with Carol Flake)
Baseball Days (with Bill Littlefield)

Juvenile
Go, Team, Go!
Spring Training
Sam Goes Trucking
Hoops
That's a Wrap!
How Is a Bicycle Made?
How Are Sneakers Made?
My Mom's a Vet

Other
(editor) *Fashion Photography: Patrick Demarchelier*
(editor) *The Photographic Essay: William Albert Allard*
A Cat's Life (with Pierre Le-Tan)
A Dog's Life (with Pierre Le-Tan)

A Pond Press Book

First Edition
Fifth Printing, 2001

All photographs not credited are © Henry Horenstein.

Library of Congress-in-Publication Data
Horenstein, Henry.
Color photography : a working manual/by Henry Horenstein.
p. cm.
Includes bibliographical references and index.
ISBN 0-316-37317-6 (hc) — ISBN 0-316-37316-8 (pb)
1. Color photography — Handbooks, manuals, etc. I. Title.
778.6 — dc20 93-21445

Published simultaneously in Canada by Little, Brown & Company (Canada) Limited

PRINTED IN THE UNITED STATES OF AMERICA

© Lisa Hartjen

This book is for Paul Krot.

Contents

Ellie Hollinshead, *Jenny at Yaddo.*

Good color photographs aren't always that colorful. This shot was made on a sunny day, but the subject was in the shade, and the resulting colors are low in contrast and almost monochromatic. "I originally wanted to capture the timelessness of the setting," says Hollinshead, a painter by trade. "As I set up the camera, Jenny walked into perfect position below the archway, and that's what made the picture work."

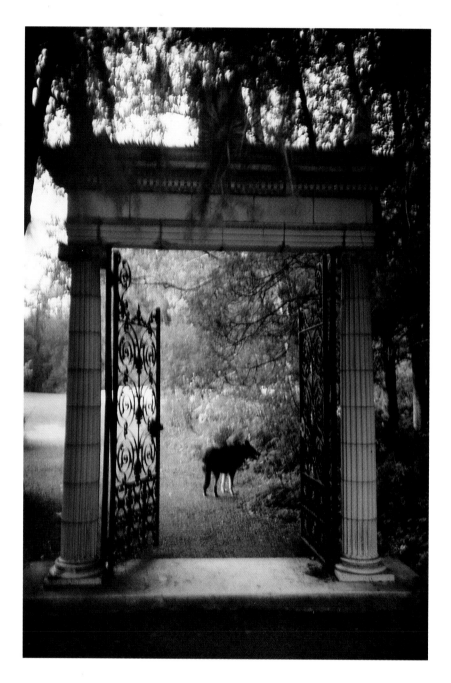

Introduction

Since the great majority of photographs are taken in color these days, it may seem odd to devote an entire book to the subject. Why not simply write a book called *Photography*, featuring mostly color illustrations and focusing on color processes, and leave it at that? Although this reasoning has a good deal of logic, there are in fact many good reasons to make a distinction. While almost all occasional amateur photographers do shoot color, many professionals and fine-art photographers as well as "serious amateurs" (including students and hobbyists) shoot mostly in black and white. And many of these photographers are "colorphobic"—reluctant to work in color or even intimidated by it.

Photography programs in schools and other institutions almost always begin by teaching black-and-white technique. Color is usually treated as a next step, rather than a beginning. As such, there is a need for a color text to guide more advanced students (although this book was written so that anyone with even a rudimentary knowledge of camera and darkroom controls would have no trouble understanding it).

The truth is that color photography is no harder to master than black-and-white photography. Some would say it's easier. Color photography does require some different skills and information, but the fine quality of current films and papers and the high degree of reliable automation provided by modern camera and lab equipment make good color photographs much easier to produce today than they were a few short years ago.

No doubt color photography is a complex subject. After all, it took some of the best scientific minds in the world some 100 years to invent a practical color system. But because you don't need to be one of those scientists to practice this system, I decided to provide a practical manual for the working photographer—something that would lay out the options and controls available to him or her and show what some fine photographers have produced with widely available equipment and the same set of

skills. This book's emphasis, then, is on making better color photographs—not on theory or criticism. As such, it's a logical follow-up to my previous texts, *Black and White Photography: A Basic Manual* and *Beyond Basic Photography: A Technical Manual.*

While this book provides much useful information, keep in mind that good photographers often break as many rules as they observe. Follow the text and try to understand the logic behind the technique, but don't be afraid to take a chance now and then and do things differently.

Color Photography: A Working Manual represents a combined effort by many people over several years, including some fine photographers, teachers, and editors. Russell Hart was my chief collaborator, technically and conceptually. He was responsible for much of the basic research, as well as text accuracy and photo selection. Jim Dow and Lorie Novak also made major contributions in shaping the book, as did Jerry Vezzuso. Readers along the way included John Auer (Agfa Corporation), Valorie Fisher, Allen Hess, Bob Hower, Kim Mosley, Jack Naylor, Elaine O'Neil, Andrea Raynor, James M. Reilly, John Reuter, Monona Rossol, and Jacquie Strasburger. Also making significant efforts were Steve Brettler of E. Phillip Levine Company; John Lane and Rich Ferrari at Polaroid Corporation; Rowena Otremba, Mary Osgood, Tom Warhol, and Brian Jacobson at Zona Photo Labs; Steve Tyminski, Wendy Erickson, and Joanne M. Kirwin at Ilford; and Joe Runde and the Marketing Technical Support Organization at Eastman Kodak.

Tom Briggs of Theurer Design produced his usual stylish and accurate illustrations. Julie Mihaly was the original and primary photography editor. Contributing technical and other research were Alexandra Foley and Richard Maurer. Tracy Hill was instrumental in guiding the book through its myriad stages, as was Megan Doyle.

Janis Owens created the elegant and accessible design. Barbara Jatkola copyedited; Cheryl Brooks provided the index; and Christina Eckerson handled production.

Among the others who helped along the way: Lindley Boegehold, Janet Bush, Bobbi Carrey, Barbara Hitchcock and Nasarian Rohani of Polaroid Corporation, Ellie Hollinshead, Jack and Penny Lueders-Booth, Sylvia Wolf, Janet Zweig, and, of course, all the photographers who allowed me to use their photographs and comments.

I especially want to thank Dick McDonough for having the vision to sign up the book and Mary Tondorf-Dick for her endless patience and encouragement in seeing it through.

Color Photography

A WORKING MANUAL

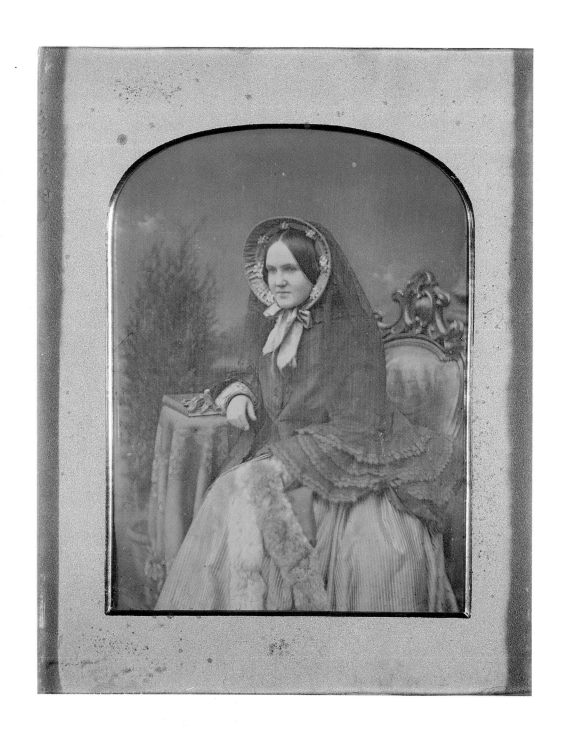

Origins of Color Photography

In early photographs color was applied by hand.

(Opposite)
John Jabez Edwin Mayall, *Portrait of Caroline Greg.*

The fragile quality and nonabsorbent shiny surface of daguerreotypes made them difficult to color. This portrait, taken about 1850, is fully colored; with most daguerreotypes, if color was applied at all, it was in small areas to accent portions of the image. George Eastman House.

The first practical systems of photography were introduced in 1839 with Louis Daguerre's daguerreotype from France and William Henry Fox Talbot's calotype from England. Although these inventions caused a great sensation, there remained a lingering sense of frustration. The first photographs were colored, but they lacked a range of color. They rendered subjects monochromatically, in tones of a single color.

Many of the early pioneers, including Daguerre and Talbot, worked actively on this problem, and some had a measure of success. As early as 1840, the Englishman John Herschel reportedly produced a primitive color image based on the interference principle (see pages 5–6). Around 1850, Frenchmen Edmond Bequerel and C. F. A. Nièpce de St. Victor (whose uncle had made what is generally credited as the first photographic image in 1826) and American Levi L. Hill all reportedly produced color photographs. However, none of these early efforts could be fixed reliably, and the images faded shortly after they were made.

Photographers took to adding color to the surface of photographs with pigments, oils, watercolors, and other substances. Examples of this technique date from the very beginning of the medium, and it remained the most popular method of producing color photographs for about 100 years.

Some processes were more suited to hand-coloring than others. Coloring a daguerreotype, for example, required great care and ingenuity because the surface was fragile and smooth. Coloring a paper print, such as a salt or an albumen print, was much easier. Many photographic portrait studios hired colorists, who were often miniature painters—a craft that was being eliminated by photography, which was cheaper and more realistic and required less sitting time.

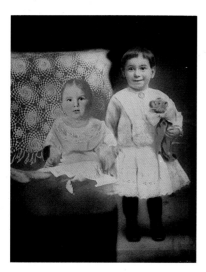

Anonymous, *Sarah and Marcia.*

Applied color remained the most common method for creating color in photographs into the twentieth century. This 1915 portrait was so heavily colored that the original photograph was almost covered.

James Clerk Maxwell, *Tartan Ribbon.*

This re-creation of Maxwell's historic demonstration of additive color was produced with three different black-and-white separation negatives, each shot through a different color filter (blue, green, and red). Cavendish Laboratory, University of Cambridge.

Coloring styles varied widely. Some colorists treated the image faintly—for example, a mild tinting of the cheeks. Others emphasized specific items of clothing, jewelry, or facial features. Some used transparent watercolors; others opted for heavy oils to cover the original image completely.

While hand-coloring thrived, the search for a true color photography process continued. One of the most important contributions came before photography was even invented. In 1802, the celebrated British physicist and mathematician Thomas Young suggested that color vision was produced by receptors in the eye responding to various proportions of three colors: blue, green, and red.

In 1861 James Clerk Maxwell, a Scottish physicist, demonstrated Young's theories by photographic means. He made three separate black-and-white negatives of a tartan ribbon. Each "separation" negative was shot through a different color filter. For filters, Maxwell used three glass containers filled with blue, green, and red liquids. He made positive transparencies from each negative and projected each transparency through the same filter with which the original negative had been exposed. When the three images were superimposed, they re-created the original colors of the tartan ribbon.

Maxwell's method of creating color was based on *additive* principles—mixing proportions of blue, green, and red light—and became the basis for the earliest successful systems of color photography. Most current systems use *subtractive* principles, by which color can be created by mixing various amounts of cyan, magenta, and yellow, known as the subtractive primaries. (See Appendix 1 for more on additive and subtractive color principles.)

Subtractive color formation was originally proposed by Louis Ducos du Hauron and fellow Frenchman Charles Cros, who worked independently of each other but announced their findings at about the same time in the late 1860s. Whereas Ducos du Hauron concentrated on practical applications, Cros focused primarily on theory.

Like Maxwell, Ducos du Hauron made three separate exposures on different pieces of black-and-white film through blue, green, and red filters. He made positives from these, then stripped off the positive emulsion and applied pigments to them using gelatin coatings. For the pigments, Ducos du Hauron used the complements of the filters through which he had shot the negatives. For the negatives made through exposure to the blue filter, he applied yellow pigment; for

Louis Ducos du Hauron, *Rooster and Parrot.*

Du Hauron's main photographic contribution was in demonstrating how color could be created by subtractive means, mixing cyan, magenta, and yellow dyes, as in this 1879 still life. Although additive principles were used to make most of the successful early color photographs, subtractive methods eventually prevailed. Virtually all color materials today are based on subtractive principles. George Eastman House.

Early subtractive processes were impractical.

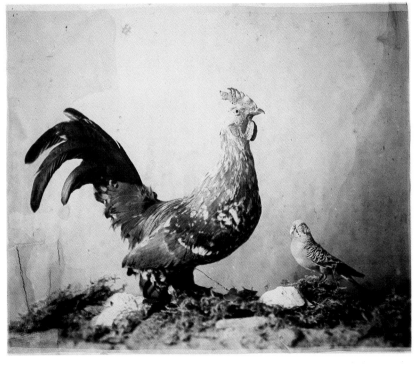

green he applied magenta; and for red he applied cyan. The gelatin absorbed the pigment of each in proportion to the density of the negative.

Ducos du Hauron thus produced the first examples of color photographs created by subtractive means. His methods were highly influential and spawned many important color processes over the years, including carbro, dye transfer, and Fresson.

Unfortunately, early subtractive color processes were clumsy and slow. They required photographing the same subject three times on three separate plates. Exposure often took many minutes, due to the density of the filters and the slow emulsions of the period, which made photographing live subjects virtually impossible.

Not all early color photography research concentrated on additive and subtractive principles. Some of the most promising work was based on interference principles, which produced color through the chemical response of a silver chloride emulsion to reflected light waves, much the same way color is produced on oil slicks or in mother-of-pearl when viewed at a certain angle.

A French physicist and Nobel Prize winner, Gabriel Lippmann, came close to success with his interference efforts. The process he

Gabriel Lippmann, *View of Versailles.*

Lippmann created highly accurate color photographs using the interference principle, which involved reflected light waves. His efforts were promising, but the results could not be adequately fixed and were difficult to view. This 1900 landscape is one of a very few remaining examples. George Eastman House.

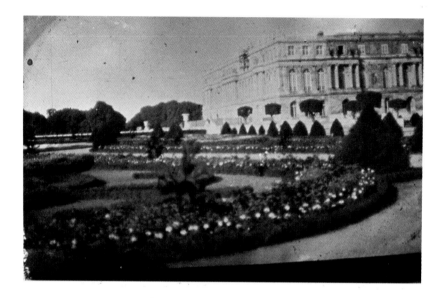

(Opposite)
Frederic Eugene Ives, *Flowers in Vase.*

Ives was an important figure in the history of color photography, contributing a three-color additive process as well as research in subtractive color that helped lead to the development of Kodachrome. This 1896 still life was created with three positives made from separation negatives, one each taken through a blue, green, and red filter. The positives were superimposed and viewed together through a stereo viewer. (The original was a stereo image.) George Eastman House.

introduced in 1891 produced remarkably natural colors, but he was not able to solve many of the problems that had plagued earlier interference experiments, including long exposures and awkward viewing methods.

Meanwhile, research in additive color continued with inventions from Frederick Ives, an American printer, beginning in 1892. Ives produced color separations with light entering a camera and bouncing off various reflective surfaces into three separate channels through either a blue, green, or red filter. He later introduced the Kromskop for viewing color stereo images and the Projection Kromskop for color lantern slides.

The Ives color process required the use of an ingenious but bulky and awkward camera. Nevertheless, versions of his process (variously called the three-color or color-separation process) remained in use well into the twentieth century, primarily because they were well suited for making photoengravings. A last notable refinement, the Devin One-Shot, was introduced as late as the 1940s.

Additive screen plate processes represented the next generation of color photography. The first breakthrough came in 1893 when John Joly, an Irishman, introduced a system that exposed a single plate of black-and-white film through a "taking screen" of microscopic lines of blue, green, and red dyes. The resulting black-and-white negative was printed onto another plate to produce a positive sheet of film. The positive reproduced the color of the original subject when seen

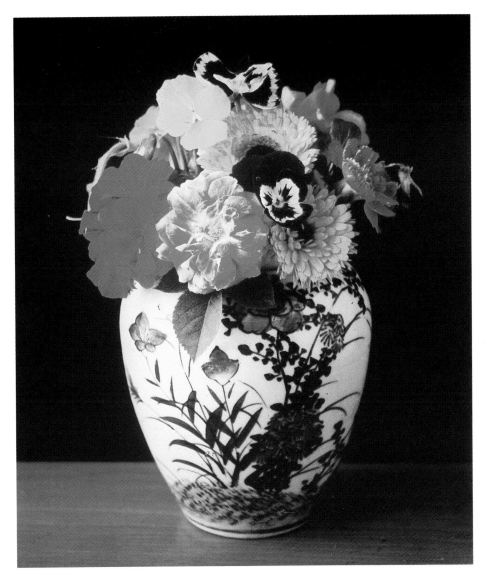

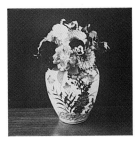

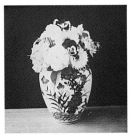

Blue Filter

Green Filter

Red Filter

 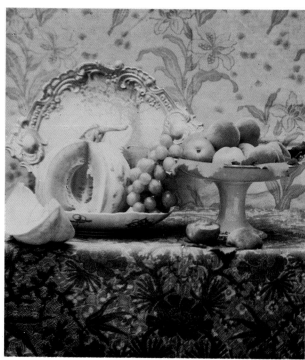

Auguste and Louis Jean Lumière, *Still Life of Fruit.*

The Lumière Brothers were innovators in color photography, experimenting with many different processes before introducing Autochrome, the first commercially viable color process. This stereo image from about 1899 was created using gum bichromate, which was popular with fine-art photographers around the turn of the century. The color was applied by hand using individual layers of an emulsion consisting of gum arabic, potassium bichromate, and colored pigment. George Eastman House.

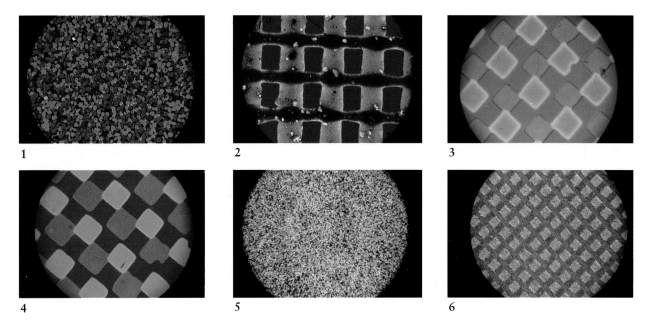

Autochrome was the first and best known commercial additive screen system. However, several manufacturers later introduced their own additive screen materials. The screen patterns from different manufacturers, six of which are illustrated here, varied widely from regular to random. (1) Autochrome (1907) (2) Omnicolor (1909) (3) Paget (1913) (4) Finlay Color (1929) (5) Agfacolor Ultra (1934) (6) Dufaycolor (1935)
R. C. Smith, *The Illustrated History of Color Photography* by Jack Coote, Fountain Press (England).

The first successful color product, Autochrome, used a screen built into the film to create color.

through a "viewing screen" that lined up with the original taking screen.

Like so many early color methods, Joly's screen process was awkward and slow. Also, the color was poor, and the image was often out of register; it was difficult to line up the taking and viewing screens with precision.

Still, the Joly process was widely imitated and improved upon, most notably by the Lumière brothers, Frenchmen well-known for their innovations in motion pictures. In 1907, they introduced Autochrome, a one-plate additive process that eliminated the need for separate taking and viewing screens.

Autochrome is generally considered the first commercially successful color process. It used different-colored starch grains to filter light, but the construction of the color filters was a limiting factor. Spreading the grains evenly over the film surface was a problem, causing grains of like colors to clump together. Even though the grains were extremely small, about 4 million to the square inch, Autochromes often displayed random blotches of blue, green, and red.

Also, the filters sometimes overlapped, with reds merging into greens and greens into blues. The effect diluted the quality of the

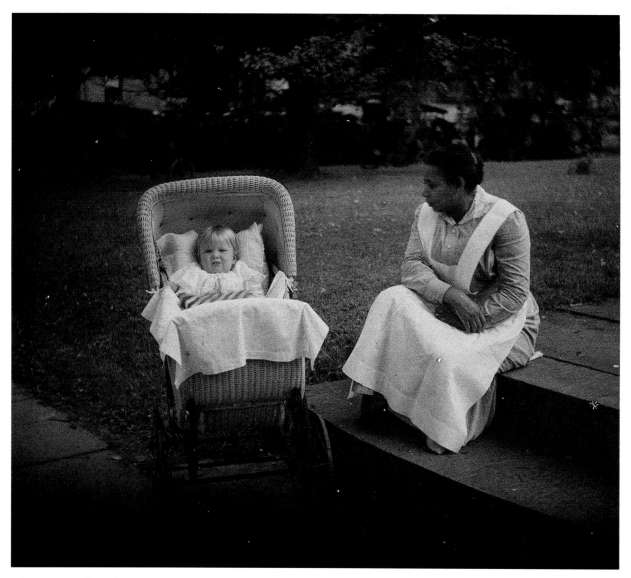

Charles C. Zoller, *Child and Nurse.*

Autochrome was the first widely used color photography process. Its characteristics included muted colors and a pointillist texture resulting from the random patterns of starched grains that helped create the color. Zoller, who was based in Rochester, New York, was one of Autochrome's most prolific practitioners, producing thousands of images, including this one taken in 1920. George Eastman House.

Leopold Mannes and Leopold Godowsky, inventors of Kodachrome, also were accomplished classical musicians. Their contributions to color photography were so significant that they often were called "Man and God" by their colleagues at Kodak. The Naylor Collection.

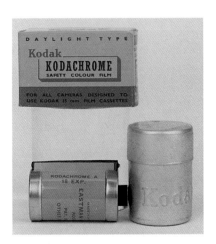

The original 35mm Kodachrome packaging consisted of film in a cartridge, a protective metal container, and an outer box. The Naylor Collection.

color, making it appear less accurate and bright, and softened the image, which often looked slightly out of focus.

Like all early color processes, Autochrome was very slow. A typical bright sunlight exposure might have taken 4 seconds at f/16. This was due to the inherent slowness of the emulsion, the added density of the color filtering starch grains, and the need for a filter on the lens to help achieve accurate color.

Color quality improved markedly as competitors produced their own additive screen plate processes. Some of the most notable included Dufaycolor (1910), which used a flexible film base rather than a glass plate; Agfa Colour (1916), which packed colored grains in a tighter pattern; and Finlay Color (patented in 1906 but not marketed until 1929), which used independent taking and viewing screens to accommodate a variety of black-and-white emulsions.

The search for a practical subtractive color process continued, despite the growing success of additive screen plate products. Even the Lumière brothers produced some primitive subtractive images in 1895, exhibiting them at the Paris Exposition in 1900.

Subtractive principles were finally made practical with the discovery that color forming chemicals, called *couplers,* could be incorporated in photographic materials to produce color photographs. The major breakthrough was made by the German chemist Rudolph Fischer, with contributions from Johann Siegrist, Karl Schinzel, and others. What Fischer described in a 1912 patent became the basis for modern color photography.

Fischer's process could be used in any camera, which was significant since most early processes required the use of dedicated equipment. It involved three emulsion layers, sensitive to blue, green, and red light. Development activated couplers that formed complementary dye colors in each layer; yellow dyes formed in the blue layer, magenta in the green, and cyan in the red. The three layers overlapped to create the color image.

Fischer's discoveries were critical, but it took Americans Leopold Mannes and Leopold Godowsky, both dedicated musicians who started working on methods of color photography together as teenagers, to make a practical product. Working for Kodak in the 1930s, Mannes and Godowsky originally designed a film with dye couplers built in, but they couldn't achieve accurate color because the couplers kept migrating from one layer of film to another. Changing

The biggest limitation of Kodachrome was (and remains) complex processing requirements.

(Opposite)
Francis Hart, *Portrait of Lorena Hart.*

Kodachrome produced razor-sharp images and vibrant, accurate color, the first commercially available color film to do so. Kodachrome has always had outstanding stability characteristics; this snapshot from 1953 has held its color well with no noticeable image deterioration.

direction, they succeeded by introducing the couplers during development. The result was Kodachrome. Originally introduced as a motion picture film for amateurs, Kodachrome was available by 1936 as transparency film in rolls for still photography.

Kodachrome has three light-sensitive layers, each containing separate black-and-white emulsions with different color sensitivities. The top layer is sensitive to blue light, the middle layer to green, and the bottom layer to red. (There also is a yellow filter layer positioned below the blue to keep blue light from affecting the bottom layers. The yellow filter layer disappears when the film is processed.)

Each black-and-white emulsion layer records light in proportion to the original colors of the subject. The blue-sensitive layer, for example, receives the most exposure from blue parts of the subject. In the first developing stage, the film turns into the equivalent of three separate black-and-white negatives, with silver density deposited on each layer according to the amount of exposure each area of that layer has received. Thus, a blue sweater records with greatest density on the film's blue layer. The second development reverses the image to create a positive and introduces dye in each layer complementary to that layer's original sensitivity (again in proportion to the original exposure). The overlapping complementary dyes form the image color. Subsequent processing steps include bleaching and fixing to remove the silver.

Kodachrome was a landmark invention, capable of producing high-quality color images with sharpness and color fidelity. Improved versions remained the standard color film for decades, and many amateurs and professionals still swear by it. As a practical matter, Kodachrome has one major limitation: processing is so complex that only a few labs are set up to do it.

The introduction of Agfacolor Neu in 1936 solved this problem. This was the first successful *chromogenic* color film; it had built-in couplers that didn't migrate between layers. In the chromogenic process, the color is formed, instead of added, during development. As the silver density builds, chemical by-products activate couplers and release dyes in proportion to the silver buildup on each emulsion layer. Subsequent bleaching and fixing remove the silver, leaving only the color image.

Processing chromogenic films is much easier than processing Kodachrome. It can even be done in home darkrooms, although early

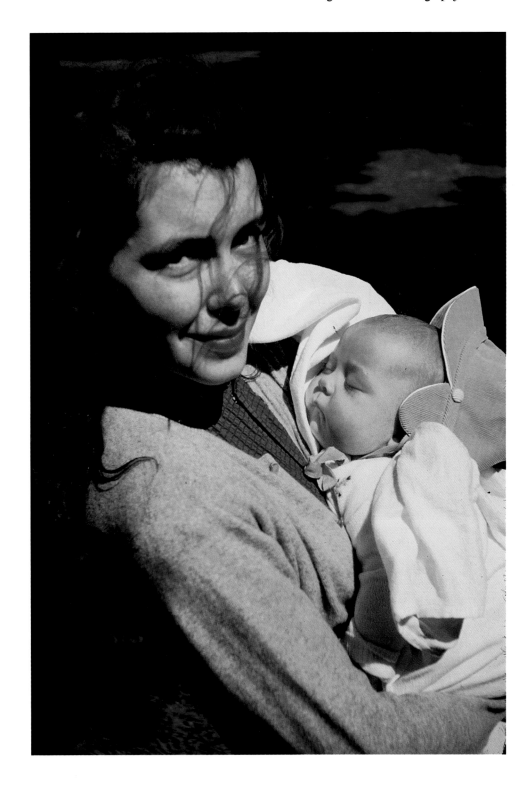

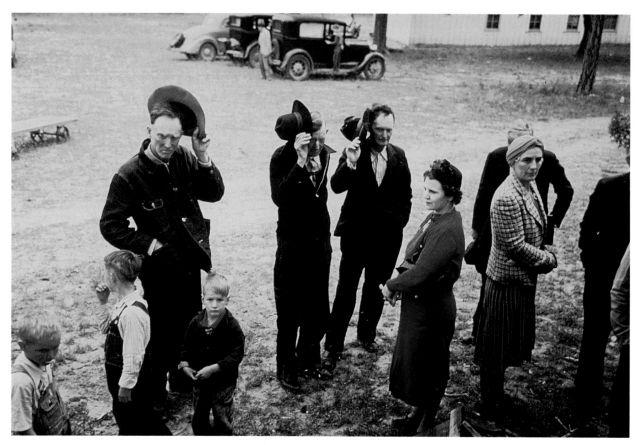

Russell Lee, *Saying Grace Before the Barbeque Dinner
at the Pie Town, New Mexico Fair.*

*The Farm Security Administration (FSA) produced a
major documentation of American life during the Great
Depression. The many fine photographers who worked
on the project included Walker Evans, Dorothea Lange,
Marion Post Wolcott, Carl Mydans, and Russell Lee.
Almost all of the FSA photographs are black and white,
influencing the way that era is generally remembered.
However, several hundred color photographs also were
shot for the FSA on the newly available Kodachrome film.*
Courtesy of The Library of Congress.

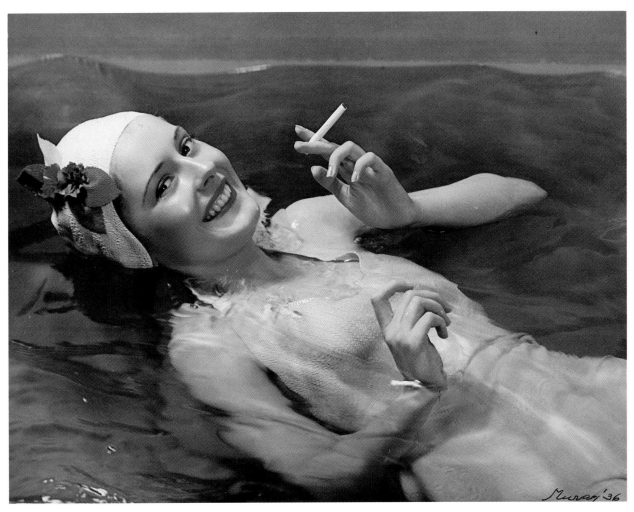

Nickolas Muray, *Girl in Pool.*

Advertising photographers, among the first professional photographers to use the emerging color processes, were extremely fussy about accurate color rendition. Muray, an influential pioneer, made this ad for Camel cigarettes in 1936 with the carbro process, which used three pigmented tissues (one each of cyan, magenta, and yellow) to transfer the separation images to the printing paper. Carbro, which competed with Kodak's dye transfer for many years as the process favored by professionals for fine prints, remained in use well into the 1950s. George Eastman House.

This 1946 advertisement was made with the Ansco Printon transparency-to-print process. A process similar to Minicolor, which had been introduced five years earlier by Kodak, Printon was the first chromogenic printing process that could be used by individuals as well as commercial labs. George Eastman House.

Chromogenic films can be processed much more easily than Kodachrome.

processing systems were fussy and took a long time. However, early chromogenic color and image quality were not up to Kodachrome quality. Over the years, this has changed. Modern chromogenic films are excellent and now dominate color photography. In fact, Kodachrome is now the only commonly used nonchromogenic color film.

For 35mm Kodachrome users, Kodak introduced 2" x 2" cardboard Koda Slide Mounts in 1939. These were attached to individual film exposures at the processing lab so the results could be projected for viewing.

Prints from Kodachrome also were needed. In 1941, Kodak introduced its first color printing service with Minicolor prints for 35mm and roll film cameras in 2x (2¼" x 3¼") and 5x (5" x 7½") sizes. Minicolor prints were made on an opalized white cellulose acetate base, with a feel similar to modern resin-coated papers. That same year, Kodak also introduced Kotavachrome prints, in sizes ranging from 8" x 10" to 30" x 40", for professionals using Kodachrome in sheet form.

The earliest negative films based on subtractive color principles actually came before Kodachrome. In 1928, Color Snapshots, an

Albert Wittmer, *Group with Car and Horse.*

Bela Gaspar introduced the first practical silver dye-bleach material, the process on which Ilfochrome (formerly called Cibachrome) is based. Fully formed dyes were incorporated in the paper emulsion, and processing bleached out the unwanted colors, producing a print with excellent color, sharpness, and image stability characteristics. Wittmer's photograph was made in 1941 on Kodachrome transparency film and printed on a Kodak silver dye-bleach material called Azochrome. George Eastman House.

Chromogenic methods developed in the 1930s were the basis for almost all color films and papers commonly used today.

(Opposite)
Voyager 1, *Jupiter's Moon Io.*

The Jet Propulsion Laboratory, in Pasadena, California, played a large role in developing digital photography as an efficient means for transmitting data across vast distances of space. In 1979, the Voyager 1 spacecraft sent home this image of Jupiter's moon Io. Digital enhancement of the edge of the moon (note the pixilated blue outline) reveals a gaseous plume from one of Io's erupting volcanos. Jet Propulsion Laboratory/NASA.

English company, introduced Colorsnap, a product based somewhat on Ducos du Hauron's concepts. The company went bankrupt soon after. Agfa also licensed the product and produced a similar film. In 1939, Agfa introduced Agfacolor, the first chromogenic negative motion picture film. Three years later, Kodak brought out Kodacolor color negative film.

Negative film was especially popular with amateur photographers. It produced better-quality prints than transparency-to-print processes such as Minicolor. It also had more exposure latitude than transparency film, allowing color photographs to be made using simple box cameras with rudimentary exposure controls.

Early color negative films also were faster (more sensitive to light) than early transparency films. When Kodacolor was introduced, it had a film speed equivalent to ISO 32, almost four times faster than the original Kodachrome.

Other, more complicated methods of making color prints were being developed for professional photographers. Kodak's wash-off relief process (1935) and dye-transfer process (1945) were related processes that took Ducos du Hauron's discoveries several steps further. Both formed color by absorbing dyes from a series of gelatin-relief images—a highly complex and time-intensive matter, but one that resulted in excellent color fidelity and outstanding image stability.

Bela Gaspar, a Hungarian chemist, introduced the first successful silver dye-bleach color process in 1934. This subtractive method reproduced color by bleaching out unnecessary dyes already contained in the emulsion rather than activating or adding them. Originally released as a motion picture film, Gasparcolor was the forerunner of Ilfochrome, a popular modern process introduced in 1963 as Cibachrome (see pages 193–197).

Most modern films and papers are based on processes from the 1930s, but the materials have improved enormously. The color is far more accurate, processing is quicker and less fussy, emulsions are much faster, and images are razor sharp. Processing is universally standardized. For example, you can process various-speed transparency films by Agfa, Fuji, Kodak (except for Kodachrome), and Konica together in the same tank for the same amount of time.

In addition, there are now dozens of different color films and papers, offering a wide range of color palettes, speeds, and other characteristics. Most have much-improved stability characteristics;

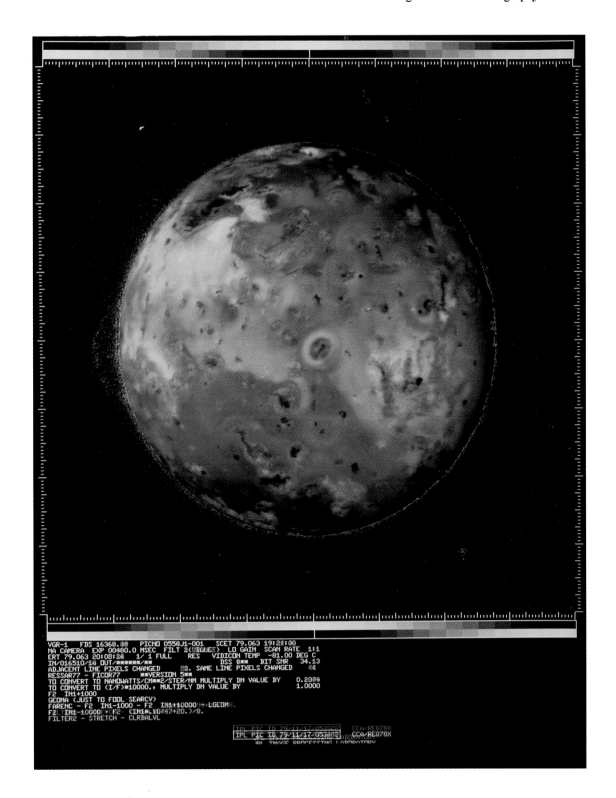

VGR-1 FDS 16368.00 PICNO 0550J1-001 SCET 79.063 19:20:00
NA CAMERA EXP 00480.0 MSEC FILT 2(ORANGE) LO GAIN SCAN RATE 1:1
ERT 79.063 20:08:26 1/ 1 FULL RES VIDICON TEMP -81.00 DEG C
IN/016510/16 OUT/******/** DSS 0** BIT SNR 34.13
ADJACENT LINE PIXELS CHANGED 00. SAME LINE PIXELS CHANGED 44
RESSAR77 - FICOR77 **VERSION 5**
TO CONVERT TO NANOWATTS/CM**2/STER/NM MULTIPLY DN VALUE BY 0.2086
TO CONVERT TO (I/F)*10000., MULTIPLY DN VALUE BY 1.0000
F2 IN1+1000
GEOMA (JUST TO FOOL SEARCY)
FAREMC - F2 IN1-1000 - F2 IN1+10000 + LGEOMB.
F2 IN1-10000 + F2 (IN1 10262+20.)/8.
FILTER2 - STRETCH - CLRBALVL

IPL PIC ID 79/11/17 053222 CCA/REQ78X
IPL PIC ID 79/11/17 053402 CCA/REQ78X
IPL IMAGE PROCESSING LABORATORY

Polaroid film was first introduced in the late 1940s, but it wasn't until 1963 that the company offered a color version, called Polacolor. This early example was made during the testing of the film, just before it was released as a product. Polacolor was "peeled apart" after development to reveal the positive image, a method still used to process Polaroid professional materials. Polaroid Corporation Archives.

(Opposite)
Eliot Porter, *Redbud Tree in Bottom Land, Red River Gorge, Kentucky.*

Landscape photography was dominated by photographers working in black and white into the 1980s. Eliot Porter was an exception, shooting almost exclusively in color from the 1940s until his death in 1990. To make his prints, he used the now-defunct Kodak dye-transfer process, which was laborious but produced excellent color and long-term image stability. Amon Carter Museum.

when properly handled and stored, they last much longer than early films and papers, without fading or otherwise deteriorating (see Appendix 2).

Probably the most important color process introduced after chromogenic materials came from Polaroid. Edwin Land, who founded the company, started his business by developing and selling polarizing filters. Land's passion was vision research, and in 1947 he introduced the first instant photography system. In 1963, Polaroid added a color version called Polacolor.

Land's process was based on diffusion transfer, a technology used in early photocopiers. The film contains a negative and a positive receiving sheet to make the print. After exposure, a roller in the camera (or a separate film holder) presses the sheets together for the image transfer, during which silver dyes migrate to the positive receiving sheet. You wait for a minute or two (depending on the type of film), then peel the negative from the positive, discard the negative, and keep the positive.

In 1972, Polaroid introduced SX-70, a self-developing film that didn't need to be peeled. In 1983, the company released several instant 35mm films, including one that was based on old-fashioned additive screen technology to form color.

In the 1960s, NASA developed methods of digital imaging for recording and transmitting images of the planets from spacecraft. Digital cameras use electronic sensors, which break the image down into tiny picture elements (called *pixels*). In this form, an image can be stored in a computer, then seamlessly retouched, altered, and combined with other images and text. It also can be transmitted almost instantaneously to other locations through telephone lines or microwave signals.

Digital images are stored electronically on either a chip or a magnetic disk and require no film or paper, although negatives, transparencies, or prints can be made from digital files if desired. The technology has been widely adopted for applications such as medical imaging, computer graphics, and weather mapping. The design and printing industries also use it to lay out, retouch, and reproduce photographs.

In 1981, Sony introduced the Mavica, which was the first electronic camera for consumers. Using analog rather than digital signals, the Mavica recorded the image and stored it on a 2-inch disk. Several manufacturers have since introduced both analog and digital elec-

tronic cameras, as well as digital backs for existing cameras. You also can "capture" (photograph) the subject with conventional materials, then scan negatives, transparencies, or prints to turn them into digital files (or have a service bureau scan them for you).

Today, more than 95 percent of all photographs taken are in color, whether for snapshots or professional purposes. Home processing of color materials is now easy and affordable, and digital image capture and processing is available to individuals with access to personal computers and scanners.

It wasn't that long ago that color photography was looked upon with skepticism by many creative and professional photographers. Today color photographs are routinely exhibited in the world's finest galleries and museums. Whatever materials and processes are used, it's still the individual who creates the final result. Ansel Adams, the legendary landscape photographer best known for his black-and-white work, summed up the matter in 1969 when he said, "As yet we do not have much effective control in color photography except in control of subject matter and the applied lighting. However, were I starting all over again, I am sure I would be deeply concerned with color. The medium will create its own aesthetic, its own standards of craft and application. The artist, in the end, always controls the medium."

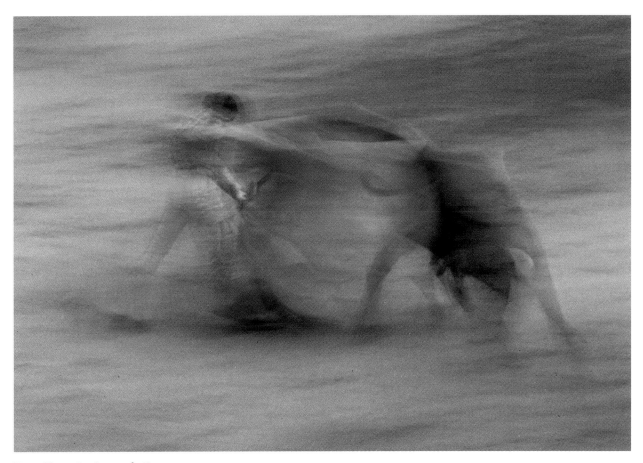

Ernst Haas, *La Suerte de Capa.*

Haas was one of the first photojournalists to work extensively (and successfully) in color. He made this classic bullfight photograph on assignment for Life *magazine in 1956, using a slow shutter speed and moving the camera to create a sense of motion. Haas wrote, "To follow a movement with a camera is as obvious as following a movement with one's eyes.... I work by moving my whole body and not only my head and hands."*

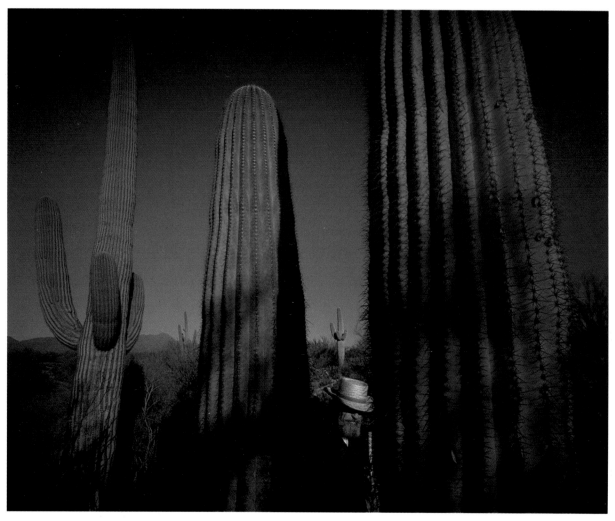

Gregory Heisler, *Edward Abbey.*

Greg Heisler shot this portrait for a series on American naturalist writers in Life *magazine. He chose a cactus for the foreground because Abbey was known to be a rather prickly character. The crew first set up to photograph in Saguaro National Forest, but a park ranger booted them out after lecturing them on conservation—a lecture Abbey himself might have written. Shot with a 4" x 5" camera and daylight transparency film, the photograph's strongly saturated colors are due to a combination of lighting conditions (late afternoon sun), location (Arizona), and season (summer).*

Photographing in Color

Photographing in color is similar in many ways to photographing in black-and-white, but there are important differences.

Shooting color film is in most ways similar to shooting black-and-white film. You load the camera, adjust the film speed, and set the lens aperture, shutter speed, and focus (or let the camera do any of these things for you). Then you press the shutter button to make the exposure. Naturally, you also have to consider the usual critical matters of content, composition, and subject lighting.

Perhaps the most important difference between photographing in color and in black-and-white is the effect of light on color. Under one type of light, film may record a subject neutrally, whereas another type of light on the same subject may produce warm (yellow/red) or even cool (blue) results. When the overall image shifts away from neutral (toward warm, cool, or any specific shade), the result is often referred to as a *color cast*.

Color films and lighting must be balanced for neutral color.

To render the subject color in a neutral way, you'll have to match, or *balance*, the film type with the light source. This may require using a particular type of film, changing the lighting, using filters when photographing, or changing your filters when making prints.

Contrast also must be considered. As with black-and-white films, flat lighting produces low-contrast results, and harsh lighting produces high contrast. Unlike black-and-white films, color films allow relatively little contrast control. You can influence the contrast of color materials in a limited way, however, by using a different type of film, varying film exposure and development time, using papers with different contrast grades, and applying advanced printing techniques such as flashing (see pages 180–184).

Subject lighting is a critical factor in determining color balance and contrast.

HOW TIME OF DAY AFFECTS COLOR

Photographs look very different at different times of the day. Specifics may vary with other factors, but typically outdoor light is very cool before dawn. It warms as the *sun rises, but later in the morning and into early afternoon becomes neutral. As the sun goes down, the resulting light warms up again, then cools down after sunset.*

6:30 A.M.

7:00 A.M.

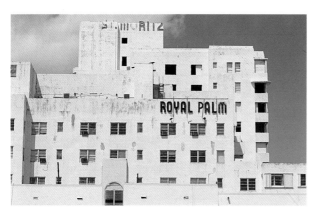

Noon

3:45 P.M.

6:00 P.M.

8:30 P.M.

Because of these limitations, the light on your subject is especially important with color photography. Natural light won't always provide the color and contrast you want. It will vary enormously depending on factors such as weather (and other atmospheric conditions), time of day, location, and season. Late afternoon sun, for example, may provide a warm, golden cast and high contrast, whereas dark clouds may yield cool and monochromatic results with very low contrast.

You'll achieve maximum control over color and contrast only by lighting the subject exactly the way you want to—in a studio or totally dark room. You can use electronic flash, hot lights (photofloods or quartz lights), or any other light source, such as candles or a flashlight. You can even cover the light source with inexpensive colored filters and produce your own colors.

Color Films

Color films offer a wide variety of choices. There are films to produce negatives and films to produce positives. Some films are for daylight use and others for use with tungsten light sources. Many films come in both amateur and professional versions and in a variety of sizes. Film speeds vary widely, as do contrast, sharpness, graininess, and color characteristics.

Negative versus Transparency Films

Negative films, also called *print films,* are usually identified by the suffix -*color* attached to the manufacturer's name, as in Agfacolor and Fujicolor. Transparency films generally have the suffix -*chrome,* as in Ektachrome and Fujichrome. Thirty-five millimeter transparency films also are called *slide films* (a *slide* is a transparency, usually 35mm, framed in a cardboard or plastic mount). Regardless of format, processed transparencies are often called *chromes.*

Negatives are designed to be printed to create a positive image, usually on paper but occasionally on a clear film base for purposes such as overhead projection and display. As with black-and-white negatives, color negatives reverse the tones of the original subject (making dark areas thin and light areas dense), but they also use complementary colors (making blue areas yellow, green areas magenta, and red areas cyan, see page 88). Color negatives contain an overall

Color slides are transparencies secured in a cardboard or plastic mount.

HOW SEASON AFFECTS COLOR

Season is another important influence on the color of a photograph. From season to season subject color may change (leaves in the fall or snow in the winter), as does the color temperature of outdoor light. Example by John Shaw.

Winter

Spring

Summer

Fall

Color negatives have an overall orange or reddish cast, with colors complementary to those of the subject.

Negative films are used for prints. Transparency films can be printed, but they are used mostly for projection, reproduction, and display.

Color negative films are used widely for snapshots as well as for a variety of professional applications.

orange "mask," which is formed during processing, to help control color balance and contrast in printing.

Negative films are the usual choice for snapshots of family events, vacations, and holidays. They also are used by many professionals for portraits, weddings, editorial (mostly magazine) work, photojournalism, fine-art photography, and other purposes.

Amateur photographers sometimes use transparency films, but these films are more popular among professionals. Transparency films are sometimes printed on paper (or a clear film base), and the results can be excellent, but they are much more often the end product—intended for projection (onto a screen); reproduction (in books, magazines, ads, brochures, and other printed material); stock (resale of rights for limited use of photographs); or backlit displays.

Daylight versus Tungsten Films

Different types of light produce very different colors. For example, natural light varies widely from warm to cool, and light from common household bulbs and photofloods is relatively warm. You don't always notice these differences because the human brain interprets color so that it appears more or less neutral. However, film records the various colors of light objectively and yields warm casts when the light is warm and cool casts when it's cool.

For photographic purposes, the color of light is described in terms of its *color temperature* and is measured on the *Kelvin* scale. Warm light has a low Kelvin temperature, and cool light has a high temperature. A 100-watt household bulb, for example, has a color temperature of 2900K (Kelvin), while daylight on an overcast day is about 7000K (although one overcast day may vary in color temperature from another). See the box on page 34 for more about the Kelvin scale and a list of the color temperatures of many common light sources.

Most color films are *daylight balanced*—usually matched for 5500K light, which is the average color temperature of direct sunlight at noon. Daylight films record color neutrally when the color temperature of the light is close to 5500K (or when using an electronic flash, which emits approximately 5500K light).

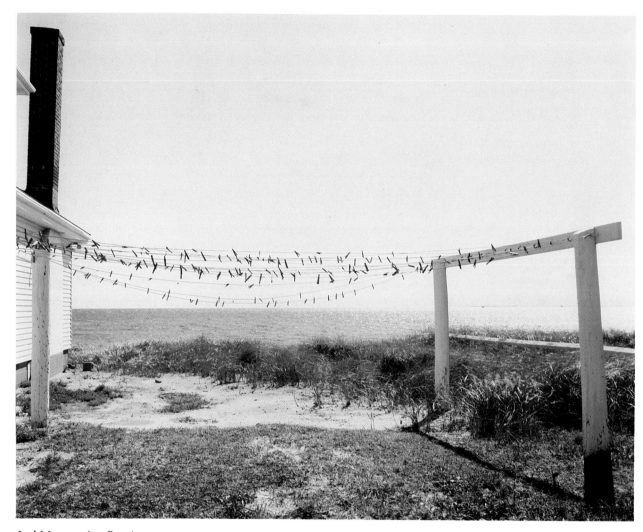

Joel Meyerowitz, *Provincetown.*

Meyerowitz was one of the first fine-art photographers to have wide success exhibiting color work. This photograph was made around noon, giving it a neutral color balance and so emphasizing formal composition over color qualities. "I went and stood in front of (the clothespins)," Meyerowitz says in an interview in his book Cape Light, *"and I remember that when they were below the surface, they were clothespins on the line, and when they were above the surface, they were clothespins on the line; but when I brought them in relationship to the horizon, you see, and put them in the same focus as the horizon, they became music and birds and figures and clothespins. . . . Somehow the tension—when they're kissing the horizon—it became a photograph. It's the smallest subject; there's nothing going on here. I mean, who the hell wants to take a picture of clothespins? . . . And yet, I'm very moved by it."*

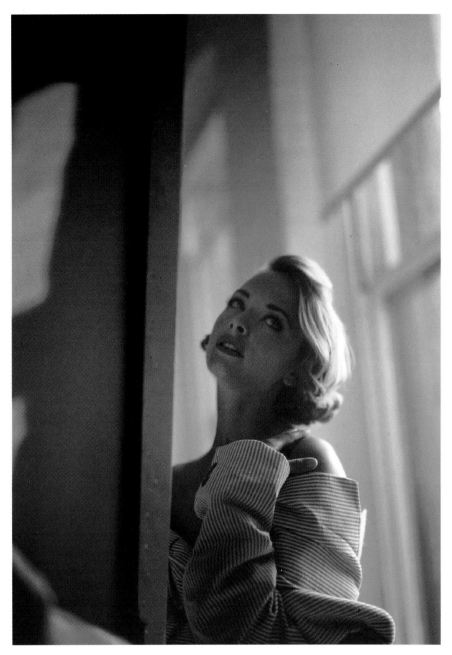

John Goodman, *Charlotte and the Mirror.*

At the end of a fashion shoot, Goodman made dramatic use of mixed daylight and incandescent light for this informal portrait of a model. Taken with tungsten film, the image has a strong blue cast on one side, which was lit by daylight coming through the studio window. The model's face was illuminated by a standard household light, which has a lower color temperature than tungsten film and thus produced a warm yellowish-orange cast.

Color films are balanced for either daylight or tungsten light.

Since natural light varies widely, daylight film shot in light with a low color temperature, such as at sunrise or sunset or with ordinary household bulbs, produces a warm cast. Daylight film produces cool results when light has a high color temperature, such as in shadow areas on sunny days, in fog and rain, and in landscapes with a lot of ultraviolet (UV) rays.

Tungsten-balanced films are made for light with a low color temperature, such as household bulbs and photographic photofloods and quartz-halogen lamps. Most are transparency films balanced for 3200K. Subjects lit by photofloods and quartz lights should record neutrally with tungsten films, and subjects lit by household bulbs will have a slightly warm cast because these bulbs have a color temperature below 3200K.

Two other types of tungsten film are available, although neither is widely used. *Type A* film is balanced for 3400K, which matches the color temperature of some types of photofloods or quartz lights (currently there is only one Type A film available). *Type L* is a 3200K-balanced negative film, which allows you to use long exposures without reciprocity failure setting in (see pages 67–69).

If the lighting and film type don't match, you can usually achieve neutral color by using filters when photographing. Negative films don't need filtering as often as transparency films do, since negatives can be filtered when printed to correct color. (If you print transparencies, you can color correct with filters, but with less control.)

Discontinuous light sources are especially difficult to color balance.

Discontinuous light sources, such as fluorescent, mercury vapor, and sodium vapor lamps, have missing wavelengths and are likely to produce strong and unpredictable color casts no matter what type of film you use. They generally require strong filtration for color correction, and sometimes even that won't do the job. (See pages 95–96 for information on filtering with discontinuous light sources.)

Most fluorescent lights produce a strong green cast with daylight films (or a bluish cast with tungsten). Mercury and sodium vapor lamps (used for lighting streets, parking lots, roads, and other public areas) yield widely varying results depending on the type of light and the type of film, from offbeat and eerie to monochromatic.

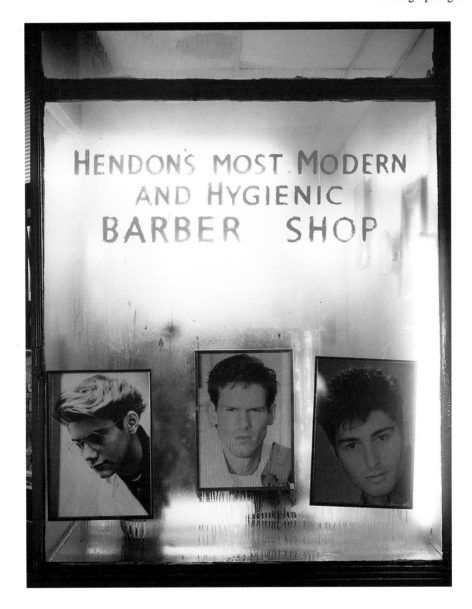

Jim Dow, *Barbershop Window, Hendon, London.*

"Photographing is the least time-consuming part of what I do," says Dow. *"It takes hours to find a location, get permission to shoot, and prepare. Then I sometimes go back and shoot the same subject again three or four times."* This photograph, part of a long-term series on small British shops, is typical of Dow's painstaking technique. He used 8" x 10" daylight negative film and left the shutter open for 15 seconds, long enough to adequately expose the interior of the shop window.

For the window exposure (lettering and photographs) he used a portable studio flash, popping the flash on the subject while the shutter was open (six times on the left side and six on the right), a technique called *open flash.* This evened out the exposure on the interior and the window, but created a color imbalance. The flash produced somewhat neutral color on the exterior with the daylight film, but didn't affect the interior, which was lit by fluorescent light and printed green.

The Kelvin Scale

Color temperature is defined in scientific terms as a black body—a hypothetical object that absorbs all the energy that falls on it. When heated, the black body turns color. At first it turns red, then yellow, and ultimately blue and violet. The temperature at which the black body matches the color of a given light source is said to be the color temperature of that light.

The measure of color temperature is degrees Kelvin (for Lord Kelvin, a nineteenthth-century British physicist). A *Kelvin* is a unit of temperature in the absolute scale. The absolute scale, which has a variety of scientific uses besides photography, starts at a hypothetical point (absolute zero) where molecular motion stops. Degrees Kelvin represent the same intervals as degrees Celsius, but the scale begins at a different level; 0 degrees Kelvin equals –273°C.

Following are the color temperatures (in degrees Kelvin) of some common light sources. Some are approximations. The color temperature of sunlight at the end of the day, for example, is given as 3500K, but it varies depending on season, weather, atmospheric conditions, and other factors.

Candlelight	1900K
40-watt bulb	2650K
60-watt bulb	2790K
75-watt bulb	2820K
100-watt bulb	2900K
200-watt bulb	2980K
Sunrise/sunset	3100K
500-watt photoflood bulb (ECT or EAL)	3200K
500-watt photoflood bulb (EBV or DXC)	3400K
Sunlight/end of day	3500K
1 hour after sunrise/before sunset	3600K
Clear flashbulb	3800K
2 hours after sunrise/before sunset	3950K
Flashcube	4950K
Daylight: noon/direct sun	5500K
Electronic flash	5500K
Daylight: overcast sky	7000K
Daylight: dull/foggy weather	8500K
Daylight: clear skylight/ open shade/no direct sun	10,000K and up

THE KELVIN SCALE

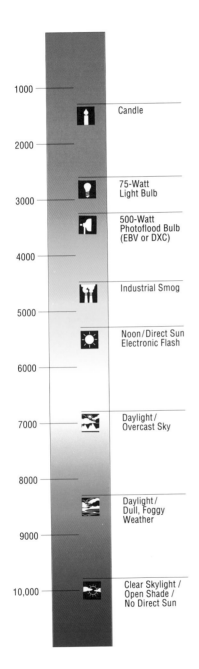

1000

— Candle

2000

3000 — 75-Watt Light Bulb

— 500-Watt Photoflood Bulb (EBV or DXC)

4000

— Industrial Smog

5000

— Noon/Direct Sun Electronic Flash

6000

7000 — Daylight/ Overcast Sky

8000

— Daylight/ Dull, Foggy Weather

9000

10,000 — Clear Skylight / Open Shade / No Direct Sun

Color temperature is measured on the Kelvin scale. The low end of the scale represents warm colors, such as yellow and red, while the high end of the scale represents cool hues, such as blue and violet.

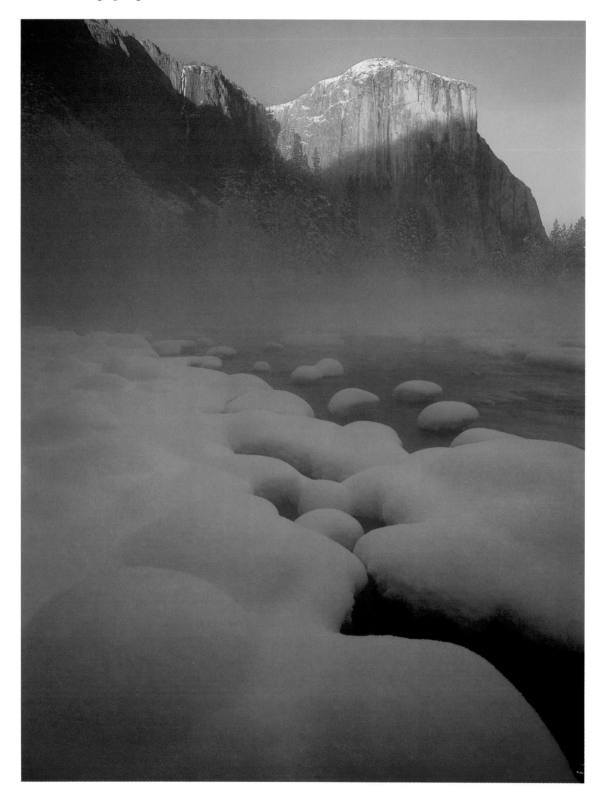

Professional Films

Unexposed and unprocessed films are subject to aging. With color films, this means that certain characteristics (notably color balance, speed, and contrast) will change with time. To help guarantee peak performance, manufacturers offer professional versions of many of their films. Some color films, including most medium-format and all large-format films, are available only in professional versions.

Exactly what *professional* means varies somewhat with the manufacturer. However, the main thing all professional films have in common is the fact that they are shipped from the manufacturer to the camera store when they reach their peak criteria (in terms of color balance, speed, contrast); amateur films are shipped before they reach their peak. Professional films also have a shorter expiration date, reflecting the peak limits.

Some professional films are designed and manufactured to different color specifications. For example, the amateur version of a certain film may have more highly saturated color and higher contrast for added impact, whereas the professional version of the same film may have less intense color and lower contrast for more accurate skin tones and greater subject detail.

Other characteristics of professional films may include a heavier film base, a more durable emulsion, and/or more flexibility in push and pull processing (see pages 59–63). Naturally, professional films are more expensive than comparable amateur films.

Emulsion Batches

Film emulsions are manufactured in specific lots, called *batches*. Each batch is subject to minor variations in color balance, speed, and contrast. Such variations present a greater problem when shooting transparency films than when shooting negative films because the processed transparency is usually the end product, whereas negative films have more exposure latitude and better correctability when printed.

Each emulsion batch is identified by a number printed on the film package. To guarantee consistent exposure and color balance, you should use film from the same batch, especially when working on related series of photographs. Buy the film in quantity and put it in the refrigerator or freezer until you're ready to use it. Then shoot a test roll, process it, and examine the results. Adjust the exposure and/or add filters as necessary for the rest of the rolls from that batch,

Professional films are shipped to the camera store when they are at their peak.

(Opposite)
Pat O'Hara, *Yosemite National Park, California.*

This photograph, taken in the last evening sunlight after a January snowstorm, shows the dramatic extremes of photographic color. Explains O'Hara, "The unusual combinations of virgin snow, fog hovering over the Merced River, and the warm light on El Capitan gave inspiration to photograph this scene." The light on the snow in deep shadow has a high color temperature and appears blue, while the cap of the mountain has a low color temperature and looks very warm and rich.

making sure that you use the same lab for film processing. Different labs may produce somewhat different results; even the same lab may produce different results at different times. See page 98 for a method of testing film.

Some packages of professional transparency film, include exposure and filtration recommendations to compensate for the characteristics of a particular emulsion batch. These recommendations are helpful as a starting point, but testing is preferable because it allows you to factor in variables such as the particular processing lab and personal judgment.

Film Characteristics

Each color film has its own characteristics. For example, color quality varies widely from film to film. Some films are manufactured to have a warm bias, but others have no appreciable bias at all. Some films produce more saturated (intense) colors than others. Furthermore, dyes used by different manufacturers vary. A red sweater photographed with one film may appear a different shade of red than when photographed with another film.

Film speed has an important effect on how film renders a subject. Slower films generally produce greater sharpness, richer colors, often more contrast, and a less grainy appearance (see the box on page 40). However, this can vary with the brand and type of film; a particular film rated at ISO 100 may produce sharper results than another ISO 100 film.

The choice of film is a highly individual matter. Whereas one photographer might prefer vivid colors for impact, another might prefer visible grain pattern to achieve a painterly effect. Also, different subjects may suggest totally different approaches.

Practical considerations also come into play. For example, with subjects in motion, you may have no choice but to use a high-speed film so that you can set a faster shutter speed to stop action, or you may need a low-speed film for a slower shutter speed to create a blur. At times, you may use a negative film rather than a transparency film, not because of the film's characteristics but because you need both a black-and-white and a color print of the same subject. (It's easier to make good quality black-and-white prints from color negatives than from transparencies.)

Different types of color film vary in their color rendition, sharpness, contrast, graininess, and other characteristics.

(Opposite)
Jody Dole, *Green Urn with Orchid.*

Most photographers try to minimize image graininess, but advertising photographer Jody Dole likes to emphasize it—to take his subjects, in his words, "beyond their ordinariness." For this photograph documenting the blooming of an orchid, Dole used a very grainy (now discontinued) ISO 1000 transparency film in natural light. Dole sometimes pushes film 2 or 3 stops or more to create this softly textured effect.

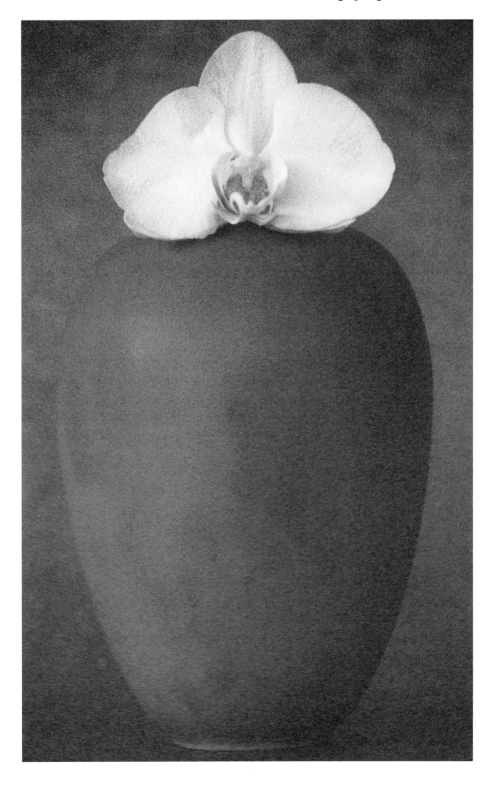

Grain and Color Films

The processed emulsion of a black-and-white negative is made up of clusters of metallic silver crystals known as *grain*. The more the negative is enlarged to make the final print, the more visible is the grain. Color negatives and transparencies also exhibit graininess, but they contain no silver. Undeveloped color films do contain silver compounds, which help form color dyes as they are developed, but these compounds are removed during processing by bleaching and fixing. As the dyes form, "dye clouds" materialize around the silver particles and remain after the silver is gone, "remembering" its grain pattern. These dye clouds create the "grain" in a color negative or transparency.

This electron micrograph of a processed Agfa transparency film shows color photographic grain structure. The image displays all three layers simultaneously, so you can see cyan, magenta, and yellow dye clouds. Courtesy of Agfa-Gevaert AG, Leverkusen, Germany.

Refrigeration or freezing extends the useful life of most films.

Heat, Humidity, and X Rays

Color films keep very well when stored properly, which means away from heat and humidity. Proper refrigeration should help extend film life, even though some manufacturers say it's not necessary.

Use any frost-free refrigerator, set at 55°F or lower, and store the film in its original box and/or plastic canister. (If the film has been removed from its box or canister, put it in a plastic storage bag and close it tightly for storage.) When you're ready to use the film, take it out of the refrigerator and let it reach room temperature before unpacking. This will take about 1 to 2 hours. If you take the film out of its packaging while it's cold, condensation may form on the emulsion and damage it.

Process the film as soon as possible after exposing it. If you have to wait, store the exposed film away from heat and humidity, or put it in its original canister or envelope or in a plastic storage bag and keep it in the refrigerator until you can process it.

All films, with the exception of Polaroid instant films (see pages 74–80), can be frozen for even greater protection against aging. Freezing is especially useful if you are storing film for a long time. Again, use a frost-free refrigerator and allow the film to reach room temperature before removing it from its packaging. This will take a

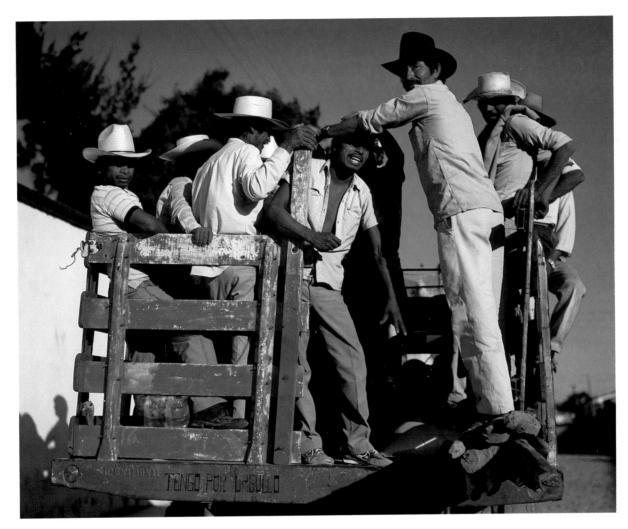

Jay Maisel, *Oaxaca, Mexico.*

"This photograph was shot in a small market town at the end of the day while people were packing up to go home," says Maisel. *"I used a 4" x 5" Graflex camera, hand held."* The strong, late afternoon sun accounts for the strikingly warm and highly saturated color. Shadows, reduced to blacks, help emphasize the powerful forms of the subjects.

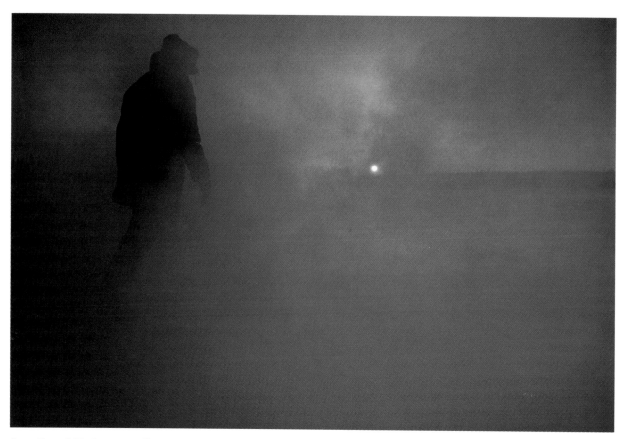

Stan Grossfeld, *Sunset Walk.*

"I wasn't thinking about f-stops and shutter speeds when I took this picture," says Grossfeld, a two-time Pulitzer Prize winner for photojournalism. "I was trying to remember not to press my cheek against the camera in the −40°F Siberian chill. If you forget, you leave part of your face on your camera." Particles in the frozen air create a natural filter in the end-of-day light, giving the photograph a strong, warm red cast and an impressionistic feel.

lot longer for frozen film (as much as 4 to 5 hours) than for refrigerated film.

X-ray machines at airport security stations can cause film to fog under some circumstances. Fogged film may mean dense negatives, washed-out transparencies, reduced contrast, and/or flawed color. The likelihood of damage varies with the strength of the X-ray machine, which is a factor you can't control.

To be safe, you should avoid having your film X-rayed whenever possible. High-speed films (ISO 400 or higher) are especially sensitive to fogging, but all films are susceptible, especially when subject to repeated exposures. The effect is cumulative, so be especially careful when your travel plans require several trips through security.

Exposing Color Films

Correct film exposure is the primary factor in determining whether or not you'll get good negatives and transparencies. Film that receives the right amount of exposure produces negatives and transparencies that print, project, and reproduce well. Too much or too little exposure may yield unusable results (especially with transparencies). Film processing and printing are important, of course, but you can't get the best results from poorly exposed film no matter how good you are in the darkroom.

Correct exposure technique is important to guarantee good negatives and transparencies.

For the most part, the following techniques for exposing color films also apply to exposing black-and-white films. Matters that are specific to exposing color negatives and transparencies are detailed on pages 55–59.

Reviewing Exposure Basics

For practical purposes, good exposure means setting the right shutter speed and lens aperture for the given lighting conditions and film speed. The shutter speed determines how long film will be exposed; the aperture determines how much light it will receive through the lens.

Exposure variables include shutter speed, lens aperture, lighting conditions, and film speed.

With bright light, you'll need a fairly fast shutter speed and/or a relatively small aperture to keep the film from receiving too much exposure; with low light, you'll need a slower shutter speed and/or a wider aperture to guarantee enough exposure. Films with a high

speed rating are especially sensitive to light, so they'll need a faster shutter speed and/or a smaller aperture than slower films when used in the same lighting conditions.

To determine the correct exposure, use a light meter to measure the light and translate that measurement into a workable combination of shutter speed and aperture. Modern 35mm cameras and some larger format models have built-in light meters that read light as it travels through the lens. If you have an older 35mm camera without a through-the-lens meter, or a medium- or large-format camera, you'll probably need a separate hand-held meter. (Some older cameras have meters that attach to the camera body. For practical purposes, these function like hand-held meters, since they don't read light through the lens.)

The first step, regardless of the type of meter used, is to let the meter know the speed of the film. Many cameras do this automatically by reading a DX code imprinted on the film cassette. If your camera doesn't have this capability, or if you're using a hand-held meter, you must set the film speed manually.

Then point the camera (or hand-held meter) at the subject. Most in-camera and hand-held exposure meters, with the exception of incident meters (see page 55), read *reflected light,* which is light that bounces off the subject.

As the meter reads the reflected light, it either suggests or automatically sets a shutter speed–aperture combination, which is displayed in the camera viewfinder (and/or in a numerical panel on top of the camera) or on the hand-held meter. The display may take a variety of forms, such as a digital readout, colored diodes, or moving needles. Refer to your camera or meter manual for specifics.

Shutter speeds are indicated in fractions of seconds and seconds. The fractional speeds are almost always used, with seconds reserved for low-light situations and long exposures. The smaller the number is, the shorter the exposure. The shutter speed 1/500 is shorter (faster) than 1/125, and therefore lets in less light (at a given aperture). To save space, 1/500 is usually represented on the camera or hand-held meter as 500. Apertures are measured in *f-stops,* with the larger f-numbers representing smaller openings: f/11 lets in less light than f/5.6 and more than f/16. See page 50 for a list of commonly available shutter speeds and apertures.

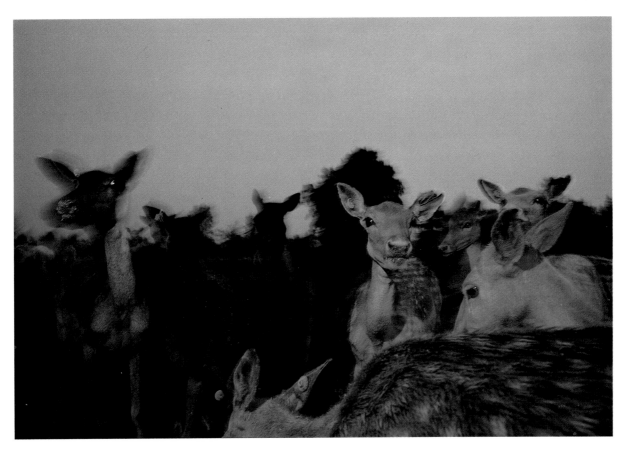

Jeff Jacobson, *Deer Ranch.*

"I took this picture on assignment for the now-defunct Connoisseur *magazine," says Jacobson. "It was for an article on a deer ranch in upstate New York that provides venison for fancy restaurants. I was surprised that they used the picture, because it has a rather ominous quality."* Part of the reason for that quality was the dark, overcast light, which Jacobson mixed with a flash by setting a long shutter speed (in this case, 1/8). The flash provided the primary exposure, freezing portions of the subject, while the long shutter speed captured enough ambient light to record some camera and subject movement. The ambient light "fringes" or blur also contributes to the ominous effect.

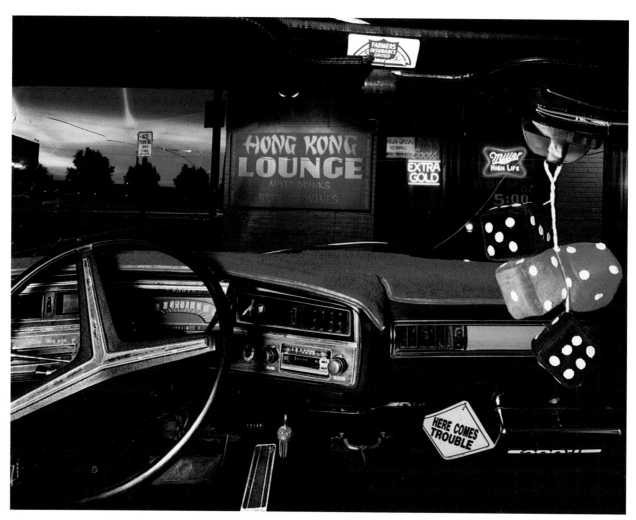

Alex Harris, *Hong Kong Lounge, Las Vegas, New Mexico, Looking North from Richard Lucero's 1972 Buick Centarian, July 1987.*

One way documentary photographer Harris tells people's stories is by shooting their personalized car interiors. Explains Harris, "When I would find a car interior I especially liked, I would photograph it against the backdrop of the man's village, or the landscape he frequently drove through. As I learned to control depth of field and to balance light with my view camera, I realized I could show what it was like for these men to be—and to see—in their cars." In this case, Lucero, the car's owner, spent much of his time at the Hong Kong Lounge. Harris used a 4" x 5" camera on a tripod from the back seat of the car, filling in the foreground exposure with a portable strobe. To get enough depth of field to have both foreground and background in focus and to show the entire dashboard, he used a wide-angle lens set at a very small aperture (f/64). Because the small aperture dictated a long exposure time, Harris used Type L film (to avoid reciprocity failure) and an 85B filter on the lens (to match the tungsten film to the background daylight and strobe). See pages 91–93 for information on color conversion filters.

Cameras and lenses typically indicate full shutter speeds and f-stops. Full shutter speeds include 1/8000, 1/4000, 1/2000, 1/1000, 1/500, 1/250, 1/125, 1/60, 1/30, 1/15, 1/8, 1/4, 1/2, 1 second, 2 seconds, 4 seconds, and so forth. Full f-stops include f/32, f/22, f/16, f/11, f/8, f/5.6, f/4, f/2.8, f/2, and f/1.4. Not all cameras and lenses offer these exact choices; some may offer slightly different ones. (Aperture openings between these full numbers are available on all lenses; in-between shutter speed settings are available on some cameras. See page 50 for details.)

Full shutter speeds and f-stops have a specific relationship to each other. Each setting allows twice or half as much light to reach the film as the adjacent setting. Thus, at 1/250, the shutter allows twice as much light in as at 1/500, and half as much as at 1/125. At f/11, the aperture allows twice as much light in as at f/16, and half as much as at f/8.

This sets up a useful reciprocal relationship between shutter speed and aperture. If the meter indicates an exposure of, say, 1/60 at f/8, then 1/30 at f/11 will produce the same amount of exposure (assuming your equipment is accurate); 1/30 lets in twice as much light as 1/60, and f/11 lets in half as much light as f/8. The following combinations will provide the same exposure: 1/15 at f/16, 1/8 at f/22, 1/125 at f/5.6, 1/250 at f/4, and 1/500 at f/2.8.

The decision to use one exposure combination instead of another generally depends on whether motion or depth of field is your priority. If you want to stop action and render a moving subject sharply, choose a combination with a fast shutter speed, say 1/500 at f/2.8. To create a blur, go for a slow speed, perhaps 1/15 at f/16. Unless you want an overall blur, don't set your shutter speed too slow without using a tripod to steady the camera. The slowest speed you should use when hand-holding a camera is 1/30 (some say 1/60); a longer or bulkier lens will require an even faster shutter speed. (One way you can determine the slowest hand-held shutter speed for the lens used is to put a 1/ over the focal length. Thus, use a shutter speed no slower than 1/50 with a 50mm lens and no slower than 1/200 with a 200mm lens. These are only approximations, as the sizes of lenses from different manufacturers—in particular zoom lenses—vary widely.)

The aperture helps control *depth of field,* which is the area between the foreground and background of an image that's acceptably sharp. If you choose an exposure combination with a small

Each setting of full shutter speeds and f-stops doubles or halves exposure.

Shutter speed controls subject and camera movement. Aperture controls depth of field.

opening, such as 1/8 at f/22, you'll get greater depth of field than if you choose a combination with a large opening, say 1/500 at f/2.8.

The term *stop* is used in a general way to describe a doubling or halving of exposure. Thus, 1/125 is said to be a stop slower than 1/250 and a stop faster than 1/60; f/5.6 allows a stop more light through the lens than f/8 and a stop less light than f/4.

Changes in film speed and subject lighting also are sometimes described in stops. Film rated at ISO 50 has 1 stop less speed than film at ISO 100. And an area of the subject that's twice as bright as another area has 1 stop more light.

Many cameras have an exposure compensation control that adjusts the overall exposure in automatic exposure mode. Setting the camera at +1 adds a stop of exposure to the camera-selected exposure, and setting it at −1 reduces the exposure by 1 stop.

Most cameras allow you to adjust the f-stop or shutter speed in either 1/2- or 1/3-stop increments. Don't confuse these with full stops. If the meter's suggested exposure is 1/250 at f/6.7 (halfway between f/5.6 and f/8), you'll need to use 1/125 at f/9.5 (between f/8 and f/11) or 1/60 at f/13.5 (between f/11 and f/16) for the same results.

Equipment variation is another factor in exposure. One shutter set at 1/60 may let in 1/3 stop more light than another shutter also set at 1/60. (The same goes for aperture, exposure compensation, and film speed settings, although shutter speeds are the most likely to show variation.) You can run exposure tests for all your equipment, or you can make adjustments as problems become evident. If your exposures are consistently slightly underexposed, keep the exposure compensation control set at +1/3 stop (in automatic exposure mode) or the film speed set at 1/3 stop lower to provide a little more light. If your exposures are consistently off when using a particular lens, make an adjustment only when using that lens.

The term "stop" can refer to any doubling or halving of exposure.

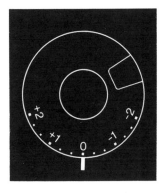

An exposure compensation dial allows you to make adjustments in automatic exposure mode—here, up to 2 stops more or less exposure in 1/3-stop increments.

Different types of meters read light from different areas of the subject.

Metering Patterns

All light meters read light, but they don't all target the same area of the subject. Some meters focus on a very small section of the subject, while others "see" a much broader area. Many in-camera meters offer a choice of several different metering patterns, while some in-camera meters and most hand-held meters read light in one way only. The following metering patterns are commonly available.

METERING PATTERNS

(Top) When making its exposure recommendation, a center-weighted averaging meter gives the most weight to the area of the subject within the viewfinder's large central section.
(Middle) A multisegment meter makes its exposure recommendations by reading light from different sections of the subject and using computer algorithms to analyze each section.
(Bottom) A spot meter measures light from a small area in the center of the viewfinder only.

Averaging. Virtually all averaging meters are hand-held meters. They accept a broad angle of light (about 30 degrees measured from the meter's light-receiving sensor) and average all the light values (shadows, mid-tones, and highlights) read to determine exposure.

Center-Weighted Averaging. These in-camera meters also measure a broad angle of light. They average all the light in the viewfinder but give more weight (about 60 percent to 80 percent) to the center when determining exposure. The center area is usually indicated by a circle or ellipse in the viewfinder.

Spot. Spot meters read a very narrow angle of light from a limited area of the subject, which is usually represented by a small circle in the center of the viewfinder. The area varies with the model. Hand-held spot meters have an angle of acceptance of about 1 to 2 degrees. In-camera spot meters almost always read a wider angle, which varies with the focal length of lens being used; it gets narrower with a telephoto lens and broader with a wide-angle lens.

Multisegment. These in-camera meters (also called *matrix, evaluative,* or *multipattern* meters by their manufacturers) divide the viewfinder into several sections. They read light from the entire viewfinder and use computer algorithms to individually analyze each section. If a particular section is much darker or lighter than the others, for example, the meter may discount or ignore that section when coming up with an exposure reading.

Exposure Systems

All meters measure light and suggest an appropriate exposure, but a number of systems are available for determining which shutter speed and f-stop are actually used in making the exposure. These systems range from fully manual to fully automatic, depending on the equipment used. Many cameras offer more than one system.

Manual Exposure. Most in-camera meters offer manual exposure—and exposure is always manual when using hand-held meters. The photographer sets both the shutter speed and the f-stop, using the meter's suggestions as a guide. Although manual exposure takes a little longer to set than automatic exposure, it allows you to fine-tune results easily.

Automatic Exposure (AE). In AE systems, the in-camera meter measures light, and the camera sets the shutter speed and/or f-stop accordingly. There are several AE variations. In the *aperture priority*

Shutter Speeds and F-stops

This chart shows shutter speeds and f-stops in full-, 1/2-, and 1/3-stop increments. Your options depend on your equipment. Some cameras allow full shutter speeds only; others allow either 1/2- or 1/3-stop increments (but not both) as well. All lenses allow you to set full-stop and either 1/2- or 1/3-stop (and even smaller) increments. The range of options also varies with the equipment. Not all cameras provide shutter speeds as fast as 1/8000, and few lenses open as wide as f/1 or close to f/32.

SHUTTER SPEED*		
Full Stops	1/2 Stops	1/3 Stops
1/8000		
		1/6400
	1/6000	
		1/5000
1/4000		
		1/3200
	1/3000	
		1/2500
1/2000		
		1/1600
	1/1500	
		1/1250
1/1000		
		1/800
	1/750	
		1/640
1/500		
		1/400
	1/350	
		1/320
1/250		
		1/200
	1/180	
		1/160
1/125		
		1/100
	1/90	
		1/80
1/60		
		1/50
	1/45	
		1/40
1/30		
		1/25
	1/22	
		1/20
1/15		
		1/13
	1/12	
		1/10
1/8		
		1/7
	1/6	
		1/5
1/4		
		5/16
	3/8	
		7/16
1/2		
		5/8
	3/4	
		7/8
1**		

APERTURE*		
Full Stops	1/2 Stops	1/3 Stops
f/32		
		f/29
	f/27	
		f/25
f/22		
		f/20
	f/19	
		f/18
f/16		
		f/14
	f/13.5	
		f/13
f/11		
		f/10
	f/9.5	
		f/9
f/8		
		f/7.1
	f/6.7	
		f/6.3
f/5.6		
		f/5
	f/4.5	
		f/4.3
f/4		
		f/3.8
	f/3.5	
		f/3.2
f/2.8		
		f/2.7
	f/2.5	
		f/2.2
f/2		
		f/1.8
	f/1.7	
		f/1.6
f/1.4		
		f/1.3
	f/1.2	
		f/1.1
f/1		

*In some cases, 1/2- and 1/3-stop increments have been rounded off for convenience. Designated numbers for these stops may vary with different brands of equipment.
**Many cameras offer several shutter speeds slower than 1 second, such as 2 seconds, 4 seconds, 8 seconds, and so forth.

mode, you set the f-stop, and the camera chooses the shutter speed. Aperture priority is especially useful when your priority is controlling depth of field.

In the *shutter priority* mode, you set the shutter speed, and the camera chooses the f-stop. Shutter priority is especially useful with moving subjects, if you want to stop or blur the action.

The *program* mode is the most fully automatic. The camera automatically sets both shutter speed and f-stop. This promotes quick shooting by eliminating all exposure decisions. The program mode has several possible variations, such as subject-oriented programs (perhaps favoring high shutter speeds for active subjects and small apertures for landscapes) and program shift (which allows you to change the camera-selected combination of shutter speed and f-stop for any given frame, while preserving the program exposure).

How Light Meters Work
The suggested meter reading will produce well-exposed negatives and transparencies most of the time, regardless of the metering pattern or exposure system you use. However, the suggested reading also may result in underexposure or overexposure, usually due to user error (not aiming or reading the meter correctly) and/or tricky lighting situations. Understanding how meters work should help you avoid these problems. (Occasionally, incorrect exposure also is caused by meters that are incorrectly calibrated or in need of repair.)

Meter readings are generally based on middle gray—a gray tone that reflects 18 percent of the light that hits it. Most subjects are made up of a mixture of shadows, mid-tones, and highlights that average out to about 18 percent gray. This usually allows meters to provide accurate readings.

Inaccurate readings are most likely to occur when the meter "sees" an imbalance of shadow and highlight values, such as when it's pointed only at mostly shadow or highlight areas or when the subject is made up of mostly dark or light values. Multisegment meters usually recognize such an imbalance and discount the areas that cause it before providing a suggested exposure. Other types of meters don't distinguish between dark and light areas; they average the light they read and sometimes suggest an incorrect reading.

If the meter is reading mostly shadow areas, or if the subject is mostly dark, the suggested settings may overexpose the film (causing

Many cameras provide several options for determining exposure.

Most of the time meter readings indicate correct exposure, but you can't always count on it.

Most light meters assume that the tones of a subject will average out to 18 percent gray.

If a subject has more dark values than light, the suggested meter reading may lead to overexposure. If it has more light values than dark, the reading may lead to underexposure.

dense negatives or light transparencies). This is because dark values absorb more light than 18 percent gray, which fools the meter into "thinking" there is less light present than there really is. The meter will overcompensate by suggesting an f-stop and shutter speed combination that allows too much light to reach the film.

The opposite occurs if the meter is reading mostly highlight areas or the subject is mostly light. The suggested reading may underexpose the film (causing thin negatives or dark transparencies). Light values reflect more light than 18 percent gray, so the meter compensates for what it reads as too much light by suggesting an f-stop and shutter speed combination that allows too little light to reach the film.

Subjects with mostly light values are more common than subjects with mostly dark values, so they more often result in exposure problems. Some examples of the former include bright skies, sand, and snow; Caucasian skin; interiors with strong window light; white or light clothing; and sidewalks and sides of office buildings in sunlight. Examples of the latter include some night scenes, a spotlit stage, and dark clothing.

Adjusting Exposure

There are several ways to avoid unintentional overexposure or underexposure. Using a multisegment meter will usually help by discounting extremely dark or bright areas. Although multisegment meters do an excellent job most of the time, they also can be thrown off—by user error or extremely tricky lighting situations (such as when the subject is made up entirely of highlights or shadows).

With manual metering, you can point the camera or hand-held meter away from extremely dark or light areas and toward areas that are medium in value, such as green grass (lit the same as your subject) or areas with a good mix of values. (For example, avoid reading bright skies with landscape subjects.) Expose with that reading, even if the camera meter indicates incorrect exposure when you recompose the subject.

You can make a simple correction to any meter reading to achieve a similar result. If the meter is reading mostly shadow areas or the subject has mostly dark values, reduce the suggested exposure; if the meter is reading mostly highlight areas or the subject is mostly light, add exposure. For minor corrections, you should reduce or increase

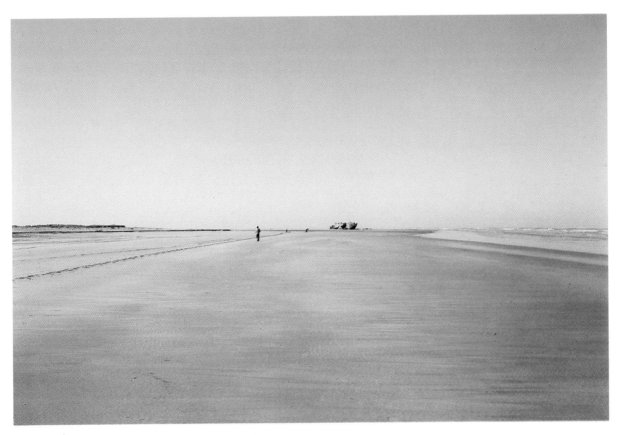

Harry Callahan, *Morocco.*

Although Callahan was first recognized as a master of black-and-white photography, he has worked extensively in color since the mid-1940s. This 1981 photograph was made on transparency film and printed using the dye-transfer process. "I was in Morocco just walking around," says Callahan. *"It was very* picturesque." *Subjects like this, with mostly light values, may throw off a meter reading and lead to underexposed results. To compensate, overexpose slightly from the indicated reading.* Hallmark Photographic Collection.

the suggested exposure by 1/3 to 1/2 stop; for stronger corrections, try 1 stop or so.

There are several ways to make these corrections. Using manual exposure, start with the meter's suggested exposure, then choose a slower shutter speed or wider aperture to add exposure or a faster shutter speed or smaller aperture to reduce it. Let's say the suggested reading is 1/60 at f/8. For 1 stop more exposure, use 1/30 at f/8 or 1/60 at f/5.6; for 1 stop less exposure, use 1/125 at f/8 or 1/60 at f/11.

In any of the AE modes, you can accomplish the same thing with the exposure compensation control (see page 48), which has a scale that designates the following stops, with fractional markings in between:

$$-2 \quad -1 \quad 0 \quad +1 \quad +2$$

(Some exposure compensation controls offer more than a 2-stop range.) To increase exposure by 1 stop, set the camera for +1; to decrease it by the same amount, use −1. In aperture priority mode, it will change the shutter speed to make the adjustment; in shutter priority, it will change the aperture; in program mode, it may change either or both.

Adjusting the film speed rating produces similar results (see the box on page 62). If you want to increase exposure by 1 stop, cut the manufacturer's film speed rating in half. With ISO 100 film, set the meter for EI 50. (EI stands for *exposure index* and represents any speed rating that varies from the manufacturer's recommended setting.) This tricks the meter into thinking that a less sensitive film (by one-half) is in use, and the meter will suggest (or set) twice as much exposure.

To decrease exposure by 1 stop, double the film speed rating. If you use EI 200 for ISO 100 film, the suggested reading will produce half as much exposure, because film that is twice as sensitive needs half as much light.

Many cameras that use a DX code to set film speed have an override that allows you to set the speed manually. Some DX-reading cameras, mostly inexpensive models, won't allow you to override them.

Decreasing or increasing exposure by 1/3 to 1/2 stop is usually enough for minor meter corrections.

There are several ways to adjust the suggested meter reading: by changing the f-stop, shutter speed, exposure compensation control, or film speed.

To make a gray card reading, position the card in front of the subject and read the light that reflects off the card.

Use an incident meter by placing the meter at the subject position and pointing it back toward the camera.

Alternative Metering Methods

You can get around the matter of whether you're pointing the meter at shadow or highlight areas, or whether the subject has mostly dark or light values, by not reading light directly from the subject. Instead, use a gray card or take an incident reading.

A *gray card* is medium gray in color and reflects 18 percent of the light that reaches it—exactly what most meter readings are based on. Gray cards are inexpensive and available from any good camera store or mail-order source. Most types are made of thick cardboard and measure about 8" x 10".

To use a gray card, place it in front of the subject, facing the camera, making sure that it's lit the same way as your subject. Take a meter reading by filling the viewfinder with the card (with an in-camera meter) or getting very close (with a hand-held meter). Make sure you don't include anything but the card in the viewfinder, and avoid any glare or shadow. The suggested reading will provide accurate exposure most of the time, although some negative films may benefit by a little more exposure and some transparency films may benefit by a little less or more (see the following pages).

Incident meters read light that falls on the subject (unlike reflective meters, which read light that bounces off the subject). To use an incident meter, hold it at the subject position and point it back toward the camera. Then make the exposure using the suggested reading. As with the gray card reading, you may want to make a slight adjustment with some negative and transparency films.

All incident meters are hand-held meters (although there are incident attachments for in-camera meters that fit on the front of the lens). Many hand-held meters offer both reflective and incident capability.

Exposing Color Negative Films

It's easier to get good exposures with negative films than with transparency films, partly because negative films have more *exposure latitude* (margin for error). Exposure latitude varies with the lighting conditions. There's more margin for error when the lighting is soft (low contrast) than when it's hard (high contrast). Latitude also varies somewhat with the film type. You can get information on the specific exposure latitude of any film from a camera store or the manufacturer.

(Opposite)
Jan Groover, *Untitled.*

Groover's classic still lifes are as much the work of a stylist as a photographer. Groover sets up her subjects and lighting with great care, then uses the camera to complete the process. Distinguished curator John Szarkowski once wrote that Groover's training as a painter "disposed her to think of a picture as something that was made, not discovered." Robert Miller Gallery

This negative is correctly exposed.

A negative of the same subject overexposed by 1/2 stop may print better than the "correctly" exposed negative.

In practice, slightly overexposed color negatives often print better than negatives that have been exposed normally (or underexposed). In fact, some photographers routinely overexpose color negative films by 1/3 to 2/3 stop or even more. Overexposure shouldn't affect the image color and will probably improve your prints by increasing shadow detail and reducing graininess. (Unlike overexposure of black-and-white films, which often causes increased graininess, overexposure of color negative film creates larger dye clouds in each emulsion layer. As the dye clouds get larger, they overlap and fill in from layer to layer, giving the appearance of less graininess.)

There are several ways to overexpose deliberately. In manual exposure mode, open up the aperture by, say, 1/3, 1/2, or 2/3 stop from the suggested meter reading. In AE mode, set the exposure compensation control at +1/3, +1/2, or +2/3. In either manual or AE mode, set the film speed at a 1/3- or 2/3-stop lower setting (meters don't usually allow you to set film speed in 1/2-stop increments), such as EI 80 or EI 64 when using ISO 100 films. Refer to the chart on page 62 for equivalent settings for different film speeds.

Often you can make adequate prints from slightly underexposed negatives, but you can rarely make excellent prints if the negative is thin. They may look muddled, cloudy, and flat (lacking contrast). Shadow areas are a particular problem. Prints from underexposed negatives may lack shadow detail and represent shadow areas as a flat color cast.

Exposing Color Transparency Films

Transparency films have less exposure latitude than negative films. Underexposure by as little as 1/2 to 2/3 stop may produce a dark transparency with inadequate shadow detail. The same amount of overexposure may lead to light transparencies with washed-out highlights. (Remember, unlike negatives, transparencies become lighter with more exposure and darker with less.) Printing transparencies allows you to make some corrections, but not as much as printing negatives. For example, you can't restore detail in the highlight areas that's been lost due to overexposure.

Usually you'll get the best results by exposing transparency films normally (at the stated film-speed setting). Some photographers routinely underexpose very slightly (1/3 stop) when shooting transparency film to get more color saturation and greater highlight detail.

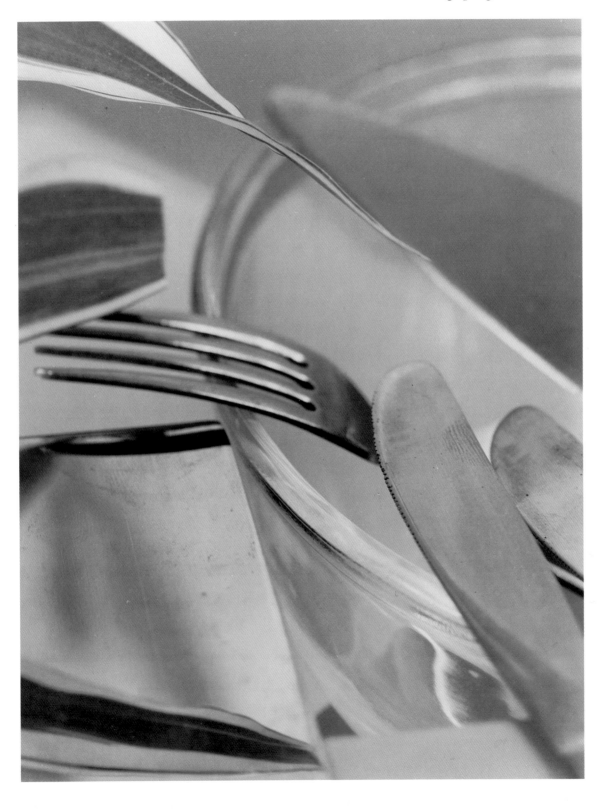

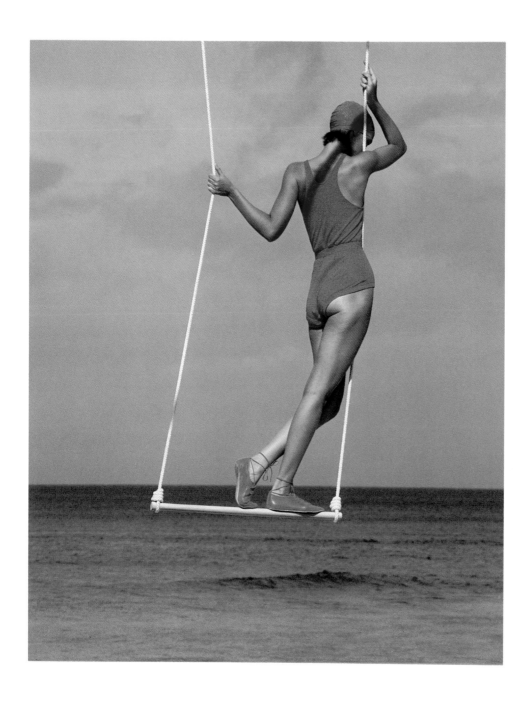

However, certain newer transparency films, especially those that have a high degree of color saturation, respond better to slight (again, 1/3 stop) overexposure.

There are also several ways to underexpose film deliberately. In manual exposure mode, close the aperture by 1/3 stop from the suggested meter reading. In AE mode, set the exposure compensation control at −1/3. In either manual or AE mode, set the film speed at a 1/3-stop higher setting, such as EI 80 when using ISO 64 films. Again, refer to the chart on page 62 for equivalent settings for different film speeds.

As with negative films, the exposure latitude of transparency films varies with the lighting conditions and the specific film used. High-contrast light allows less margin for error than low-contrast light, and some types of film have inherently more or less latitude than others.

Pushing and Pulling

Many color films can be *pushed* and/or *pulled*. Pushing involves underexposing the film (deliberately setting a higher film speed than the manufacturer's rating) and overdeveloping to compensate. Pulling is overexposing the film (using a lower speed rating) and underdeveloping. (See pages 124–125 and 128–129 for information on push and pull processing.)

The success of these techniques varies with the type and brand of film. Almost all transparency films can be pushed or pulled within limits. Many negative films can be pushed, but with some types pushing produces little effect. Pulling negative films is not recommended. (Most of the time negative films are developed with automatic equipment that doesn't allow easy adjustments; if you plan to push negative film, make sure you go to a professional lab that is set up to vary processing times.)

Pushing is by far the more widely used technique for both transparency and negative films. The main reason for pushing film is to help achieve acceptable results in low-light situations. For example, if you're using ISO 400 film and the suggested meter reading is 1/15 at f/2.8, shooting at 1/15 without a tripod is almost certain to cause the camera to move during exposure (and regardless of whether a tripod is used 1/15 will cause most subjects in motion to blur). Setting the film speed at EI 1600 (2 stops) gives you a meter reading of 1/60 at

Pulling film involves more quality trade-offs than pushing film and is not recommended at all when shooting color negative film.

(Opposite)
Patrick Demarchelier, *Untitled*.

Top fashion photographer Demarchelier shoots primarily for Harper's Bazaar *and for dozens of high-profile advertising clients, such as Calvin Klein, The Gap, L'Oreal, Lancome, Ralph Lauren, and Chanel. His success, according to Sean Callahan—who founded and edited* American Photographer—*is largely due to a "talent for creating fanciful pictures, rooted in reality." This photograph was shot in Barbados for British* Vogue. *"We made our own props," Demarchelier explains. "Our objective was simply to give the model an attitude with which to work, and to create a picture that reflected the lithe quality of her movements interacting with the beauty of natural light." Technical matters were kept simple: 35mm daylight transparency film, an 85mm lens, and rich natural light.*

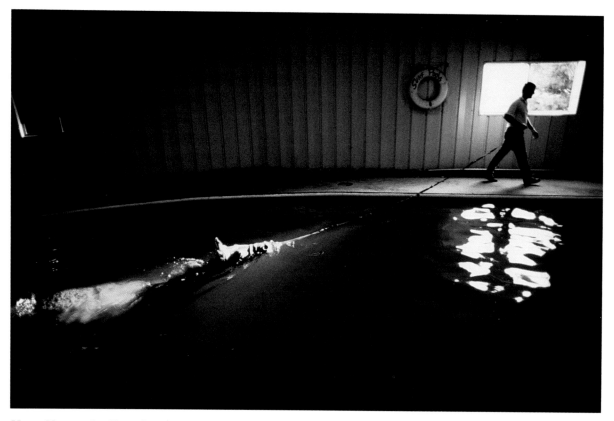

Henry Horenstein, *Horse Swimming*.

Pushing film often allows you to photograph in low-level available light. Here, using ISO 400 film, the meter suggested an exposure of 1/30 at f/2. Rating the film at EI 1600 allowed an exposure of 1/125 at f/2—a shutter speed fast enough to freeze the action of the horse swimming. Because the film was push-processed to compensate for the underexposure, the resulting image shows only some loss of shadow detail (in the pool and the top left corner) and not an overall darkness.

f/2.8—fast enough so that you can hand-hold the camera steadily (and stop the action of many moving subjects).

The usual goal of pushing film is a faster shutter speed, but you also may push to increase depth of field. Let's say the suggested reading is 1/60 at f/2.8 with an ISO 400 film. By rating the film at EI 1600, you can use 1/60 at f/5.6; the smaller aperture produces greater depth of field.

Increasing film speed causes film to be underexposed. After all, ISO 400 films are not as sensitive as EI 1600 films. To compensate, you have to extend the developing time to avoid producing thin (low density) negatives and dark transparencies.

Pushing film leads to reduced shadow detail (due to underexposure), as well as increased contrast and possibly increased graininess and exaggerated color (due to overdevelopment). Although in most cases these qualities are considered undesirable, they may enhance certain photographs.

The limits on pushing vary somewhat with the film type. Most transparency films can be pushed up to 2 stops and still produce acceptable results; some can be pushed as much as 3 or more stops, but image quality may be noticeably degraded.

Pushing film is not the only way to get results in dim light. You can use a flash, photofloods, or other lights to brighten the subject. Or you can use a tripod and shoot at a slow shutter speed if the subject is still enough. Film shot at very slow speeds (about 1/8 and even slower with most color films) is subject to reciprocity failure and may require additional exposure and possibly filtration when photographing to compensate (see pages 67–69).

Pulling involves overexposing film (using a lower speed rating) and underdeveloping to compensate. For example, if you're using an ISO 100 film and the suggested meter reading is 1/250 at f/8, you can lower the film speed to EI 50 (1 stop), which will increase the exposure to 1/125 at f/8 (or 1/250 at f/5.6, and so forth).

For practical purposes, pulling is not used very often. One reason to pull film is to lower contrast, which is what reduced development accomplishes. Reduced development also allows you to compensate for accidental overexposure, a more common use of pulling, such as when you set the film speed at the wrong rating or when you run a clip test, which may indicate the need for either pushing or pulling after you examine the test results (see pages 65–67).

Pushing film helps when shooting in low light, but it can cause image degradation.

Adjusting Film Speed Settings

Sometimes the most convenient way to make minor exposure adjust-ments is to "trick" the meter by rating the film at an artificially lower or higher speed. Lowering the rating will increase exposure because the meter "thinks" the film is slower than it really is. Thus, setting the speed at EI 64 will increase the exposure of ISO 100 films by 2/3 stop. Increasing the rating will decrease exposure; the meter's recommended settings will let in less light because of the supposed faster speed. Setting ISO 400 films at EI 1600, for example, will reduce exposure by 2 stops.

To adjust film speed with many in-camera meters and most hand-held meters, you simply turn a dial. Film speed choices are usually indicated numerically or by a notch (or some other marking). If your camera sets film speed automatically by reading the DX code on the film cassette, you'll have to override the setting (if possible) or adjust exposure by another method (changing the shutter speed, f-stop, or exposure compen-sation control).

The following chart provides comparable EI ratings for adjusting the film speeds of commonly available color films. (Meters allow film speed settings in 1/3 stops only.) Some of the ratings have been rounded off.

Rated Film Speed (ISO)	TO OVEREXPOSE BY			
	1/3 Stop (EI)	2/3 Stop (EI)	1 Stop (EI)	2 Stops (EI)
25	20	16	12	6
50	40	32	25	12
64	50	40	32	16
100	80	64	50	25
160	125	100	80	40
200	160	125	100	50
400	320	250	200	100
1000	800	640	500	250
1600	1250	1000	800	400

Rated Film Speed (ISO)	TO UNDEREXPOSE BY			
	1/3 Stop (EI)	2/3 Stop (EI)	1 Stop (EI)	2 Stops (EI)
25	32	40	50	100
50	64	80	100	200
64	80	100	125	250
100	125	160	200	400
160	200	250	320	640
200	250	320	400	800
400	500	640	800	1600
1000	1250	1600	2000	4000
1600	2000	2500	3200	6400

The danger of underdeveloping color films is that the individual dye-forming layers may not have time to develop fully, and this could cause unwanted color casts and *color crossovers* (when contrast among the three processed dye layers is so inconsistent that corrective filtration can't produce neutral color). You certainly can't pull film as much as you can push it and still expect good results. The limit is about 1/2 to 1 stop. Beyond that, you can expect muddiness, unbalanced color, and possibly mottling.

Today's color films are offered in such a wide range of speeds that you can almost always find a film that meets your exposure needs without pushing or pulling. And you'll get better quality negatives and transparencies by using film at the rated speed and processing it normally than if you alter the speed and development. For low-light use, shoot an ISO 1600 film rather than pushing an ISO 400 film 2 stops to EI 1600. For general use, shoot an ISO 100 film rather than pulling an ISO 200 film 1 stop to EI 100.

Still, pushing and pulling are viable techniques, especially when you don't have the right speed film on hand or when you need to compensate for unintentional underexposure or overexposure (such as after running a clip test). Pushing and pulling also are useful when you want to vary contrast, exaggerate graininess or color, or push the film speed beyond the standard limits (say to EI 6400 or beyond).

Bracketing Exposures

Bracketing involves shooting different exposures of the same subject to help guarantee the best possible results. To bracket, you make an initial exposure based on the suggested meter reading (and any necessary adjustments), then make additional exposures that allow in more and less light while using the exact same framing. Adjusting the f-stop is usually the easiest, most practical, and most precise way to bracket, but you also can bracket by adjusting shutter speed or even exposure compensation control or film speed.

The number of brackets depends on how tricky the lighting is and how certain you are of your exposure skills and the accuracy of your equipment. Usually one or two brackets on each side of the initial exposure will do the job. You might make more brackets if the light is difficult to judge, such as with extremely high contrast subjects or outdoors at night.

Bracketing is especially useful when shooting transparency films, for which correct exposure is so critical. Most photographers bracket transparency films in 1/3-stop increments (although you may be able to get away with 1/2 stops). Let's say the initial exposure is:

<div align="center">1/60 at f/8</div>

These are the settings for 1/3- and 2/3-stop brackets:

Less Exposure	More Exposure
1/60 at f/9	1/60 at f/7.1
1/60 at f/10	1/60 at f/6.3

If your camera or lens provides increments only in 1/2 stops, you can still make 1/3-stop brackets by making your settings between the designated markings on many lens apertures, exposure compensation controls, and film speed dials.

Bracket negative films in 1/2-stop increments (although you may be able to get away with 1-stop increments). With an initial exposure at:

<div align="center">1/60 at f/8</div>

These are the settings for 1/2- and 1-stop brackets:

Less Exposure	More Exposure
1/60 at f/9.5	1/60 at f/6.7
1/60 at f/11	1/60 at f/5.6

Sometimes partial bracketing is all that's needed. For example, you might make the initial exposure, then bracket on only one side of it (for either less or more exposure). Partial bracketing is especially use-

BRACKETING

This strip of transparency film shows exposures bracketed in 1/3 stops. For the bracketed shots, only the f-stop was changed; the shutter speed remained constant at 1/250. Note that the various exposures affect not only density, but also color. Subjects with very light or white areas usually are best exposed when those areas have just enough density to show some detail—in this case, f/5.6.

| f/4 | f/4.3 | f/5 | f/5.6 ▲ | f/6.3 |

ful with negative films; because they can tolerate dense negatives better than thin negatives, bracketing them only for more exposure is usually sufficient. Even if the initial exposure provides a slightly dense negative, it will probably print well, and the additional brackets will guarantee that you have at least one negative that's dense enough.

Bracketing works best for static subjects, such as landscapes and still lifes. It's less suited for subjects that change from frame to frame, such as candids, portraits, sports events, and street scenes. If you bracket exposures with such subjects, you may find that the best pictures—in terms of gesture, expression, or action—turn out too dark or too light.

Some cameras provide automatic bracketing, using a built-in motor to advance the film quickly after each exposure. This allows you to change exposures faster and makes bracketing more practical for moving or otherwise changeable subjects.

Use bracketing for subjects that don't change from frame to frame.

Clip Tests

A *clip test* (also known as a *snip test*) is another way to help guarantee the best possible results. It involves cutting a small section from the beginning of a roll, processing that section, examining the results, and adjusting the developing time, when necessary, for the rest of the roll (and subsequent rolls shot in the same light with the same exposure). If the clip indicates that the film was underexposed (thin negatives or dark transparencies), push the rest of the film. If it indicates overexposure (light transparencies only; negative film shouldn't be pulled, and somewhat dense negatives usually print well anyway), pull the film.

Clip tests can benefit both negative and transparency films, but they are far more likely to be used for transparency films. This is because exposure is so much more critical with transparency films,

f/7.1 f/8 f/9 f/10

Use clip tests instead of bracketing for subjects that change from frame to frame.

CLIP TEST

Running a clip test is a good way to ensure sufficient image density, especially with transparency films. A clip test is most useful in situations where the lighting does not vary from one frame to the next. In this example, an editorial shoot for Forbes *magazine, the photographer had a limited amount of time with his subjects, who were an executive and a union leader from General Electric Corporation. So he set up his lights, framed the shot, and shot a roll of film using his assistants as stand-ins for the subjects. When the real subjects arrived, the photographer placed them in the scene and shot several rolls using varied expressions and gestures and slightly different framing, but kept the lighting and exposure the same. After the shoot, the first roll (the first part of which showed the stand-ins) was clip tested, and the results were slightly dense (underexposed). The photographer then push-processed the rest of the roll 1/2 stop, and the results looked fine, so he gave the remaining rolls the same 1/2-stop push. Example by Ted Wathen/Quadrant.*

and because they are generally more responsive to push and pull processing.

Clip tests are more useful than bracketing with changing subjects, such as portraits and candids. They help reduce the amount of film you shoot, since—unlike bracketing—they require only one exposure for each image. Processing costs may be higher, however, since labs charge for the test as well as for push or pull processing if needed.

The exposure and lighting of the first few frames should be the same as for the rest of the roll, since you are basing the clip test on these frames. Also, make sure the clipped film doesn't contain essential images (for example, striking gestures or expressions with portrait subjects). The clip won't fall precisely between frames, so some of the first frames will be physically damaged.

Use film from the same emulsion batch when making a clip test to determine the processing for several rolls. Otherwise, the test could be less useful, since film speed may vary slightly from one batch to another.

You can process the clip test yourself, but a lab will almost certainly do a better job. Labs are equipped to provide consistent processing, and the value of the test depends on consistency throughout. Also, an experienced lab worker can help you decide exactly how much pushing or pulling is needed. This can vary from 1/4 to 1/3 stop for slight underexposure or overexposure to 1 stop or more in extreme cases.

If you shoot several rolls of film within a short period of time, perhaps on a job or on vacation, you can use a variation of clip testing to guarantee that your equipment and metering technique are working well (even when the subjects, exposures, and lighting situations vary). First, process a couple of rolls of film and examine the results. If they look good, process the rest of the film accordingly. If the results aren't consistent (or conclusive), process a couple more rolls. Keep processing the film in small lots until you see a pattern. If the film is coming out consistently well after a couple of lots, you can probably process the rest of the film with confidence. If it's coming out consistently dark or light, you should push or pull process the next couple of rolls, examine the results, and possibly process a couple more rolls in the same manner before deciding whether to push or pull the rest of the film.

Reciprocity Failure

The *reciprocity law* states that light quantity (f-stop) and time (shutter speed) can be varied in inverse proportion to provide the same amount of exposure. This means that film exposed at 1/60 at f/11 should have the same density as film exposed at 1/125 at f/8 or 1/250 at f/5.6.

The reciprocity law works reliably with exposures in a normal shooting range—from about 1/8 to 1/10,000 second with most daylight color films. Exposures outside a normal shooting range (shorter than 1/10,000 or longer than 1/8 with daylight films) may cause a breakdown in the reciprocity law, called *reciprocity failure*. The primary effects of reciprocity failure with color films are underexposure and

The reciprocity law holds true with most color daylight films in a range of 1/8 to 1/10,000 second.

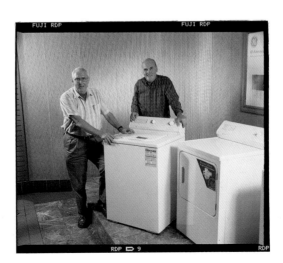

Andrea Raynor, *West End, Portland, Maine.*

This photograph was taken at 3 A.M. The weather was foggy, and the only available light was from sodium vapor street lamps and household bulbs. Raynor couldn't see well enough to focus critically, so she set the distance scale on the lens at about 30 feet and exposed the film for a half-hour at f/11. "I was hoping the fog would disperse the light and give the shift of color a more gradual feel," says Raynor. "The end result was surprising, because I can see more detail and more color-shifting in the photograph than I could while I was standing there, due to the combination of the mixed light sources and reciprocity failure from the long exposure."

color shifts. (Reciprocity failure happens with printing papers as well, with long or short exposure times replacing slow or fast shutter speeds in the f-stop–shutter speed equation.)

Reciprocity failure due to shorter exposures is hardly ever a problem, except with certain high-speed electronic flash units. However, exposures longer than 1/8 are fairly common, especially when photographing by existing light.

As the reciprocity law breaks down, the response of film to light slows. Thus, 4 seconds at f/2.8 may yield less exposure than 2 seconds at f/2, even though 4 seconds doubles the exposure time and f/2.8 passes half as much light to the film as f/2. The slower the shutter speed, the more pronounced the effect.

Light meters don't automatically correct for the effects of reciprocity failure. To compensate, you'll have to add more exposure than the meter suggests, either by opening the aperture or further slowing the shutter speed. If possible, correct for reciprocity failure by using a wider f-stop rather than a slower shutter speed (exposing for a longer time may cause additional reciprocity failure and require even more exposure compensation) and bracket exposures or run a clip test to be sure you've made the right correction. Reciprocity characteristics and required corrections vary from film to film. For details, refer to the technical literature available from the film's manufacturer.

Long exposures also may cause noticeable color shifts, because each of the film's color-recording layers is subject to a different rate of reciprocity failure. At a particularly slow shutter speed, one layer might respond normally to light, but another might respond more slowly than usual and become underexposed. You can often use filters to recover the lost color (although some color shifts are uncorrectable), but filters usually require additional exposure, which can lead to further reciprocity failure.

Tungsten transparency films and Type L negative films allow for longer exposures without reciprocity failure.

When photographing by tungsten lighting, you can minimize or eliminate reciprocity failure at long exposures by using tungsten and Type L films. Tungsten transparency films, for example, can generally be exposed for 1 to 2 minutes or more without reciprocity failure. In practice, these films often can be exposed for much longer times and still produce excellent color quality, although you may have to adjust exposure to compensate for reciprocity failure. (Note that Type L films are available only in medium and large formats.)

Projecting Slides

Transparency films are sometimes printed, but more often they are used as they are, either for publication or for projection. In the former case, you take the pictures, process and edit them, then give them directly to a photography editor or designer. In the latter case, you put mounted transparencies (slides) in a projector for viewing on a screen or a white wall. Most projectors accept only 35mm slides, but a few are designed for medium format.

Slides are rarely shown individually; they are usually displayed in a grouping, perhaps to illustrate a lecture or sales presentation. Such presentations are usually called *slide shows* or, if a soundtrack is added, *audiovisual (A-V) presentations*. Some fine artists use slide projections in a room or some other environment as part of a broader installation.

Simple slide presentations use a single projector, but others use multiple projectors, usually with images dissolving into one another. Complex presentations may require the services of a programmer to control the visual and audio sequences by computer.

There are different types of projectors available, but most use a round Carousel tray with slots that hold the slides. There are two types of trays: one that holds 80 slides and another that holds 140. The 80-slide trays are less susceptible to jamming and can handle slides with glass mounts, which are thicker than standard plastic or

Lorie Novak, *Playback*.

This is an interior view from a five-projector slide and sound installation that, says Novak, "explores the relationship between my family snapshots and media imagery."
It combines a 15-minute sequence of large images dissolving on one wall with smaller images of children jumping into a swimming pool, which are projected into a plastic wading pool on the floor. In order to project onto the floor, Novak aimed the projector at a mirror that was mounted on the ceiling and angled down. (Because slides drop only by gravity, the projector itself could not be pointed straight down.)

When placing a slide in a projector tray, first hold it in its correct orientation.

Then turn the slide upside down and put it in the tray. The emulsion side of the slide should face the lens and screen.

cardboard mounts. Some plastic mounts are thicker than others, and these also may not fit in a 140-slide tray.

Place slides into a tray with the image upside down and with the emulsion side of the slide facing the lens and screen (or wall). Projecting can cause slides to fade or otherwise discolor much faster than they would under normal light conditions, so keep your projection times short, or, better yet, project only duplicate slides *(dupes)* and keep the originals stored safely away (see Appendix 2 for advice on safe storage conditions).

Most projectors have a switch that controls the brightness level of the bulb. This is helpful in adjusting for slides that are a little dark or a little light, and in compensating for ambient light levels or different projection distances. If your projector is only a few feet from the screen, you may want to use the low-light level; if it's farther away, you may need the brighter level.

Another option is to change the projector bulb, using a bulb with more wattage when you need more light and a bulb with less wattage when you need less light. There are special projectors available if you need exceptionally bright bulbs, such as when projecting slides in a large auditorium.

The room conditions during projection also are important. Turn off all room lights and close and seal blinds to keep windows from letting in outdoor light. The darker the room, the more satisfactory the results, since ambient room light can make an image appear to have less contrast and be less bright and less saturated. Special opaque window shades are recommended if you do a lot of projecting in a particular room.

The projector lens also is an important factor in determining image brightness. As with camera lenses, fixed-focal-length projector lenses usually provide a brighter image than do zoom lenses because they have a wider aperture. Commonly used focal lengths include 76mm (3 inches) and 124mm (5 inches), but projector lenses are available in other lengths as well. Long lenses provide more brightness than short lenses because they project a smaller image size, concentrating the light. The shorter the lens, the larger and dimmer the projected image at a given projector-to-screen distance.

Even though their smaller apertures provide dimmer light, zoom lenses are often preferred over fixed-focal-length lenses because they let you adjust the image size. Typical zoom lens ranges include

Dupes

Many photographers shoot transparencies and never print them. They may use them in a slide show or to illustrate a lecture, or may send them directly to clients for reproduction or to stock agencies for resale. Some photographers also use transparencies rather than prints for their portfolio.

Properly exposed and processed transparencies usually look great (often better than prints), and they project and reproduce well. However, when originals are circulated they are vulnerable to physical damage, fading (especially when projected or otherwise displayed in bright light), and loss. Negatives are far less vulnerable because of the way they are used; once they are printed they are rarely handled or sent away (except possibly to a lab).

When working with transparencies, it's often a good practice to use *dupes* (duplicate transparencies) whenever possible, storing the originals safely away from light, heat, and humidity (see Appendix 2). You can make dupes yourself, either with a slide duplicator (there are several models available) or by enlarging them onto a sheet of film, as though you were making a print. Always use duplicating film to minimize the inevitable increase in contrast gained when copying.

Making your own dupes can be tricky. The process usually requires filtering with CC filters (with a slide duplicator) or CP or dichroic filters (in an enlarger) to maintain the correct color balance. To determine the correct filtration with certainty, you'll also need to run tests. You can save a lot of money this way, but only if you're making a lot of dupes on a fairly regular basis. Otherwise, you're better off having your dupes made for you.

Professional labs are set up to make dupes, and the price is reasonable for 35mm dupes. Higher-quality dupes (usually designated "reproduction quality") for 35mm and larger film formats also are available, enlarged and/or contact-printed onto 120, 4" x 5", or larger film. These are excellent for portfolio pieces and other critical uses—in fact, many of the photographs in this book were reproduced from high-quality dupes—but they cost much more than standard 35mm dupes.

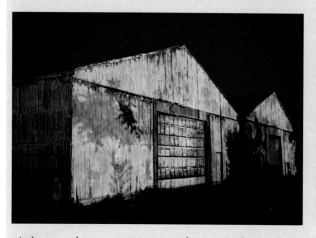 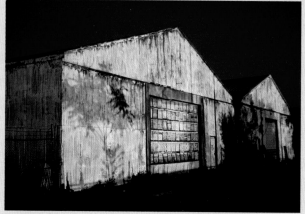

A dupe can be an accurate copy of an original transparency, or it can be color corrected. The original (left) was duped with CC filters (right) to eliminate the yellowish cast on the front of the building. (See pages 93–96 for information on CC filters.)

70mm–210mm and 100mm–150mm. The lens can be set at any focal length in between, allowing you to fine-tune the size of an image to suit projection distance and screen size.

The reflectance of the projection screen also has an important influence on image brightness. Screens come in varying degrees of reflectance. Screens with special reflective surfaces, such as lenticular screens, provide brighter images than matte surface screens (or white walls). However, there is an important disadvantage to some highly reflective screens: their viewing angle is narrow, which means you have to sit near the middle of the screen for the best viewing. With matte screens, you can sit at the edge of the room, at an angle to the screen, and still see virtually as bright an image as you would sitting in the middle of the room.

One common problem when projecting is keystoning, which occurs when the edges of the projected image are not parallel. This happens when the projector is aimed up at (or at any angle to) the screen. A few models of projectors have perspective controls to counter the effects of keystoning, but with most projectors the best way to avoid keystoning is to keep the surface of the screen and the slide parallel. Often the easiest way to do this is to raise (or lower) the height of the projector so it's on a level with the middle of the screen. Special projector stands with adjustable height levels are available for this purpose. Increasing the distance from the projector to the screen also helps by creating a less steep angle. (To compensate for the increased distance, you may need to use a longer lens or a longer setting on a zoom lens to reduce the projected image size.) Another way to counter keystoning is to angle the screen to straighten out the image shape, though this can be trickier to execute.

A dissolve unit is one of the most popular accessories for projecting. (Some models of projectors have dissolve features built in.) It connects two or more projectors and allows you to fade (dissolve) one image into another. The order of the slides must be alternated between projectors so they'll be in correct sequence. Good dissolve units have controls regulating the duration and speed of the dissolve.

Here are some additional tips for improving your slide shows. Use slides with equal density for best viewing. (It's possible to adjust slide density when making dupes.) Special opaque masking tape is available to crop out unwanted areas of the image; some types of tape are prone to pinholes, so double taping may be needed. Using glass

mounts helps protect the surface of slides that are projected over and over; they also may slow the fading of the image color. The glass may break, however, so be very careful when shipping or otherwise transporting glass-mounted slides.

It's often best to keep the orientation of the slides consistent throughout—vertical or horizontal, although horizontal is almost always preferred. Finally, always test the projector and make sure the bulb is good before starting to show slides. Bring along an extra bulb and an extra slide tray, since bulbs sometimes burn out and trays are prone to jamming.

Polaroid Materials

Polaroid is best known for its instant amateur products, but the company also makes dozens of other useful films, mostly for professional photography and a variety of special applications. Following are the broad categories of Polaroid films.

Integral (or Self-developing) Films

This category was introduced in 1972 with the original SX-70 system. Many changes and improvements have been made since then, but integral films still work pretty much the same way. You place a pack of 10 exposures in a camera specially made for the film and shoot the picture. The film then passes through rollers, which spread a pouch of developer, and ejects from the camera, self-developing in a matter of minutes. Most cameras made for integral film have a built-in flash and allow little if any control over the automatic exposure. Popular integral films past and present include SX-70, Time-Zero, Type 600, Spectra, and Captiva.

Integral films self-develop and must be used in cameras specially designed to hold them.

Most integral films are made for amateur use, although some have limited technical, medical, and scientific applications. A number of professional and fine-art photographers also have worked with integral films over the years.

Integral films are not up to the technical standards of conventional films. They have less sharpness and color quality; they can't be printed (there's no reusable negative); they offer little flexibility in lighting and exposure; and they are more vulnerable to fading and physical damage. What integral films do best is offer instant results and convenience, which are qualities more suitable for snapshooting than fine photography.

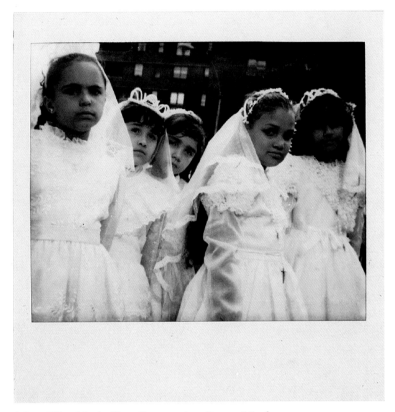

Mary Ellen Mark, *First Communion, Lower Manhattan.*

Although she is best known for her black-and-white documentary photographs, Mark works equally well in color. This photograph, taken with Polaroid Spectra film, shows that integral films can produce sophisticated results as well as the simple snapshots for which they are intended. Courtesy of Polaroid Corporation.

After Polaroid peel-apart film is exposed, it is pulled out of its holder, an action that breaks open and spreads a pod of development chemicals between the negative and receiving sheet.

The negative and receiving sheet are peeled apart about 1 to 1½ minutes after the film is pulled from the holder.

Peel-Apart Films

This family of Polaroid color and black-and-white films was originally intended for amateurs, but it is now used almost exclusively by professionals, and not always by photographers. Its applications range widely from medical documentation to driver's license and passport identification. Photographers sometimes use peel-apart films to produce final art, but far more often they use them for making test shots (proofing) to adjust composition, lighting, and exposure. Once the photographer gets a "Polaroid" with the desired results, he or she switches over to a conventional film to make the desired shot.

Almost all peel-apart color films are daylight balanced (there is a tungsten-balanced version). In practice, the daylight films become progressively warmer (closer to tungsten balanced) at slow shutter speeds. Peel-apart films come in packs holding 8 or 10 exposures or in individual sheets. These formats are commonly available: 3⅛" x 3¾"(pack), 3¼" x 4¼" (pack), 4" x 5" (pack and sheet), and 8" x 10" (sheet). (Polaroid also makes peel-apart film for 20" x 24" and 40" x 80" photographs, which comes from the same film stock as other peel-apart color films. However, these must be used in special cameras available at a handful of Polaroid studios worldwide.)

Either the pack of film or the sheet loads into a dedicated holder, which fits on a camera (sometimes a 35mm camera but usually a medium-format or view camera). Such film holders are available for virtually every camera of professional quality. (The 4" x 5" and 8" x 10" types slip under the ground glass of the camera, just like a conventional film holder.)

Peel-apart films consist of a negative to capture the image and a receiving sheet to make the print. Both are protected by a lighttight sleeve or cover sheet. After exposing the film in the camera, you pull it smoothly but firmly out of its holder. As the film slides out, rollers in the holder break a pod containing the processing chemicals and spread those chemicals evenly between the negative and the receiving sheet. This initiates development and allows the dyes forming the negative image to "migrate" to the receiving sheet.

Processing 8" x 10" peel-apart film requires a separate dedicated processor. After exposure, you remove the holder from the camera and place it with a receiving sheet in the processor, which automatically pulls the film and sheet together through a set of rollers for processing.

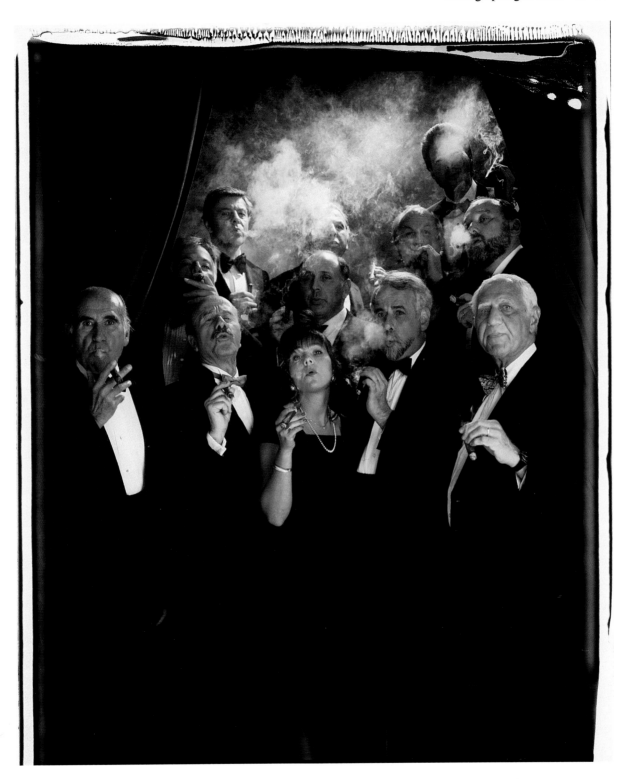

Most peel-apart color films take 1 to 1½ minutes to process. Then you separate (peel apart) the negative and receiving sheet to reveal the positive image. The negative is not printable using standard means, although it is used to make Polaroid transfers (see pages 80–83).

Instant 35mm Films

Polaroid offers several instant 35mm films for both color and black-and-white transparencies. Two color versions are available—one for normal contrast and the other for high contrast. All Polaroid Instant films must be processed in a dedicated machine that comes in two versions—the manual AutoProcessor or the motorized PowerProcessor.

Instant 35mm films are packaged in metal cassettes and load in any 35mm camera the same way that conventional films do. They are packaged with a processing pack containing the developing chemicals and a polyester strip, which is approximately the same length as the film and is used to transfer the chemicals to the film. The film and packs can be refrigerated for storage, but they shouldn't be frozen. Once exposed, the film should be processed as soon as possible.

Instant 35mm color films have an unusual appearance that recalls early screen processes, such as Autochrome. This appearance is due largely to a very thin additive screen, which creates an impression of relatively coarse graininess. The screen consists of microscopic blue, green, and red lines of color filter elements, which filter the light and form the image color. The lines of the screen show up on close examination of the film, such as when it is projected or viewed through a loupe. (Unlike with conventional slides, Polaroid Instant 35mm films are viewed through the emulsion side.)

As with any transparency film, the exposure latitude of Instant 35mm color films is limited. They respond better to slight overexposure than to normal exposure or underexposure. Rather than their rated speed of ISO 40, try shooting them at EI 32 or even EI 25.

The surface of the Instant 35mm film base prevents off-the-film (OTF) metering systems from providing accurate readings. (Polaroid publishes exposure compensation information for use with some of the cameras that have these types of meters.) Use a camera that allows you to set film speed manually, since the film cassettes have no bar codes.

(Overleaf)
Neal Slavin, *The Nat Sherman Cigar Club.*

"I am an avid lover of fine cigars," Slavin says of this group portrait, *"and I wanted to express my love of the cigar."* He used Polaroid 20" x 24" film and lit his subjects with electronic flash. The results demonstrate Slavin's strong formal sense and quirky sense of humor. Courtesy of Polaroid Corporation.

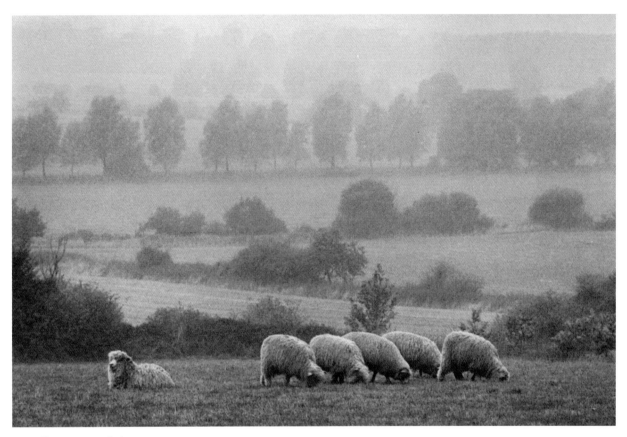

Russell Hart, *Untitled*.

Hart used Polachrome Instant 35mm film to make this photograph in East Anglia, England. The film's color comes from an additive color screen over a black-and-white emulsion. "The toothy grain pattern of the film has an impressionistic quality that suited the subject," says Hart. Because Polachrome is slow (rated at ISO 40) and often produces its best results when slightly overexposed at EI 32, a tripod may be required to guarantee sharp results.

Instant 35mm films are made for projection, but they also can be printed. You can make internegatives (see pages 188–189) and print these as you would print any color negative. Or you can print the transparencies directly. The additive screen becomes more evident with enlargement.

Be especially careful when handling and storing Instant 35mm films. They are delicate and especially vulnerable to scratching and other types of physical damage. Use the slide mounts sold by Polaroid or glass mounts for surface protection, and read the instruction sheets packaged with the film for further information.

Conventional Films

Polaroid offers 35mm negative and transparency films, which are exposed and processed much the same way as other films, in C-41 or E-6 chemicals. The negative films are intended for snapshots, and the transparency film, which has inherently high contrast, is made for presentation graphics. Both types are made by other manufacturers and packaged and marketed by Polaroid.

Polaroid Transfers

Polaroid transfer is a technique popular with many professional and fine-art photographers. The procedure is simple and can be accomplished in room light with minimal equipment.

The first step is to make the image that you plan to transfer. Use almost any Polaroid peel-apart color film. Either shoot the picture directly or print an existing transparency on Polaroid film using an enlarger or a slide printer (available from various companies, depending on the desired size print). Both options produce good results, but printing allows you to choose from already-available transparencies. Enlarging adds more control to the process, allowing you to crop precisely, burn in, and dodge.

When photographing specifically for transfer, overexpose the film slightly (1/2 to 2/3 stop). Some photographers also use a red CC filter—anywhere from a 10R to 20R—to adjust the color. (See pages 93–96 for information on CC filters.)

To enlarge transparencies on Polaroid film, use an empty film holder as an easel, positioning it under the enlarger with a sheet of white paper or thin mat board resting where the Polaroid film normally sits. Put the transparency in the enlarger's film carrier, then put

(Opposite)
John Reuter, *Comes Between Us.*

This piece combines four separate Polaroid transfers. Each was made individually, then overlapped and reworked as one image with dry pigment and pastel. Although the effect is very painterly, the original images were created from photographs that were computer manipulated, then enlarged onto Polaroid 20" x 24" peel-apart film. The finished piece measures 42" x 52". "It's from a series on relationships," Reuter comments. "In this case, the image of the child or the notion of childhood is coming between the relationship of two adult lovers. The viewer can add the rest."

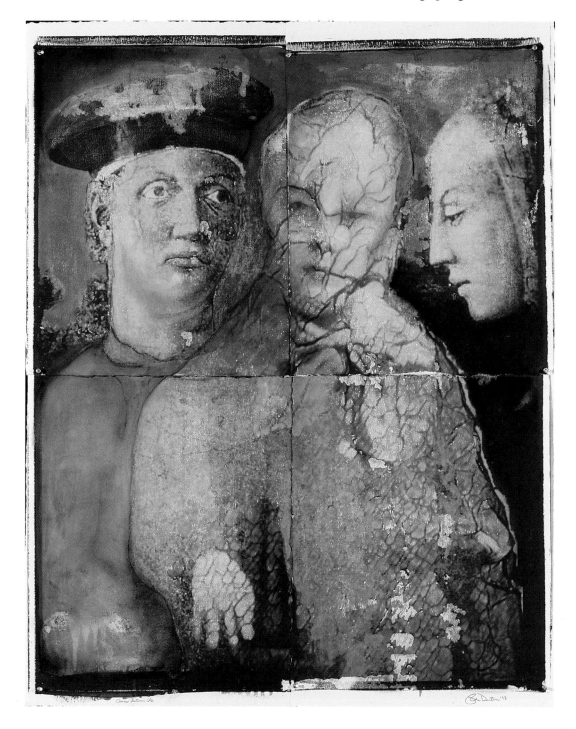

the carrier in the enlarger. Project the image onto the easel (Polaroid film holder), using the white sheet to compose and focus the image. When you're ready to print, load Polaroid film into the holder and shut off the lights; never use a safelight with Polaroid films. You may have to construct guides out of tape or cardboard so you'll know exactly where the holder goes in case it gets moved when the film is loaded or during the exposure.

Follow the steps for exposing printing paper described on pages 154–157. You'll probably have to use very short exposure increments for the test strip (and remember to slide the built-in dark sleeve back in when you're finished). You may or may not need a filter pack in the enlarger to control color balance. Enlarger bulbs are tungsten, so they are a reasonable color match for tungsten Polaroid films. They should provide warm results with daylight films, but at the long exposures required for enlargement, Polaroid daylight films undergo reciprocity failure, causing the color to shift so it more closely matches tungsten light.

Once the Polaroid film is exposed, whether in the camera or from a transparency, pull it out of the holder to start development and wait 15 seconds or so before peeling it apart. One side of the sandwich holds the positive, and the other side holds the negative. Put the negative facedown on a sheet of paper and rub or roll the back of it to transfer the dyes.

Several factors affect the final result. The type of receiving sheet is especially important. Printmaking or watercolor papers, such as D'Arches Cover and Rives BFK, with slightly rough to slightly smooth surfaces are most commonly used. These are available in any good art supply store. You also can make good transfers with vellum, silk, rice paper, wood veneer, and many other materials.

Polaroid transfers can easily be touched up and altered while they're still wet or after they're dry. Try reworking them with soft colored pencils, pastels, watercolors, spotting dyes, acrylics, markers, and/or ink.

Making a Polaroid Transfer

Polaroid transfers don't always go smoothly or predictably, nor are they as repeatable as standard photographic processes. Fortunately, mistakes often lead to interesting results. You can get good transfers most of the time by following these instructions, but feel free to experiment. That's what everyone does with this process.

Wetting the receiving sheet produces softer, more painterly results and makes the transfer easier. However, some materials, such as rice paper, don't take well to water. With dry paper, you'll get a sharper, more photographic look. Skip steps 1 and 2 below when working with dry paper.

1. Thoroughly soak the receiving sheet in a tray of water for at least 1 minute.
2. Take the sheet out of the tray and lay it on a clean, dry, flat surface. Blot both sides of the sheet with a paper towel or rubber squeegee to remove any excess water.
3. Tape down the corners of the receiving sheet so that it won't move during the process. Moving may result in a lack of sharpness. (You can leave the sheet untaped if you want less sharpness.)
4. Expose the Polaroid film, either by taking a picture or by printing an existing transparency, and pull it through its holder or other processing system. Wait about 15 seconds and peel apart the film. Use thin rubber gloves when handling the Polaroids, as the processing gel can cause skin irritation. If you get any gel on your skin, wash it off immediately.
5. Place the negative face down on the receiving sheet immediately after peeling (the dyes dry quickly). Do this by placing one end of the negative against the receiving sheet and lowering it carefully for contact.
6. Rub the back of the negative with firm, smooth strokes using a roller, squeegee, or burnishing tool. This will transfer the dyes from the negative to the receiving sheet. If dense areas of dye don't transfer completely, try applying pressure to these areas selectively with the rounded back of a spoon.
7. Wait 1½ to 2 minutes, then peel the negative off the receiving sheet to unveil the positive. Peel with a slow, gentle, steady motion, or you may pull off

To transfer the image, the back of the negative is rolled or rubbed onto the paper.

After 1½ to 2 minutes, the negative is peeled off to reveal the positive transfer.

some of the dyes. You can vary the waiting time somewhat to achieve different results.

8. Air dry the transfer by hanging it up by the corners with clothespins or clips on a piece of taut wire or string. Or you can lay it faceup on a clean surface or drying screen.

Photographing with Filters

Some filters make strong changes in color; others have a more subtle effect.

Glass filters are most common, but filters made of gelatin, plastic, and other materials also are available.

Filters are used both for photographing and printing in color. For photographing, their most common use is to change the color temperature of the light to create a desired effect, such as balancing the film with the light source. Some filters do this by making a strong change in the color of light, for example allowing you to shoot in daylight with tungsten film or indoors with daylight film. Others have a more subtle fine-tuning effect, such as reducing or eliminating the blue cast typical of shadow areas on a sunny day or increasing the overall color saturation. Still other filters diffuse the subject, reduce overall exposure, protect the front of the lens, or produce special effects.

Filtering negatives when printing provides the same basic effect as filtering when photographing. However, negatives that have been filtered on camera are sometimes easier to print, especially when extreme color correction is called for. It's far more common to use filters when photographing with transparency films, especially when you want to neutralize or eliminate unwanted color casts, since transparencies are usually the final product.

Buying Filters

Filters are made of glass, gelatin, plastic, or other materials. Almost all types attach to the front of the lens, although some go behind the lens or in a slot somewhere in the middle (as with some bulky lenses, such as ultra-wide-angle and very long or very fast telephoto lenses).

Glass filters are the most common. They are usually set inside a threaded circular rim that screws into the front of the lens. Glass filters are durable; you can handle, clean, and store them easily without scratching. Most are relatively inexpensive and made to high optical standards. You can get even higher optical quality premium glass filters for a premium price.

Screw-in glass filters are measured according to their diameter. You match the filter diameter to the thread diameter of the front of your lens. The following lens diameters are common for 35mm cameras: 49mm, 52mm, 55mm, 58mm, 62mm, 67mm, 72mm, and 77mm. Several other diameters also are available.

Unfortunately, different lenses made for the same camera sometimes have different front diameters. Thus, if you own more than one lens, you may need duplicate filters in the required sizes, which can be expensive.

The most practical way around this problem is to buy a single set of large filters—at least large enough to cover the front rim of your largest lens—and use a filter holder (or adapter) to connect them to smaller-diameter lenses. Filter holders clip, clamp, or screw onto the front of the lens. With the screw-on type, you'll need a different holder for each size lens. Some holders use a hinged bracket that opens and closes to secure the filter; others have a slot for the filter to slide into.

Some adapters (*step-up rings, step-down rings*), are made for threaded filters, but most are made for nonthreaded filters, of which there are several types. *Series filters*, for example, are made of glass and are classified numerically: Series 5 (for lenses with a diameter of 28mm to 36mm), Series 6 (31mm to 47mm), Series 7 (44mm to 56mm), Series 8 (51mm to 69mm), and Series 9 (62mm to 85mm).

Another type of nonthreaded filter is the *gelatin filter,* often called a *gel.* Gelatin filters come in individual square sheets of various colors and sizes, including 75mm (3 inches), 100mm (4 inches), 125mm (5 inches), 150mm (6 inches), and 250mm (10 inches). Their optical characteristics are excellent—as good or better than most glass filters—but they are thin and fragile, so you must handle them with care to avoid scratching, warping, dimpling, and other damage. Gels get dirty easily, which can adversely affect image quality, and they are virtually impossible to clean. You should store each filter separately in its protective packaging in a cool, dry place. Gels cost about the same as or a little more than standard glass filters, but they are less expensive than premium glass filters. (Don't confuse gelatin filters with non-optical-quality plastic filters, which are used over lights to color or "gel" the light.)

Optical plastic filters, made of resin, polyester, or other materials, are another type of nonthreaded filter. Plastic filters are sturdier and easier to clean than gelatin filters. They are good to excellent optically, depending on the brand and whether you choose a standard or premium type. The price of plastic filters varies, but it's pretty much in line with that of glass and gelatin types. Some plastic filters are sold individually; others are sold in kits that include a selection of filters and a holder.

Some photographers believe that filters compromise image quality because they're generally made of less expensive materials than lenses. Such problems are more likely to come from the way filters are handled and used than from their composition. For maximum quality,

A filter holder, which fits on the front of a lens, holds gelatin or plastic filters in place.

use clean, unscratched filters and never stack (use more than one filter at a time) glass or standard plastic filters. You can stack up to three gelatin filters or premium plastic filters and still get good results, but the less stacking the better.

Filter Factors

Photographing with filters usually requires the use of a slower shutter speed or wider aperture to ensure the correct film exposure, since most filters block at least some light overall. Each filter has a *filter factor,* which indicates just how much additional exposure is needed. Factors for commonly used filters can be found on pages 87–89, but check the instruction sheet packaged with the filters for specific factors.

A filter with a 2x factor halves the light (see page 87). That means that you'll have to double the exposure (add 1 stop) to compensate. A 4x factor requires a 2-stop compensation, and an 8x factor requires 3 stops. Keep in mind that if the correction is made by opening the aperture, it can reduce depth of field; if it's made by slowing the shutter speed, it may cause image blur or possibly reciprocity failure. (To avoid these problems, you can switch to a faster film speed.)

Most filters require a small adjustment in the exposure setting—an increase of a stop or two at most. But if you stack filters, the effective filter factor increases markedly. For example, stacking a 2x filter with a 3x filter produces a factor of 5x.

With separate hand-held light meters, you'll have to calculate the filter factor and adjust the settings manually. One way to do this is to change the indicated f-stop and/or shutter speed according to the chart on page 87. Another way is to calculate and set a new film speed by dividing the speed by the filter factor. If you're using ISO 400 film and a filter with a 4x factor, set the meter for EI 100, which will automatically increase exposure by 2 stops (4x). (Be sure to reset the film speed when you remove or change the filter.)

Cameras with a through-the-lens meter indicate or set the needed correction automatically, since they read the light after it's been filtered. Most of the time, the filtered exposure will be accurate. However, it's a good idea to bracket exposures when using filters, especially when using strong (dense) filters and transparency films, because the specific color of the filter can have an adverse affect on the meter reading. (Hand-held meters don't cause such problems because they read unfiltered light.)

Most filters block some of the light reaching the film, requiring an adjustment in the exposure setting to compensate.

Let's say you're using a blue filter with a blue main subject. Filters transmit like colors (blue), so the filter will allow more light from the main subject to pass through than it would if the filter and subject colors were different. The meter will register that higher light level and as a result will recommend (or automatically choose) exposure settings that would cause underexposure. To compensate, you'll have to add a little extra exposure to the meter's suggested reading.

The opposite happens if the subject consists mostly of colors complementary to the filter color (see the box on the next page). Imagine the same blue filter and a yellow subject. The filter will absorb more light than it would from a different-colored subject, causing the meter to recommend (or choose) settings that would cause overexposure. In that case, you'll have to reduce the suggested exposure to compensate.

Wratten Filters

Many of the filters used for color photography are classified according to the Kodak *Wratten* filter system, which uses a numerical designation often followed by a letter. For example, the Wratten 81 series consists of these filters: 81, 81A, 81B, 81C, 81D, and 81EF. The num-

Adjusting for Filter Factors

The following chart shows the effect of filter factors on exposure. Cameras with through-the-lens meters will make the adjustment automatically. If you use a hand-held meter, you'll have to adjust manually.

Filter Factor	Exposure Adjustment
1.2x	+1/3 stop
1.5x	+2/3 stop
2x	+1 stop
2.5x	+1 1/3 stops
3x	+1 2/3 stops
4x	+2 stops
5x	+2 1/3 stops
6x	+2 2/3 stops
8x	+3 stops
10x	+3 1/3 stops
12x	+3 2/3 stops
16x	+4 stops
32x	+5 stops

Color Wheel and How Filters Work

This color wheel shows the primary colors of light. Each color is complementary to the color opposite it. Thus, red is cyan's complement, yellow is blue's complement, and green is magenta's complement. Also, each color is made up of equal parts of the colors next to it. Yellow is made up of green and red; magenta is made up of red and blue; and so forth. (See Appendix 1 for more information on color theory.)

Filters alter color by transmitting light of a similar color and blocking (absorbing) light of complementary colors. Thus, a yellow filter lets yellow light pass and blocks blue light. The degree of transmission and absorption depends on the filter's color and density. The denser (more heavily colored) the filter, the more light of like color is transmitted relative to complementary colors. Filters also affect related colors. Since yellow is made up of red and green, a yellow filter will transmit red and green light.

ber 81 represents the color of the filter (here, amber), and the letter designates density (81EF is the most dense).

Wratten filters are available for both color and black-and-white photography, but many can be used for both. For example, a 25 (deep red) filter creates an almost monochromatic red subject with color films and darkens blue skies with black-and-white films.

The following filters are the most common Wratten series used for photographing in color, along with their filter factors and effects. (Color compensating filters also are Wratten filters; they are covered in detail on pages 93–96.)

Filter	Filter Factor	Color Effect
80A	5x	Provides varying degrees of correc-
80B	4x	tion when using daylight film with
80C	2x	tungsten light.
80D	2x	
81	1.25x	Provides fine control in lowering the
81A	1.25x	color temperature of light, adding
81B	1.25x	warmth to the subject.
81C	1.25x	
81D	1.6x	
81EF	1.6x	

Filter	Filter Factor	Color Effect
82	1.25x	Provides fine control in raising the
82A	1.25x	color temperature of light, adding
82B	1.6x	coolness to the subject.
82C	1.6x	
85	1.6x	Provides varying degrees of correc-
85B	1.6x	tion when using tungsten film with
85C	1.25x	daylight.

Light-Balancing Filters

Light-balancing filters produce mild changes in the color temperature of the light. There are two types: 81 series (amber), which add warmth by blocking blue light, and 82 series (blue), which add coolness by blocking yellow light. The denser the filter is, the stronger the effect. In practice, however, you'll probably use weaker filters, such as 81, 81A, 82, and 82A, far more often than denser ones.

Light-balancing filters are for fine-tuning color, not for major changes.

The 81 series is especially useful for photographing in daylight, at times when the light is cool (blue), such as on overcast or rainy days and in the shade. Some electronic flash units also produce a mildly blue cast, which can be neutralized with an 81-series filter either on your lens or on the flash unit. Some photographers routinely use a weak 81-series filter (usually an 81A or 81B) to add additional warmth to the subject whether or not the light has a blue cast.

81A FILTER

Daylight film can produce a cool (bluish) cast in pictures taken in open shade or on an overcast day.

An 81A filter on the lens warms the light and produces a more natural color.

Most photographers prefer warm light to cool, so 82-series filters aren't used nearly as often as 81-series filters. You could use an 82-series filter to add a blue cast to create a sense of mystery or drama, but a more likely use is to achieve neutral color when matching com-

Using 82 Series Filters with Tungsten Films

The following chart shows how 82-series filters balance the color temperature of indoor light (and sunrise/sunset) when you're using 3200K tungsten films.

Color Temperature of the Light	Light Source	Filters
2650K	40-watt bulb	82C + 82A
2790K	60-watt bulb	82C
2820K	75-watt bulb	82C
2900K	100-watt bulb	82B
2980K	200-watt bulb	82A
3100K	Sunrise/sunset	82

85B FILTER

Using tungsten film in daylight produces a strong cool (bluish) cast.

An 85B filter on the lens when photographing converts daylight to a tungsten balance, allowing you to shoot tungsten film in daylight. Example by Jim Dow.

mon household lights and tungsten films. Using an 82B filter, for example, raises the color temperature of a 100-watt bulb from 2900K to 3200K—the Kelvin temperature of almost all tungsten films.

Such corrections assume that you want neutral color from indoor light, which is not always the case. Often indoor light is best left a little warm (household bulbs have a warm color, after all), in which case you should use no filter at all, or a weak filter for partial effect.

Conversion Filters

Conversion filters are used for major changes in the color of light.

Conversion filters produce much stronger changes in color temperature than light-balancing filters and are most often used when you have the wrong type of film for your lighting conditions. There are two types of conversion filters: the 85 series (orange) for lowering the color temperature and the 80 series (blue) for raising it.

The 85-series filters allow you to use tungsten films when photographing in daylight conditions. For example, the 85B, which is the most commonly used filter in the series, balances 3200K tungsten films with 5500K light. This is most useful when using long exposures, allowing you to use tungsten films, which are less subject to reciprocity failure than daylight films.

80A FILTER

Using daylight film in tungsten light produces a strong warm (yellowish-orange) cast. This scene includes a mixture of tungsten and daylight.

An 80A filter on the lens when photographing converts tungsten to daylight balance, allowing you to shoot daylight film in tungsten light and achieve neutral color. Example by Allen Hess.

Robert Hower, *Neon Motel.*

*One of the most dramatic times to photograph in color is
when the evening sky is just about to disappear into night.
"I tend to put my meter away and run more on instinct
and prayer than on science at this point," Hower says.
"You're never quite sure what's going to happen, or when
it's going to happen, or even if it's going to happen." For
an exposure of about five minutes at f/16, he used Type L
negative film to keep reciprocity failure from setting in.
Because Type L is tungsten balanced, Hower used an 85B
filter to simulate the effects of daylight film.*

Conversion Filters

| Filter | Changes Color Temperature | | Film |
	From	To	
80A	3200K	5500K	Daylight
80B	3400K	5500K	Daylight
80C	3800K	5500K	Daylight
80D	4200K	5500K	Daylight
85	5500K	3400K	Tungsten (Type A)
85B	5500K	3200K	Tungsten
85C	4650K	3400K	Tungsten (Type A)

The 80-series filters balance daylight films with tungsten light. Use the 80A when the light is 3200K or the 80B when the light is 3400K. The chart above summarizes how specific conversion filters work.

Aside from not having the right film available, the best reason to use a conversion filter is if you want to shoot 35mm color negative films, which are daylight balanced, in tungsten light. Otherwise, you're better off using film balanced for the lighting conditions to avoid the nuisance of using a filter and the resulting exposure reduction.

Color Compensating

Color compensating filters (also known as *CC filters*) are used both to create dramatic changes in the color of light and for slight fine-tuning. Unlike light-balancing and conversion filters, which warm, cool, or adjust the overall color balance of the subject, CC filters have their primary effect on individual colors. CC filters for photographing have the same effect on color and exposure as *CP filters* for printing (see page 138), but they are of much higher quality, so they can be used in the optical path of the light (in front of or behind the lens).

A CC filter is designated by a number expressing its strength, followed by the initial letter of its color. A filter's strength is measured by its density relative to its complementary color. Thus, a 30Y filter blocks less of the blue light that strikes it than the denser 50Y filter.

CC filters are available in various strengths, depending on the brand. The designations, rated weakest to strongest, are .025, .05, .10, .20, .30, .40, and .50.

CC filters come in the following colors: yellow, magenta, cyan, red, green, and blue. As with all filters, each lends its own color to the subject by blocking its complement. For instance, a cyan CC filter

CC filters primarily affect individual colors.

blocks red light, making the rendition of the subject more cyan. Follow this chart:

Filter Color	Color(s) Blocked
Yellow	Blue
Magenta	Green
Cyan	Red
Red	Blue and green (cyan)
Green	Blue and red (magenta)
Blue	Red and green (yellow)

Yellow and blue CC filters act somewhat like light-balancing and conversion filters of the same color. However, yellow is a purer color than the amber of the 81 series and less orange than the color of the 85 series. You can approximate the effects of Wratten filters by using combinations of CC filters. For example, an 80A filter is similar to 90C + 30M, an 81A filter to 05Y + 025M, an 82A to 15C + 05M, and an 85B to 65Y + 25M.

There's no need to own CC filters in all colors and densities. Instead, you can buy a small selection of filters in each color and stack them when needed (as long as you use no more than three gelatin or premium plastic filters). For example, a 10Y stacked with a 20Y is equal to a 30Y.

Stacking filters saves money and allows for finer tuning by providing densities that aren't otherwise available, such as a 15B (10B + 5B) and a 35C (20C + 10C + 5C). Stacking two different colors of equal densities creates the same density of a third color. Thus, 10B + 10G = 10C. Follow this chart:

Equal Densities of	Equal the Same Density of
Blue and green	Cyan
Yellow and magenta	Red
Cyan and magenta	Blue
Red and green	Yellow
Cyan and yellow	Green
Red and blue	Magenta

Weak CC filters provide minor modifications in the color of light when critical color balance is required. For example, an 05Y may help when the light from an electronic flash unit has a slightly blue cast (a fairly common occurrence). You may need to make a similar

CC Filter Factors

Most CC filters don't have much effect on exposure. The following filter factors, which are rounded off to 1/3 stops, are strictly recommendations. They will vary with the color of the subject (see pages 86–87).

FILTER COLOR

Density	Yellow	Magenta	Cyan	Red	Green	Blue
.025	*	*	*	*	*	*
.05	*	1.2x	1.2x	1.2x	1.2x	1.2x
.10	1.2x	1.2x	1.2x	1.2x	1.2x	1.2x
.20	1.2x	1.2x	1.2x	1.2x	1.2x	1.5x
.30	1.2x	1.5x	1.5x	1.5x	1.5x	1.5x
.40	1.2x	1.5x	1.5x	1.5x	1.5x	2x
.50	1.5x	1.5x	2x	2x	2x	2.5x

*No exposure correction needed.

Fluorescent and high-intensity discharge lamps can be difficult to color balance.

modification to correct the color of a particular emulsion batch of film or to compensate for reciprocity failure at slow shutter speeds.

Discontinuous light sources, such as fluorescent lamps and high-intensity discharge lamps, often require a heavy dose of CC filters (sometimes combined with other filters) if you want to correct the color balance. Such light is usually deficient in certain color wavelengths, which leads to a strong color cast. CC filtration won't always neutralize this completely, but it can come close.

For example, most types of fluorescent light lack red wavelengths, resulting in a green to green-blue color cast. You can use a combination of magenta and yellow filters to neutralize the cast by adding the deficient red light and absorbing the excess green and blue. (With some types of fluorescent lights, cyan and other color filters may be required.)

Note that fluorescent lamps flicker. Using a shutter speed of 1/60 or slower will help to even out the flickering and minimize the effect.

There are many different types of fluorescent light, each requiring different filtration. For general use or when the type of fluorescent light is unknown, try a 30M or 40M filter or a "fluorescent" filter available from most manufacturers.

High-intensity discharge lamps are bright, energy-efficient lights used in industry and public places, such as factories, highways, and shopping malls. As with fluorescents, most high-intensity discharge

30M FILTER

Using daylight film in fluorescent light usually produces a strong green cast. (With tungsten film, the cast is likely to be bluish.)

A 30M or 40M filter on the lens when photographing removes the green cast and produces more natural color.

Not all subjects require neutral color balance. Some look better partially filtered or even unfiltered.

lamps lack red and need magenta and yellow filtration. Others may require different combinations.

Determining the Correct Filtration

The filtration recommendations throughout this chapter should be taken as suggestions only. They all assume that you're aiming for fully corrected, neutral color. If you prefer warmer or cooler results, use a little more or a little less filtration than recommended or no filtration at all.

Other variables also make filter charts mere approximations. Individual films have different color biases and even vary from one emulsion batch to another. Lights from different manufacturers also vary in color, and their color often changes with use. Other variables include film exposure and processing, viewing light, and even the filters themselves, which may differ slightly from one manufacturer to another and fade with time.

Color meters can help in determining a filter pack by reading the color temperature of the light and recommending filtration to match the light source with the type of film being used. To use a color meter, set the film type (daylight or tungsten), place the meter near the main subject, point it toward the camera and/or light source, and read the temperature and filtration suggestions from the meter's display.

A color meter measures color temperature in degrees Kelvin and recommends the filtration needed to achieve neutral color balance. The display shown here suggests using an 81 light-balancing filter and a 10M color compensating filter.

Filtering for Discontinuous Light Sources

Fluorescent and high-intensity discharge lamps present special problems if you need to match the film to the lighting for neutral color. They usually require heavy CC (and sometimes other) filtration, which varies widely depending on the specific type of bulb. Unfortunately, it's often difficult to determine which type is being used. Other variables include the brand of bulb and how long it's been used, as well as the film type. The following recommendations should be used as a starting point only. Run a test for critical applications (see next page).

Fluorescent Bulbs

Lamp Type	Daylight	Tungsten	Type A
		FILM TYPE	
Daylight	50R	No. 85B + 30R + 10M	No. 85 + 40R
White	40M	50R + 10M	30R + 10M
Warm white	20B + 20M	40R + 10M	20R + 10M
Warm white deluxe	30C + 30B	10R	No filter needed
Cool white	30M + 10R	60R	50R
Cool white deluxe	10B + 10C	20R + 20Y	20Y + 10R
Unknown	30M	50R	40R

High-Intensity Discharge Lamps

Lamp Type	Daylight	Tungsten	Type A
		FILM TYPE	
Lucalox	80B + 20C	30M + 20B	50B + 05M
Multivapor	20R + 20M	60R + 20Y	50R + 10Y
Deluxe white mercury	30R + 30M	70R + 10Y	50R + 10Y
Clear mercury	70R	90R + 40Y	90R + 40Y

Color meters provide good enough results when you're shooting negative films, but you can't always rely on them when shooting transparency films, especially when color balance is critical. If time and subject matter allow, shoot the following test. Then process the results, examine them, make any needed adjustments (for example, in filtration), and rephotograph the subject accordingly.

Another way to test film for critical color balance is to photograph a test target. There are several commercially made targets available. The Macbeth Color Checker and Kodak Color Control Patch, for example, are made up of small squares comprising a range of the full

Run a filter test when precise color balance is critical.

Filtration Test

For critical uses, run the following test to determine the precise effect of the filters on color balance.

1. Shoot a roll of transparency film, using the intended subject, lighting, and framing. The film should come from the same emulsion batch as the film you'll be using to make the final exposures.
2. Shoot the first few exposures without any filters at the metered exposure and one or two 1/3-stop brackets around it.
3. Decide what filter (or filters) you think you need for the subject by using a filter chart, a color meter, or personal experience.
4. Place the chosen filter on the lens and make an exposure reading. If necessary, adjust the suggested reading to compensate for the filter factor when using a hand-held meter.
5. Make a few exposures, bracketing in 1/3-stop increments. If you're uncertain about what filter is needed, try shooting with a few different related filters, bracketing these exposures as well. Be sure to keep accurate notes about what you did on each frame (exposure and filtration).
6. Process the film, but don't mount it. Mounting makes it more difficult to keep track of the sequence of exposures.
7. Place the film on a 5000K-balanced light box and examine the results.
8. Adding filters to the processed film allows you to see the effects of filtration. For example, placing a 10R filter on top of a transparency has the same effect as adding 10R when photographing.
9. Rephotograph the subject with the additional filtration that makes the needed correction. If you decide to change the filtration, make sure you adjust exposure, if necessary, using the new filter's filter factor. Bracket exposures to be sure.

To critically evaluate original transparencies or dupes, view them through a loupe on a "color corrected" 5000K-balanced light box.

color spectrum. The Kodak Gray Scale contains different-stepped values of gray, ranging from white to black.

All brands of test targets are used in a similar way. In each case you place the target within the intended subject area, in the same light as the primary subject, then photograph the subject and target, process the film, and judge the resulting color. With some target brands you are supposed to fill the frame with the target, but it's usually best to show some of the subject for context. (The Kodak Gray Scale often works better than the colored test targets because grays show slight changes in color cast very clearly, whereas with intense colors even obvious differences can be difficult to detect.)

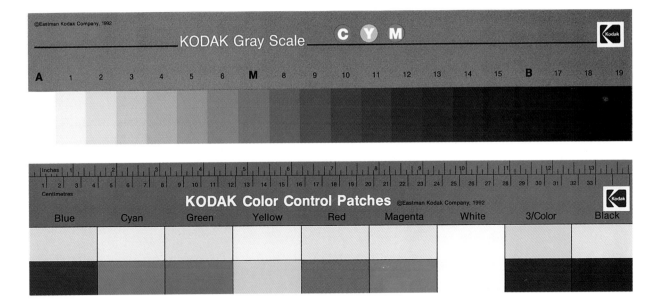

To test for critical color balance, photograph a test target, such as a Kodak Gray Scale or Kodak Color Control Patch.

You may judge the results by eye, or for more accuracy place filters over them. If the photograph of the gray scale has a slight red cast, for example, a mild cyan filter (say, 10C) held over the photograph may counteract the red. This would indicate that you should use a 10C filter when photographing to achieve more neutral color balance (assuming that you use film from the same emulsion batch processed at the same lab).

Other Common Filters

Several other filters are useful for photographing in color. Following are the most common.

Ultraviolet (UV) and *Skylight (1A).* Both are lightly colored filters used primarily to help protect the front of the lens from poor weather, scratching, and other damage as well as to absorb UV radiation. They have slight effect on image color and no effect at all on film exposure.

UV rays are present in many lighting conditions, particularly with landscape subjects (fog, open shade, blue skies) and some electronic flashes. Although UV is invisible to the human eye, color films will record it as a blue cast. UV and skylight filters may minimize this blue by absorbing UV rays, providing more clarity to distant subjects on foggy days, for example. However, the effect is subtle. For stronger

UV reduction, use a Wratten 2A or 2B filter. (Other filters, in particular the 81A and 81B, often do a better job than UV filters in reducing strong blue casts, but they do it by absorbing visible blue light and not UV.)

Some electronic flash units have UV filters built in, but this is not always enough. You also may attach a filter over the flash head to color the light. You don't need a high-quality filter for this purpose, because it is only coloring the light source. An inexpensive plastic filter such as one made for theatrical lighting will do the job.

Neutral-Density (ND). These filters reduce the amount of light reaching the film, with no effect on color. They are used most often in bright sunlight when you want a wider aperture for reduced depth of field and/or a slower shutter speed to blur the image, or if you want to use a fast film in bright light (for example to achieve a grainy effect).

ND filters are classified according to how much light they block. Each 0.1 increment blocks 1/3 stop. Thus, a 0.3 filter blocks 1 stop, a 0.5 blocks 1 2/3 stops, and so forth. When stacked, ND filters have a cumulative effect: 0.2 (2/3 stop) + 0.6 (2 stops) = 0.8 (2 2/3 stops). The following chart lists the effects of various ND filters on exposure.

UV and skylight filters are most commonly used for protecting the front of a lens.

ND filters cut down the amount of light reaching the film without affecting the image color.

ND Filter	Exposure Reduction
0.1	1/3 stop
0.2	2/3 stop
0.3	1 stop
0.4	1 1/3 stops
0.5	1 2/3 stops
0.6	2 stops
0.7	2 1/3 stops
0.8	2 2/3 stops
0.9	3 stops
1.2	4 stops
1.5	5 stops
1.8	6 stops
2.1	7 stops
3.0	10 stops

Polarizing. These filters have three main uses for color photography. They darken blue skies, increase color saturation, and reduce or eliminate reflections and glare from smooth surfaces such as water, glass, or plastic (making them useful for purposes such as copying glossy artwork). Polarizing filters have no visible effect on unpainted metallic subjects.

Most polarizing filters are made of glass and have a double rim. One rim screws into the front of the lens, and the other holds the filter and allows it to turn freely. For use, you attach the filter to the lens, then look through the viewfinder as you turn the filter to find the desired effect. (For cameras that lack through-the-lens viewing, such as rangefinders, you can hold the filter to your eye and turn it until you get the desired effect, then mount the filter on the lens in the same orientation.)

Polarizing filters intensify color and reduce reflections and glare.

Polarizing filters produce their maximum effect when positioned at an oblique angle to the subject (about 35 degrees). They also work at other angles, but with less noticeable results.

The filter factor for polarizing filters is 2.5x, regardless of how much you turn them. Most through-the-lens meters handle the adjustment automatically, as with any type of filter. However, standard polarizing filters (called *linear polarizers*) will fool certain types of metering systems (and certain types of autofocusing systems as well). With these cameras, use a *circular polarizer*. Check your camera's instruction book or ask your camera dealer if you're not sure which type of polarizing filter to use.

Too much polarization can lead to unnatural effects, such as blue skies that are too dark, exaggerated color saturation overall, and surfaces that appear dull and less reflective than they really are. Rather than trying for a total polarization effect, try turning the filter slight-

POLARIZING FILTER

Glare and reflections from the surroundings show up in this photograph of an antique car.

A polarizing filter on the camera lens cuts down both glare and reflection.

Special fluorescent filters may improve color balance with fluorescent lamps, but a 30M or 40M CC filter usually works as well or even better.

ly for a partial effect—to increase the darkness of the sky slightly, punch up the color a notch, or reduce reflection and glare without completely eliminating them.

Fluorescent. As discussed previously, different types of fluorescent lamps require different filters for color correction. Generic fluorescent filters are available for those times when you don't know the type of lamp or don't have the required CC filters. You have a choice of two types: one for use with daylight films (sometimes designated *FLD*) and one for tungsten films (*FLT* or *FLB*). Some manufacturers may use different designations, but all typically have a 2x filter factor.

In most cases, you can achieve more neutral color by using a 30M or 40M CC filter with commonly used cool white lamps and daylight films. Either the generic filters or the CC filters provide a simple solution to the problems of fluorescent light. They require no testing, color temperature metering, or other calculation. You simply put the filter on the lens and shoot. You may not always get fully corrected color, but the results usually are good enough for most purposes (especially when you're shooting negative films, which can be filtered again when printing).

Special Effects. A wide variety of filters is available for creating unusual effects with color films. Some filters simply enhance the subject's appearance; others create a whole new focus of attention—for example, you can create prisms or starbursts or add color overall or to portions of the subject. Following are some of the most common special effects filters.

Graduated filters are half clear and half colored. They come in a wide variety of colors and add their color selectively to a section of the subject. The colored half gradually becomes less dense as it meets the clear half, allowing the two parts of the image to blend together seamlessly with the right type of subject.

For example, a blue graduated filter can make the sky a deep blue, yet leave areas below the horizon unaffected. To use, turn the filter (on a rim or in its holder) so it lines up with the horizon. (Square plastic graduated filters make positioning the filter a little easier.) Using a blue graduated filter enhances a sky's appearance, but you can use a different color to make it appear otherworldly.

Graduated ND filters work in a similar way, but they selectively cut down exposure rather than add color. This helps bring light and dark areas closer together in tonality. For example, if the sky is sig-

nificantly brighter than the ground, a graduated ND filter will reduce the sky brightness only, thus evening out the overall lighting.

Split-field filters are similar to graduated filters, but they have a sharp division between the colored and uncolored halves of the filter. One half has a color of even density, and the other is either clear or a different color.

Diffusion filters soften subjects, rendering them less sharp and less detailed, and reduce image contrast overall. They can be used with any subject but are especially popular for portraits and landscapes to minimize skin "defects" (such as wrinkles, pores, and pimples) and to romanticize a scene.

There are dozens of types of diffusion filters, providing a wide range of effects from strong to subtle. Most diffuse the entire image, but some create a soft vignette just around the edges. You can make your own diffusion filter by placing cellophane or some other diffusing material over the front of the lens. Or you can spread petroleum jelly on a clear filter and place that on the lens; this is messy, but it allows you to vary the diffusing effect.

Diffusion filters make the subject less distinct and more dreamy.

Summary: Key Color Filters

Of the many filters available for color photography, the following are among the most useful.

Filter Type	Main Purposes
80A	Matches 5500K daylight films to 3200K tungsten light.
85B	Matches 3200K tungsten films to 5500K daylight.
81A/81B	Adds warmth and reduces blue casts when photographing on an overcast day or in the shade or when desired for effect.
30M/40M	Provides close to neutral color with cool white fluorescent light when photographing with daylight films.
1A/UV	Protects the front of the lens from damage and absorbs UV radiation.
2A/2B	Reduces the effect of UV rays, creating a moderate to significant warming.
ND	Reduces light without affecting image color.
Polarizing	Increases color saturation; darkens blue skies; reduces or eliminates unwanted glare and reflections from nonmetallic surfaces.

Effects from a diffusion filter
Courtesy of Cokin filters.

*Effects from a split-field neutral
density filter*
Courtesy of Cokin filters.

Multiple-image filters create repeated prismatic effects in a variety of patterns. The effect takes shape as you turn the filter (on its rim or in its holder).

Multiprism filters are sold according to the number of images produced (typically three to six or even nine) and the type of pattern. They are available in clear and multicolored versions.

Color-polarizing filters tint the entire image with the filter color. Single-color polarizing filters produce results ranging from more to less intense color as you turn the filter. Bicolor polarizing filters blend two colors to create a variety of colors in between. For example, you can create shades of red, blue, or magenta by turning a red-blue bicolor filter. Bicolor filters are available in a variety of combinations, such as green-purple and orange-green.

Diffraction filters have surface ridges that diffract light into various patterns of rainbow-colored bands. The patterns vary widely—from streaks to circles or starbursts—depending on factors such as the amount of rotation and the angle of the filter to the light.

Alex S. MacLean, *Top Soil Piles in New Residential Development.*

Most landscapes are taken more or less at ground level, but Alex MacLean works from the sky. This aerial was made on a thin overcast day with an exposure of 1/1000 on 35mm daylight transparency film. A moving subject usually requires a fast shutter speed to guarantee a sharp result, but with aerial work it's the photographer who's moving, and it's the camera motion that has to be stopped. MacLean was 700 feet above ground level and used a zoom lens set at 135mm in order to get close enough to minimize the surroundings. "The emphasis of the photo," says MacLean, "was to highlight this abstract pattern made by the lawns in a suburban housing subdivision, and to focus on the patterns created by the earth mounds." Although aerial photography is primarily used for informational purposes, in recent years it has attracted many fine-art photographers such as MacLean.

Art Wolfe, *Arctic Fox.*

Noted wildlife photographer Wolfe shot this white fox at 2:30 A.M. in Ellesmere Island, Canada. "Because I was prohibited from venturing too far from the encampment and because the light was relatively low, I had to coax the fox into an area where the light was ideal for photographing," Wolfe explains. He used a 300mm lens and an exposure of 1/30 at f/4.5 on ISO 64 transparency film. Even so early in the morning, the sun was up (albeit dim) in northern Canada in April, when the picture was taken. The resulting light produced a warm, pinkish cast and a surreal effect. Color casts show up most clearly on pastel colors, grays, and whites (as on this fox).

(Opposite)
Joyce Tenneson, *Suzanne in Chair.*

Tenneson's photographs have been variously described as haunting, ethereal, pensive, mystical, and disturbing. This photograph is one of her most popular images. "I suspect it's been successful," she says, "because of the open, haunting gaze of Suzanne, but in the end it's mystery that makes art fascinating." The sense of mystery is heightened by high tonal values (light skin and white clothes), bright lighting, painted backdrops, and the use of diaphanous fabric to shroud the subject—all of which builds to create the impression of an otherworldly glow.

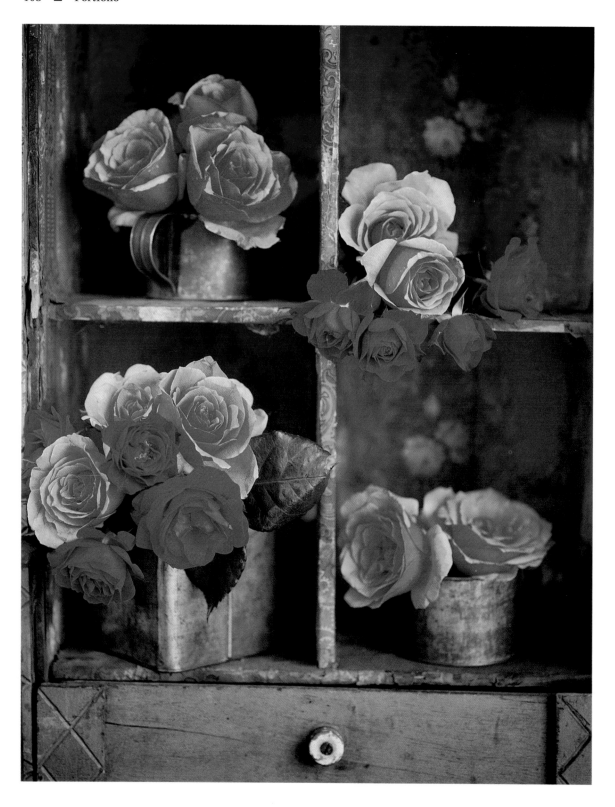

(Opposite)
Sandi Fellman, *Untitled.*

Photographers often find multiple uses for their work. Fellman made this still life on speculation for the Palm Press greeting card company, and it turned out to be the company's best-selling flower card. Later, a rose company also bought the image as a cover for its catalogue. Fellman used daylight film with studio strobes as her main light. Then she exposed the film again—"painting" the subject with a moving tungsten light during the exposure. "It gives the photograph a warm glow," Fellman explains, "which makes it feel like a beautiful sunlit room."

Luc Delahaye, *Sniper in Sarajevo.*

Photojournalists in war zones are often too busy trying to capture action and avoid injury to give much thought to the color quality of their photographs. But sometimes the color seems to fall in place, as with this monochromatic drama taking place in a bombed-out modern office building. Sipa-Press.

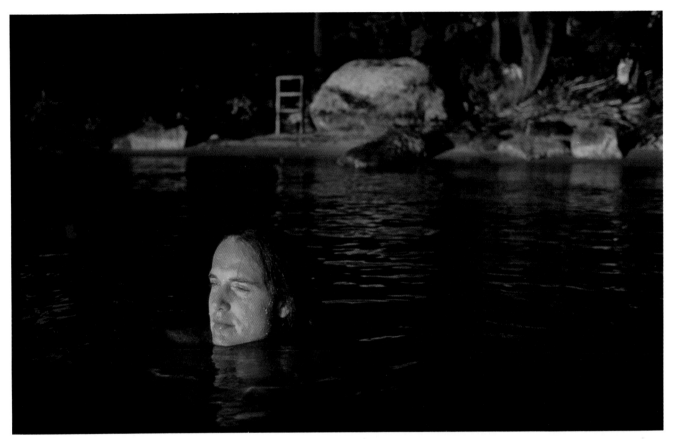

(Opposite)
Jan Staller, *Carteret, New Jersey.*

This photograph is part of an ongoing project about the man-made landscape. "I assumed that the tripod was erected to protect the plastic pipe at its center," says Staller. "But the photograph was not made simply to document the scene. Rather, I was inspired to photograph this object in such a way that would heighten its peculiar sculptural qualities." To accomplish this, Staller shot at dusk and took advantage of available mixed lighting. The tripod was found in a parking lot, where it was lit by metal halide lamps, a discontinuous source that gave a green cast to the image. But because he was photographing with negative film, Staller had a lot of flexibility when printing. He removed the green cast by subtracting magenta from his filter pack, an adjustment that caused the sky color to shift toward a strange magenta/red.

Shellburne Thurber, *Jonathan Swimming Up in New Hampshire.*

Thurber made this photograph as a part of an ongoing series on her family and friends. She shot 35mm daylight transparency film in the late afternoon to achieve the extremely warm color cast. "I was swimming with my friend Jonathan when I was struck by the quality of light," she says. "I've always loved that brief time just before the sun sets, when the light transforms everything it touches, turning the humblest landscape into a Bierstadt painting and making the most desolate scene a place of surreal beauty."

Processing Color Films

(Opposite)
Michael Lavine, *Lyle Lovett, 1992.*

This portrait of the country singer/ actor was shot on transparency film and "cross-processed" in color negative (C-41) chemistry; the resulting negative was then printed. (Exposure was at the recommended film speed, but development was pushed 1 stop.) Cross processing generally produces exaggerated colors and heightened contrast (see page 129). Outline Pictures.

Almost all color films can be developed with the same equipment you would use for processing black-and-white films. Most photographers don't bother, however, because color film processing is fairly painstaking and inflexible and allows for little creative leeway. All chemicals pretty much provide the same results. What counts most is how well you're able to maintain consistent times, agitation, and temperature throughout the process, while keeping the chemicals fresh and free of contamination.

Because of the standardization required, commercial color film processing usually provides the best results. Even a minilab that promises film and print processing in 1 hour or so will do a good job with 35mm color negative film—if its technicians are meticulous—and the machine prints it produces are a bargain. Custom professional labs are more reliable, though comparatively expensive, and they process a wider variety of films—35mm transparency films and larger-format negative and transparency films. Plus, a lab will mount 35mm slides for you, a considerable time saving over mounting them yourself.

If you prefer to develop your own color film, you can buy simple-to-use processing kits containing all the required chemicals. These kits are available from several manufacturers. Most provide similar results and all follow the same basic steps, but specifics for preparation and use may vary, so be sure to read the kit's instructions before using.

The clearest advantage of processing color film yourself is expense. With efficient use of chemicals, you can save significantly over the cost of lab processing—assuming that you process several rolls of film in a single session or store the solution carefully for later use. Some solutions don't keep well, which could offset any cost savings.

Other reasons for self-processing include a desire for hands-on involvement and distrust of local labs. Damage and loss do occur occasionally at even the best labs. Time saving is rarely a factor, as most labs can deliver processed film, including mounted slides, within a few hours.

Working with Labs

You can test your lab's (or your own) film agitation technique by photographing an entire roll of clear blue sky. Proper agitation will produce consistent tone and color, as shown here, from the beginning of the roll to the end.

Professional labs are highly automated to guarantee good, efficient results, although some are more attentive to detail than others. The best labs are those with responsible, alert workers who rigorously maintain the equipment and manage the solutions. It also helps if a lab has a high volume of business. Processing lines provide the best results when working at full capacity.

The best way to find a good lab is by word of mouth. Ask professional photographers. They're often the best source of information, because they work with labs on a daily basis. Keep in mind that labs can be unpredictable; the departure of a single key technician may cause quality to decline.

A good lab should be able to produce results with no noticeable color casts and with even density. Film that comes out too warm or too cool, or with a strong color bias, may have been subject to chemical contamination or incorrect dilution, time, or temperature.

If your film has uneven density overall (such as blotchy areas), it's probably due to poor agitation. You can evaluate a lab's agitation technique with 35mm and roll films by shooting a roll of slide film using clear blue sky as the subject. (Use a telephoto lens, or a telephoto setting on a zoom lens, to capture a small section of the sky so the blue tone is even throughout the frame; otherwise you might mistake the natural lightening of the sky toward the horizon as an agitation problem.) Have the roll processed and examine exposures at the beginning, in the middle, and at the end of the roll. (If you do the test with negative film, examine three prints, one each made from the beginning, middle, and end of the roll.) If the tone and color of the sky are consistent throughout, the agitation is probably fine. If not, point out the problem to the lab so it can correct its agitation methods, or change labs.

Labs generally process film by the *roller-transport* or the *dip-and-dunk* method. With the former, which is used by most minilabs and some custom labs, film is inserted in the processor, then carried

through the necessary solutions by a series of rollers. For dip-and-dunk processing, film is loaded on reels or hung on racks, then dropped into a succession of open tanks of solution. Highly mechanized dip-and-dunk lines use robotlike machines to lift film in and out of the tanks. In simpler systems, a technician manually transfers the film from solution to solution. Agitation is achieved either by mechanical means or with jets of gas fired into each tank.

Roller-transport processing requires little film handling. Once the film is in the processor, the rollers take over. Results can be excellent, but only if the processor is clean and well maintained. Otherwise, myriad problems, including color shifts and scratches, can occur.

Dip-and-dunk processing is more labor-intensive, thus more subject to operator error. However, it allows pushing and pulling film (roller-transport systems aren't as flexible) and can produce excellent results, assuming the technician is alert and careful. (See pages 124–125 and 128–129 for information on pushing and pulling.)

Labs use either roller-transport or dip-and-dunk processing.

The Color Darkroom

Following is a description of the equipment needed to process color film. If you are set up to process black-and-white film, you already own most of this equipment.

Tank, Reels, Deep Tray, and Heater

These items can be made of stainless steel or chemically resistant plastic. Stainless steel is generally sturdier and easier to keep clean, although dings and scratches can contribute to chemical contamination. Plastic offers better insulation, which helps keep solution temperatures constant.

Tanks and reels are needed to process 35mm, 120, and other roll films. You'll need a deep tray for a water bath to help maintain processing solutions at a constant temperature. The tray should be large enough to hold the processing tank and all the solution containers and deep enough so that the water level can reach almost to the top of the tank and containers. You can add an accessory thermostatic heating unit to the bath to help maintain the temperature or buy a tray with a built-in heater.

Most of the equipment needed for color film processing is the same as that for black-and-white film processing.

Use an accurate thermometer, as some solution temperatures are critical.

A collapsible container helps keep processing solutions fresh by reducing the solution's exposure to air.

Thermometer

Color processing requires an extremely accurate thermometer, calibrated to plus or minus ¼°F, to monitor solution temperatures. Some models display temperature digitally; others use a mercury scale or a needle and dial.

Tabletop Processor

A tabletop processor makes the job easier by automatically maintaining solutions at a constant temperature and providing consistent agitation. Most of these processors can handle a variety of formats—35mm, roll, and sheet films—and some also can process prints. Tabletop processors are expensive and impractical for most individual photographers, but they are widely used in small studios, labs, schools, and other institutions.

Storage Containers

Trapped air in partially filled storage containers will cause processing solutions to deteriorate rapidly. Collapsible, or accordion-style, containers keep air from entering when the solutions are poured out. If you use noncollapsible containers for chemical storage, keep them filled to maintain the freshness of the solution.

Miscellaneous

A darkroom should be equipped with a bottle opener to pry open 35mm film cassettes; a pair of scissors for cutting the film; and graduated beakers and cylinders, stirring rods, and funnels to mix, measure, hold, and pour solutions. If you don't have a lighttight room in which to load the film onto the reel, use a changing bag (a lighttight sack or tent for loading film onto reels and reels into a tank).

Most of the time tap water is fine for mixing chemicals. However, a filtering system will reduce any impurities in your water supply. Full-scale, built-in systems can be costly, but an inexpensive tap filter works better than nothing.

Wear heavy-duty rubber gloves at all times to minimize exposure to chemicals, some of which are potentially hazardous (see Appendix 3). You can use a respirator to prevent inhalation of fumes or dust, but make sure it's the right type, as some actually do more harm than good. A plastic or rubber lab apron will protect your clothes against chemical splashes. You'll need an accurate timer to

monitor processing times, and film clips or spring-type plastic clothespins to hang film to dry. Use a film-drying cabinet, if possible, to keep out dust and dirt.

General Considerations

These considerations apply whether you are processing color transparency or negative film. Specific information on handling each type follows.

Time, Temperature, and Agitation

Processing times and temperatures and agitation techniques for color films are standardized. You must process transparency film separately from negative film, but you don't have to separate different brands or different film speeds (with the exception of some high-speed films and films requiring push or pull processing). You can process a roll of Kodak ISO 100 transparency film and a roll of Fuji ISO 400 transparency film—or rolls of Agfa ISO 200 and Kodak ISO 25 negative film—in the same tank if you choose.

Most color-processing kits give you a choice of development times at temperatures ranging from about 70°F to 110°F. Solution temperature has a significant effect on processing time. At 75°F, processing takes almost 1 hour for transparencies and 30 minutes for negatives. At 105°F, processing takes about half as long for both. However, you may have trouble maintaining solutions at high temperatures without a carefully monitored water bath (see page 119) or a tabletop processor.

Begin timing each step in the process as you're pouring the solution into the tank. Start draining each solution about 10 seconds before the prescribed time is up.

During development, variations of as little as plus or minus $\frac{1}{4}°$ to $\frac{1}{2}°F$ may have an effect on how the image forms. Temperature is generally not as critical with the other solutions, but you should maintain it at a constant level throughout the process for the best results.

Despite extending the total processing time, lower temperatures have several advantages. You'll have an easier time maintaining solutions at 75°F (nearly room temperature) than at 105°F. Also, longer processing times make the overall timing less critical. A timing error of 10 seconds, for example, is more significant when the development time is $3\frac{1}{2}$ minutes (at 105°F) than when it's 10 minutes (at 75°F).

Time and temperature are especially important during development.

The same holds true for agitation. With lower temperatures and longer processing times, you're less likely to produce transparencies and negatives with streaks and uneven density.

Whatever the temperature and time, you must agitate correctly. With manual processing, this means using a motorized base for the tank or intermittently agitating the tank by hand with a controlled pattern for just the right amount of time. Tabletop processors usually do the job by continuously rotating the tank. However, the constant rotation may speed up development and require shorter processing times; check the instructions that come with your processing kit for details.

The following steps should provide good manual agitation in most cases:

For proper agitation, tap the processing tank a few times right after each solution has been poured in.

After tapping the tank initially, invert it continuously for the recommended time, tapping a few times after each agitation.

1. Make sure the processing tank is filled with reels—empty ones on top of loaded ones, if necessary—to keep the reels from shifting during agitation.
2. Pour enough solution into the processing tank to cover the reels, but don't fill the tank to the very top. Leave some air space so the solution can move in the tank during agitation. (Instructions packaged with the tank usually recommend a certain volume of solution per roll.)
3. Put the cap on the top of the tank and tap it a few times against a sink or counter to dislodge any air bubbles that might have formed on the film's surface. Air bubbles, also known as *air bells,* can prevent solutions from reaching the film's emulsion, causing unwanted dark or light spots to form in the image.
4. Agitate the tank—upside down, then right side up—continuously for 15 seconds. Use a gentle but constant motion and do not rotate the tank.
5. Tap the tank again, then put it in the water bath.
6. Wait 30 seconds, remove the tank from the bath, and agitate again—this time for 5 seconds.
7. Tap the tank again, then put it in the water bath.
8. Agitate the tank for 5 seconds every 30 seconds, tapping it briefly after each agitation, until the time is up. Repeat the pattern for each solution except the stabilizer.

Both overagitation and underagitation can cause problems, such as overdevelopment, underdevelopment, streaky results, and uneven density. Whatever agitation method you use, time your routine carefully and keep it consistent.

Water Bath

A *water bath* is a deep tray filled with water, which is used to keep solutions at a constant temperature. Keep the film tank (loaded with film and solution) and the containers (filled with solution) in the bath at all times, except when pouring the solutions in and out and when agitating the tank.

The key to a good water bath is to keep the temperature at a constant level. This can be difficult, especially when processing film at high temperatures. One method is to add hot water (at the correct temperature) to the bath as needed. If your household hot-water heater has the capacity, you can run a constant stream of water into the bath tray using the faucet or a hose. The other approach is to use an accessory heating unit or a complete water bath unit, which comes with built-in heaters and sometimes pumps. Accessory units made for the darkroom resemble aquarium heaters (although aquarium heaters per se are not suitable).

Whatever method you use, you must monitor the temperature of the water bath diligently during processing. Here's one way to maintain a simple water bath:

1. Fill a deep tray with water, at a level high enough to cover most of the tank and the solution containers when they're placed in the tray. Make the water temperature a few degrees warmer than the intended processing temperature (it will quickly cool down), and keep a thermometer in the bath throughout processing.
2. Place the tank (loaded with film and solution, once you begin processing) and containers (filled with solutions) in the bath. In some cases, you may have to weigh down the tank to keep it from floating.
3. Monitor the developer temperature. When it reaches the correct level, begin processing the film.
4. Maintain the water bath by running tap water at that temperature into the tray. If hot water is at a premium, fill a pail with even hotter water and add it, as needed, when the bath's temperature begins to drop. Circulate the water periodically by moving it around with your hand.

A water bath helps keep processing solutions at a constant temperature.

Washing Film

Color film processing requires frequent water washes. For a simple wash, remove the cap of the processing tank, then fill the tank with water and agitate vigorously, inverting it five times. Dump out the water, refill the tank, and agitate again. Repeat this cycle until the required rinse time is up. You also can use water directly from the tap or from a pail filled with water, but the pail is usually the best method unless the tap water runs at a reliably constant temperature.

Use a film washer, if available, for the final wash. Most models are made of clear plastic or stainless steel. Place the film reels in the washer, then fill it with water using a hose. The fresh water pushes the contaminated water over the top of the washer or out the bottom (depending on the model), thus providing a complete exchange of water every few seconds.

Processing Sheet Film

All film formats, whether rolls or sheets, require the same processing steps. Sheet film is a little more difficult to handle, especially during agitation. You'll need a careful technique to guarantee even density over such a large image area.

At all costs, avoid using trays to process color sheet film. It's hard to guarantee consistent temperature and agitation in trays. Also, since trays aren't enclosed, they can't contain potentially harmful fumes. Daylight tanks that contain the fumes are available for processing sheet film, but these require a large amount of solution, so they're practical only when you're processing a lot of film in a single session.

Most photographers wisely leave sheet film processing to professional labs, which use high-volume dip-and-dunk systems to do the job. Lab technicians load the film on hangers and drop the hangers into tanks of solution.

Hangers can cause problems, however, especially at the edges of the film. These include uneven density or even physical damage if a sloppy technician clips the film in the image area. One way around these problems is to step back when shooting and leave a little extra room all around the image, with the intention of cropping out the edges when printing (or in reproduction). Because sheet film has a large image area, slight cropping shouldn't compromise image quality.

If you want to process sheet film yourself, the best way is with a rotary drum tabletop processor. These units provide reliable temperature and agitation control, and the constant rotation of the drum on the motorized base provides very efficient use of the chemical solutions. Tabletop processors are contained units, minimizing your exposure to chemical fumes.

Processing Color Transparencies

Processing color transparency film is more complicated than processing color negative film. More solutions are required, processing takes longer, and there is less margin for error.

Kodak *E-6* is the industry standard system for processing color transparencies. Other manufacturers have their own designations, such as Fuji *CR-56* and Agfa *AP4*, but with few exceptions any brand (or speed) of color transparency film can be processed at the same time in any E-6–compatible setup. Notable exceptions include Kodachrome, Polachrome, some very high speed films, and films requiring push or pull processing. An E-6 setup in a processing lab is often referred to as an *E-6 line*.

Most labs process E-6 transparency films within 1 to 4 hours. This is especially important for professional photographers, the largest category of transparency shooters, who routinely require a quick turnaround time for their work.

Several manufacturers make E-6 processing kits. These kits contain all the necessary chemicals for do-it-yourself transparency proc-

Kodak E-6 is the industry standard color transparency process. Most labs offer 1- to 4-hour E-6 service.

Kodachrome

Kodak Kodachrome, first introduced in 1935 as a movie film, is the oldest type of color film still in use. Unlike other commonly used transparency films, Kodachrome contains no color dye couplers. Color is added during processing, a tricky matter making Kodachrome far more difficult to process than E-6–compatible films. Processing can be done only by specially equipped labs, never by individuals. The Kodachrome process is designated *K-14*.

Because it has to be sent out to special facilities, Kodachrome takes longer to get back than E-6 films. However, some professional labs do offer overnight or even same-day Kodachrome processing.

Most E-6 kits produce similar results, but specific steps and instructions may vary.

essing. Most use the same basic chemicals, but kits may vary as to packaging, number of steps, and even time and temperature recommendations. Most processing kits deliver comparable results, but be sure to follow the specific steps packaged with each kit.

General Steps

The chemicals used for E-6 processing include first developer, color developer, bleach/fix, and stabilizer. Here's what each one does.

Prewet. Soaking film in water before processing softens the film and allows the developer to soak in more evenly, which helps prevent spotting and streaking. The prewet water should be at the same temperature as the developer.

First Developer. This is a black-and-white developer that converts exposed silver halides into metallic silver, thus creating black-and-white negatives on each emulsion layer. Take extra care with this step, since first development establishes the density and contrast of the final image.

Color Developer. This step chemically fogs (exposes) the unexposed and undeveloped areas of the film and converts them to metallic silver. At the same time, it activates the color dye couplers built into each of the film's layers to form the color.

Bleach/Fix (also called *blix*). Bleach prepares the metallic silver for removal by converting it to silver bromide, which is easily dissolved in fixer, leaving only the color dye image. Make sure this solution is absolutely fresh; weak, contaminated, or exhausted bleach will produce a dull image color or a color cast. Agitation also is very important; good agitation technique ensures even results and provides air to keep the solution active.

Stabilizer. This last step helps keep colors from fading and contains a wetting agent to encourage uniform drying. Stabilizer contains formaldehyde or a derivative, which is toxic and should be handled with care.

Drying. Dry the film in a heated cabinet if you need it right away. Otherwise, let it air dry in a dust-free area at room temperature. Hang 35mm and roll film from wire or string with film clips or spring-type clothespins; put a clip or clothespin at the bottom so the film won't curl.

Wet film is soft and susceptible to scratching. Don't squeegee the film unless previous rolls have had water marks or streaks. If you do

First development is the most important step.

The bleach/fix solution must be fresh.

The E-6 Process

The instructions for E-6 processing vary somewhat depending on the kit and the type of processing (tank and reel, manual agitation or motorized base, or tabletop processor). The steps below are typical, but refer to the instructions packaged with your kit for specifics. (Commercial labs use a process with more steps and somewhat different times.)

Step	Time (minutes) at 100°F*	Agitation
Prewet	1	None
First developer	6½	First 15 seconds, then 5 seconds every 30 seconds
Water wash	1¼	Exchange water frequently
Color developer	6	First 15 seconds, then 5 seconds every 30 seconds
Water wash	1¼	Exchange water frequently
Bleach/fix	10	First 15 seconds, then 5 seconds every 30 seconds
Water wash	5	Exchange water frequently
Stabilizer	1	First 15 seconds only
Drying	Varies**	

*With most kits, you can use solutions at various temperatures, from about 75°F to 110°F, by changing the times for the first developer and color developer only, as follows:

	Time (minutes)						
	75°F	80°F	85°F	90°F	95°F	105°F	110°F
First developer	20½	16½	13	10½	8	5	4
Color developer	8½	8	7½	7	6½	5½	5

**This depends on the method of drying used. Heat drying may take 1 minute or so; air drying could take a couple of hours or more depending on the temperature and humidity of the drying area.

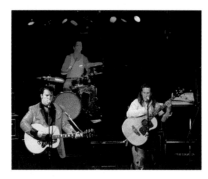

The most common reason to push film is to photograph in a low light situation like this one. Both of these exposures were made with ISO 400 film at 1/60 at f/2. The bottom exposure was overdeveloped (pushed) 2 stops to simulate a higher film speed (EI 1600).

Color transparency film can be pushed or pulled, but image quality may suffer. For optimum results, expose and develop film normally.

squeegee, wipe the film gently on both sides with a photo sponge soaked with stabilizer. Wait for the film to dry before evaluating the results; as the color will change from wet to dry.

Pushing and Pulling Transparency Film

Color transparency film can be push- or pull-processed to simulate a faster or slower speed, increase or reduce contrast, or compensate for being exposed at the wrong rating (see pages 59–63). To push-process transparency film, increase only the first developer time; to pull-process, decrease the first developer time.

Pushed or pulled film may cause image deterioration. Pushing can exaggerate color, increase graininess and contrast, and lessen shadow detail. Pulling can reduce contrast and cause color imbalances.

Some of these effects are due to underexposure or overexposure. Others are due to overdevelopment or underdevelopment. Normal development times produce the right balance of color and contrast in each layer. Longer or, especially, shorter development may cause the layers to form color differently in relation to each other. This can result in a noticeable overall color shift or crossover.

Pulling film usually requires short developing times, which makes proper agitation difficult and can lead to uneven and streaky results. To compensate, lower the processing temperature and lengthen the developing times.

Modern color films come in such a wide range of speeds that you should almost always be able to find a film that meets your needs. For optimal image quality, shoot film at its rated speed and develop normally. Certain subjects may, however, benefit from the exaggerated results that push and pull processing provide. For example, you may want to push high-speed color transparency film to produce super-grainy results.

Professional labs will push and pull film to your specifications for an extra charge. (When they alter development after running a clip test, for example, they are push- or pull-processing the rest of the film.) Or you can push- or pull-process yourself. Refer to the instructions packaged with your E-6 kit for specifics. The following first developer times are typical:

	Time (minutes)							
Push (stops)	75°F	80°F	85°F	90°F	95°F	100°F	105°F	110°F
1	33½	26½	21	16½	13	10½	8	6½
2	41½	33	26	20½	16¼	13	10¼	8
3*	52	41	32½	25½	20½	16	12½	10
Pull (stops)								
1	16¾	13½	10½	8¼	6½	5¼	4	3¼
2*	13¾	11	8½	6¾	5½	4¼	3¼	2½

*Pushing 3 stops and pulling 2 stops are recommended only as a last resort.

The top exposure was exposed and developed normally. The bottom exposure was overexposed and underdeveloped by 2 stops, causing a noticeable color change.

The times for all the other steps do not change, unless you push the film 3 stops (or more). Then you'll have to change the color developer by diluting it (to about one-third the normal concentration) and extending the time (by about two and a half times). Refer to the instructions with your E-6 kit for specifics, and don't be surprised if the results show odd colors, high contrast, and exaggerated graininess.

Processing Color Negatives

Kodak C-41 is the industry standard for processing color negatives.

Processing color negative film is easier and quicker than processing color transparency film.

Kodak *C-41* is the industry standard system for processing color negatives. Other manufacturers have their own designations, such as Fuji *CN-16,* Agfa *AP-70,* and Konica *CNK-4,* but any brand (and just about any speed, except for pushed film) of color negative film can be processed at the same time (and for the same amount of time) in any C-41-compatible setup.

Most photographers have their color negative film processed by a minilab or a professional lab. Professional labs are more expensive and take a little longer than minilabs, but they handle all film formats and are usually more careful with your film. Professional labs provide contact prints (rather than snapshot-size prints) and enlargements, as requested.

You can process color negative film on your own more easily than you can process color transparency film. The C-41 process is much simpler than the E-6 process. It has fewer steps, takes about half as long, and is generally more forgiving in terms of temperature control.

Color Transparency Processing Problems

Following are some common problems associated with color transparency film processing and their probable causes. Specifics may vary with different films and processing kits.

Problem	Probable Cause(s)
Transparencies too dark all over	1. Underexposure 2. Insufficient first development
Transparencies too light all over	1. Overexposure 2. Too much first development
Entire roll solid black except for frame numbers	Film not exposed
Film clear with no frame numbers	1. Film exposed to light 2. Incorrect processing; possibly bleach/fix used first
Transparencies generally off-color overall	1. Film not balanced for light source 2. Out-of-date or improperly stored film 3. Improper color development 4. Contaminated solutions
Transparencies too yellow	1. Daylight film with tungsten light 2. Color developer too concentrated
Transparencies too blue	Tungsten film with daylight
Transparencies too green	1. Daylight film with fluorescent light 2. Color developer exhausted
Highlight areas too yellow	Fixer exhausted
Film appears smoky	1. Film fogged 2. Film push-processed beyond acceptable limits 3. Contaminated solutions

Problem	Probable Cause(s)
Streaks, blotches, uneven density overall	Poor agitation
Weak colors with mild overall cyan cast	Insufficient color development
Black spots on film	1. Air bubbles due to trapped air in solutions 2. Fixer exhausted
Scum on film	1. Water residue 2. Stabilizer not fresh
Silver or gray streaks or blotches	Insufficient bleach/fix

Color Negative Processing Problems

Following are some common problems associated with color negative film processing and their probable causes. Specifics may vary with different films and processing kits.

Problem	Probable Cause(s)
Negative lacking in density	1. Underexposed film 2. Insufficient development
Negatives too dense or with too much contrast	1. Overexposed film 2. Overdevelopment 3. Weak bleach
Negatives too magenta, with density highest on edges near sprocket holes	1. Developer temperature too high 2. Overagitation in developer 3. Development time too long
Unusual color or contrast	1. Developer contamination 2. Overdevelopment or underdevelopment
Streaking on film surface	Stabilizer not used or mixed incorrectly
Round, light spots in negative image (dark spots in print)	Air bubbles during development

Several manufacturers make C-41 kits, which contain all the chemicals needed for the process. As with E-6 kits, all brands of C-41 kits use the same basic chemicals and produce approximately the same results. Brands vary somewhat in how the chemicals are packaged, solution volumes, and time and temperature recommendations.

General Steps

Commonly used chemicals for C-41 processing include developer, bleach/fix, and stabilizer. Here's what each one does.

Developer. This initial solution produces both a black-and-white negative and a dye image in each layer of film. First, the developer reduces the exposed silver compounds in each emulsion layer to metallic silver. Then the chemical by-product of that reaction releases dye couplers built into each layer, and the dye couplers form the image color. Development establishes the density, contrast, and color balance of the final image, making this the most critical step in the C-41 process.

Bleach/Fix (also called *blix*). Bleach prepares the metallic silver for removal by converting it to silver bromide, which is easily dissolved in fixer, leaving only the color dye image. Make sure this solution is absolutely fresh; weak, contaminated, or exhausted bleach will produce a dull image color or a color cast. Agitation also is very important; good agitation technique ensures even results and provides air to keep the solution active.

Stabilizer. This last step helps keep colors from fading and contains a wetting agent to encourage uniform drying. Stabilizer contains formaldehyde or a derivative, which is toxic and should be handled with care.

Drying. Dry the film in a heated cabinet if you need it right away. Otherwise, let it air dry in a dust-free area at room temperature. Hang 35mm and roll film from wire or string with film clips or spring-type clothespins; put a clip or clothespin at the bottom so the film won't curl.

Wet film is soft and susceptible to scratching. Don't squeegee the film unless previous rolls have yielded water marks or streaks. If you do squeegee, wipe the film gently on both sides with a photo sponge soaked with stabilizer. Wait for the film to dry before evaluating the results, as the color will change from wet to dry.

The C-41 Process

The instructions for C-41 processing vary somewhat depending on the kit and the type of processing (tank and reel, manual agitation or motorized base, or tabletop processor). The steps below are typical, but refer to the instructions packaged with your kit for specifics.

Step	Time (minutes) at 104°F*	Agitation
Developer	3½**	First 15 seconds, then 5 seconds every 30 seconds
Bleach/fix	6½	First 10 seconds, then 5 seconds every 30 seconds
Water wash	3	Exchange water frequently
Stabilizer	1	First 15 seconds only
Drying	Varies***	

*With most kits you can use solutions at various temperatures, from about 75°F to 104°F, by changing the times for the first developer and bleach/fix only, as follows:

	75°F	80°F	85°F	90°F	95°F	100°F
			Time (minutes)			
Developer	17½	14¼	10¼	8	5¼	4½
Bleach/fix	8	8	8	8	7	7

**Temperature for these steps must be controlled to within plus or minus ¼°F. Other steps can vary widely from about 75°F to 104°F.
***This depends on the method of drying used. Heat drying generally takes 1 minute or so; air drying could take an hour or two depending on the temperature and humidity of the drying area.

Pushing Color Negative Film

Color negative film can be pushed but shouldn't be pulled.

Many color negative films can be pushed to simulate a faster speed, increase contrast, or compensate for being exposed at the wrong rating. Pulling color negatives is not recommended, as underdevelopment can produce flat, muddy images and severe and often uncorrectable color shifts. Minilabs generally won't push film, but professional labs will—for an additional charge.

Some color negative films provide better results when pushed than others; some are even specially designed to allow pushing. A little push processing doesn't significantly affect image quality with most types, but at a certain point you risk degrading image quality. Some of the problems you might encounter include a grainier appearance,

reduced shadow detail (due to underexposure), and blocked high-lights, as well as possible color shifts (which can usually be corrected in printing) or crossovers (which cannot).

As with transparency film, always shoot negative film at the manufacturer's recommended speed and develop it normally for the best image quality. You'll rarely need to push negative film, because several high-speed films are available for low-light shooting. Also, color negative film has a certain amount of exposure latitude, which means that you can almost always make a good print from a somewhat overexposed negative, and sometimes even from a slightly underexposed negative.

If you do choose to push negative film, increase the developer time only. All the other steps remain the same. Follow the instructions packaged with your processing kit for specifics.

Mixing Films and Processes

With cross processing, transparency film can produce negatives and negative film can produce transparencies.

Transparency films (assuming they're E-6–compatible) can be processed in C-41 solutions to create negatives, and negative film can be processed in E-6 solutions to create transparencies. These practices, which are called *cross processing*, usually create wildly exaggerated results (see page 112).

With transparency films cross-processed to make negatives, the resulting print will have strongly saturated color and very high contrast, often leading to "blown-out" highlights—bright areas that appear totally white, with no detail. With negative films cross-processed to make transparencies, you'll get the built-in mask's characteristic reddish-orange cast (showing up most strongly in highlight areas and varying in color depending on the type of film used) and often a bluish cast in darker areas.

To cross-process transparency film, use any E-6–compatible film and expose it at the manufacturer's recommended speed (or one stop slower). Then process the film in C-41 chemistry using the standard times. To cross-process negative film, overexpose it by 1 to 2 stops and push-process in E-6 chemistry 1 to 1 1/2 stops. These guidelines are only recommendations. You should experiment with exposure by bracketing and try different processing times for the best results.

Some labs don't like to cross-process, especially if you ask them to process negative film in their E-6 line. It is generally safe to do this, but if your lab refuses you should look for another lab or cross-process the film yourself.

Lorie Novak, *Night Sky.*

Most of Novak's photographs involve projections in natural or constructed environments. "This image was made by projecting onto a tree a slide of my mother and me when I was a child, then photographing the projection," says Novak. "It was close to a full moon." The exposure took about one hour (note the streaky stars, due to the movement of the earth during the long exposure), a time she based on past experience with such subjects (and a Polaroid test exposure, to make sure). Light meters can't always be relied on to provide accurate exposure in such dark conditions, especially since reciprocity failure usually sets in at some point. To help combat reciprocity failure, Novak used Type L negative film, which is made for long exposures.

Barbara Karant, *Untitled Interior.*

*Karant constructed this set as part of an open-ended
assignment for a paper company brochure. The theme
was winter and the client was in search of a location.
Karant, a Chicago-based architectural photographer,
decided to build a room to "look warm on the inside."
For this effect, she used tungsten transparency film and lit
the room with quartz lighting.*

Lou Jones, *Dancer.*

To make this portrait, Jones found "the world's longest garden hose," connected it to his studio water supply, and dragged it down three flights of stairs and over to the park next to his building. He had his assistant stand on a ladder and aim the hose down to create the impression of a rainy day. Jones took most of the photographs of the dancer's face, the way he had originally envisioned the shot. This angle wasn't really working out, however, so he shot from the other side, and this was the photograph he liked best. By then the hot water had run out, but fortunately the subject hung tough. "As much as you plan these photographs," says Jones, "it's often the accidents that work best." Jones used a 300mm lens to minimize the depth of field, providing a soft, abstract background and bringing the subject to the fore.

Jennifer Bishop, *Khata, Turkey.*

The photographs of Baltimore-based photographer Bishop are rich with irony and humor. She took this one in the lobby of a hotel in a Kurdish village in eastern Turkey. "Village men gathered there to smoke and watch news, cartoons, and test patterns," she says. "The TV stayed on day and night regardless of whether anyone watched or what was broadcast. I liked the proud red and blue glow of the screen and the Turkish flag, the warm streaks of sunlight, the extra plug trailing off the frame."

Richard Misrach, *Desert Fire #249.*

*This photograph, a contact print from an 8" x 10"
negative, is part of a series called* Desert Cantos IV: The
Fires *(1983–85). "This canto is part of a larger exploration
of the North American desert as a symbol of the social,
ecological, and cultural landscape," Misrach explains. "All
the fires in the series were manmade. Some happened by
accident. Some were set by arsonists. Others resulted from
controlled burns, a number of which got out of control.
Fire is both a healthy force of nature and a terrifying
destructor. This photograph compels consideration of its
dual nature." Robert Mann Gallery.*

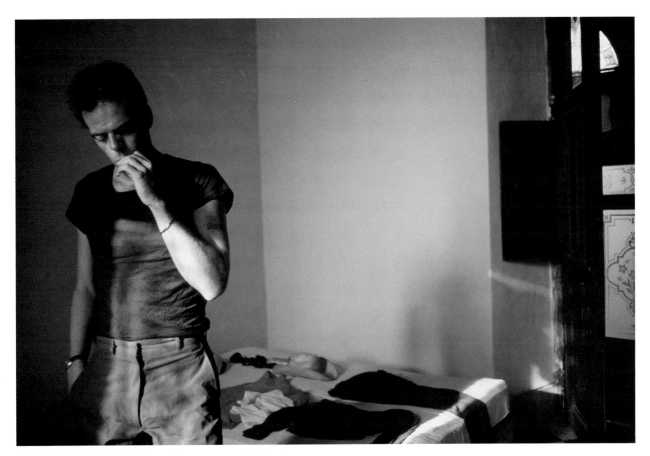

Nan Goldin, *Brian in the Hotel Room, Merida, Mexico.*

"*Brian and I had been traveling in the Yucatan for a few months together,*" *says Goldin.* "*This picture was taken at the end of the trip when we landed in a fleabag motel in Merida, after seeing the pyramids and jungles of Palenque. By then we were subsisting solely on magic mushrooms, as we'd run out of money. He thought he was Clint Eastwood. I thought I was Jane Bowles.*" *Goldin shot the photograph with daylight film, which produced a warm cast due to the combination of tungsten light in the room and late afternoon sun coming in from the window. Streaks of blue across Brian's face, hand, and shoulder as well as the back of the room—probably coming from neon or other signage just outside—add a surreal edge.*

Making Color Prints

The best prints are made from the best negatives and transparencies—those with good exposure, contrast, and color balance.

(Opposite)
Adam Fuss, *Untitled.*

"The process of making this picture involved feeling around in the rotten and slimy material at the bottom of a pond, looking for the root of the water lily," Fuss explains. The print is a photogram, an image made without a negative. Fuss laid the water lily on a sheet of Ilfochrome paper under his enlarger, established a filter pack, and exposed the paper to make the print. Ilfochrome is used for printing transparencies directly (see pages 193–197); a paper for printing negatives would have produced a negative image. Courtesy of Robert Miller Gallery.

Color printing and black-and-white printing have a lot in common. You place the negative or transparency in an enlarger, project it onto a sheet of light-sensitive paper, and process the paper in a series of chemical baths. The correct print exposure and contrast are determined by making a test print. Burning in and dodging (and sometimes other techniques) are used to fine-tune the results.

It's really no more complicated to print color, and the cost is about the same. The main difference is the need to control the color balance of the print by adjusting the color of the enlarger light.

For the easiest and best-quality results, start with negatives or transparencies that have good exposure, contrast, and color balance. Exposure is especially important. Poorly exposed negatives and transparencies produce prints with poor color quality, inadequate shadow or highlight detail, and possibly reduced sharpness.

Contrast can be controlled in printing by using different-grade papers and other fine-tuning techniques. But the controls are more complex and usually less effective than contrast controls in black-and-white printing. Subject lighting is a much more important (and reliable) variable in determining the final print contrast.

If your original negative or transparency has a color cast, you can usually correct it, especially when printing negatives (which allows more control than printing transparencies). But originals with good overall color balance are generally easier to print. Negatives and transparencies with severe casts or crossovers may be difficult or even impossible to color correct fully.

The Color Darkroom

CP filters can be placed in a drawer in black-and-white enlargers to make up a filter pack for color printing.

Cyan, magenta, and yellow dichroic filters, built into a color head, make controlling the filter pack easier and more precise than with CP filters.

Most darkrooms can be used for both color and black-and-white printing, but color printing requires additional equipment. Here's what you need for a well-equipped color darkroom.

Enlarger and Filters

You can use virtually any enlarger to make color prints. The most affordable approach is to use a basic black-and-white model with a set of *CP (color printing)* filters, which are used to create a *filter pack*—the combination of filters that allows you to adjust the color balance of a print. The pack fits in a filter drawer, which is located between the light source and the film carrier.

CP filters are similar in effect to the CC filters used when photographing, but they are made of less expensive, optically inferior materials. You can use CC filters for printing, but CP filters work just as well. The filters simply color the light; they don't sit in the image path (between the lens and the printing paper). On the rare occasions when filters are positioned in the image path, use CC filters, if available.

Besides filters, you'll also need a piece of heat-absorbing glass in the filter drawer to keep the heat of the lamp from reaching the negative or transparency, as well as an *ultraviolet (UV)* filter (such as a 2B) to minimize the effects of UV from the enlarger lamp.

Enlargers with a *color head* (also called a *dichroic head*) are easier to use and have several advantages over CP filters. A color head contains a quartz-halogen lamp (simple black-and-white enlargers use tungsten bulbs as a light source); built-in cyan, magenta, and yellow dichroic filters; heat-absorbing glass; a UV filter; and a diffusion chamber to mix the filtered light and even it out before it reaches the film carrier. The color head also has dials that adjust the filters when you're setting the filter pack.

Dichroic filters and CP filters create the same basic effect. However, dichroic filters offer several practical advantages, including a broader range of color densities (as broad as 0 to 200 or higher, rather than 0 to 50), more precise increments (you can make tiny changes in units of 1 or less), more protection from damage and dirt (since they're never handled directly), and more resistance to heat and fading. Also, changing dichroic filters has less effect on print exposure than changing CP filters.

All enlargers have a system to direct and even out light. Otherwise, some areas of the film would be more brightly illuminated than others, and this would lead to prints with uneven density.

Condenser enlargers use simple convex lenses (condensers) to do the job. They produce prints with maximum sharpness and contrast (as well as a high degree of color saturation). However, condenser enlargers are best used for black-and-white printing. The extra sharpness exaggerates graininess, as well as dust, scratches, and other negative or transparency imperfections. Also, condenser enlargers use tungsten bulbs, which are relatively dim (so exposures will be long) and become warmer in color with continued use. (You can compensate for the extra warmth with filters, but this adds a measure of inconsistency to the process.)

Diffusion enlargers are used with color heads and are generally widely preferred for color printing. (Some people use them for black-and-white printing as well.) They do an excellent job of mixing the light and color and also soften the light, which helps lower image contrast, reduce graininess, and minimize the effect of dust, scratches, and other film imperfections.

Diffusion enlargers use quartz-halogen lamps, which maintain their color better than tungsten bulbs throughout their long life span. This makes printing more consistent and predictable (although the lamps are more expensive than tungsten bulbs).

Cold-light heads are available to fit many enlargers and are popular with some printers for the low contrast and long tonal range they produce with black-and-white papers. Cold heads use fluorescent tubes as a light source. Special tubes are available for color use, but they aren't widely used.

Enlarging Lens

Most enlarging lenses work equally well for color and black-and-white printing. Higher-quality lenses generally produce sharper prints and distribute light more evenly. Using lower-quality lenses may result in reduced sharpness and a density falloff at the edges of a print.

Most enlarging lenses have a maximum aperture of f/2.8 to f/5.6. With a wider opening, you get more light for focusing and exposing, which is especially useful with negatives and transparencies that are dense or heavily filtered.

Condenser enlargers can be used for printing color, but diffusion enlargers are preferable.

For the sharpest results, close down the enlarging lens at least 2 to 3 stops before exposing the paper. A lens with a maximum opening of f/2.8 might perform best at f/5.6 to f/8, whereas a lens with a maximum opening of f/5.6 might be best at f/11. This varies from lens to lens, but in general you'll get the sharpest results somewhere in the middle of the available f-stops—neither too wide open nor too closed down.

Voltage Stabilizer

Electric current is subject to unpredictable surges and drops. These fluctuations may affect paper exposure and print color by altering the intensity and color temperature of the light.

Voltage stabilizers detect changes in electric current and adjust for them. They come either as a stand-alone unit, which connects between the enlarger timer and the electrical outlet, or as an integrated part of a color enlarger.

Drum Processor

Drums (or *tubes*) provide the most practical and economical method for most individuals to print color. These are lighttight plastic cylinders that work much like film-developing tanks. You load the exposed paper in the drum, put a top on it to keep it lighttight and watertight, and pour chemicals in and out through a light trap to process the paper—agitating the drum by hand or motor. The paper must be loaded in darkness, but processing can take place in room light once you've put the top on the drum. A cap placed on the top of the drum keeps solutions from leaking out during agitation.

Drum processors consist of a lighttight cylinder, a top, and a cap for the top.

Although it's possible to process color prints in trays, you should never do so. Drums allow you to process with the lights on (with trays you'd be working in the dark), and they also allow for much better control of temperature and agitation, which is so important in making color prints. They also are more efficient, requiring a fairly small amount of processing solution, which is discarded after each print is processed to guarantee freshness and consistent results. In addition, drums are much more effective than trays in containing potentially harmful chemical fumes (see Appendix 3).

Drums come in various sizes to hold 8" x 10" and larger paper. With simple models, you must maintain temperature and agitate manually, but you can add a temperature-control unit or motorized base for automated agitation.

Drum processors must be cleaned thoroughly after each use to avoid chemical contamination. Also, make sure that the inside of the drum is completely dry before placing an exposed sheet of paper there.

Tabletop Processor
Automated tabletop processors provide the ideal method of processing color prints. These self-contained units automate time, temperature, and agitation. Some models also replenish and maintain solutions at their correct strengths and deliver completely washed and dried prints (generally with accessory modules). Tabletop processors keep handling and inhalation of chemicals to a minimum, so they are healthier to use (although they require good ventilation and regular cleaning).

Two main types of tabletop processors are available. With one type, you insert the exposed paper, and it is guided by rollers inside the unit through several lighttight troughs containing processing solutions. With the other type, you load the exposed paper into a drum, and the machine automatically fills and empties the drum with the

The most popular type of tabletop processor automatically guides exposed paper through troughs of solution. Some models also wash and dry the processed print.

suitable solutions (or you do the filling and emptying yourself with semiautomatic models). Most drum tabletop processors also can process film.

Both types of tabletop processors are lighttight. Once the exposed paper is loaded, you can turn on the room lights. This allows you to do other tasks during processing, such as take notes on exposure and filtration or set up a new negative or transparency to print.

Many models of tabletop processors are available, at widely varying prices. The factors determining the cost of a unit include the size of the prints it can process, the degree of automation, and the unit's ruggedness. Processors are available for all the common photographic processes: color prints from negatives and transparencies, black-and-white prints, and roll and sheet film development. Some units are limited to a single process, but others can be adapted for multiple processes.

Smaller tabletop processors are available for individual darkrooms, but professional labs, schools, and other institutional settings often need models that produce a large number of prints, as well as prints in large sizes. You might be able to gain access to a processor by leasing time from a rental lab or enrolling in a class that includes darkroom and processor use. Or consider buying a tabletop processor and sharing the purchase price and maintenance costs with others.

Most processors perform better with constant use. It is important to keep the unit clean and monitor the freshness of the chemicals, which is sometimes hard to do in a shared darkroom. Dirty processors and contaminated solutions may cause staining and unwanted color casts.

Safelight

Color printing papers are easily fogged, so they should be handled and exposed in total darkness until they are loaded into a drum or tabletop processor. Also, be sure to turn off or block any stray light, such as from the timer or color head, before removing unexposed paper from its box.

If absolutely necessary, you can use a very dim safelight when handling some color printing papers, making the exposure, and loading the paper into the processor. Special color printing safelights are available, but a #13 dark amber filter in a standard safelight housing

Color printing papers should be handled in total darkness until they are placed in a drum or tabletop processor; then the lights can be turned on for processing.

Plastic screens provide a simple, inexpensive method of air drying prints.

also will work. Don't use the light for long. Limit exposure to about 30 seconds at most, and make sure the bulb is no brighter than 7.5 watts, positioned 4 feet or more away from the enlarger.

Analyzer

Color analyzers read the density and color of the negative or transparency and recommend a workable print exposure and filter pack. They are usually self-contained units, with a probe attached to a wire and a needle or digital readout to display the recommendations.

Analyzers are often used by professional labs. Affordable units are available for individuals, but they are for the most part a waste of time. Simple test prints and common sense can usually produce better results more quickly and at less cost. And, unlike the results from color analyzers, they will be tailored to your individual taste and judgment.

Miscellaneous

A Kodak Color Print Viewing Filter Kit helps in evaluating print color. An accurate thermometer made specifically for color printing is needed because strict temperature control is critical for good results. Spotting colors or dyes are needed for retouching dust spots on the surface of dried prints.

You may find the following required equipment in black-and-white as well as color darkrooms: Beakers and containers are needed to measure and hold solutions; they can be made of chemically resistant plastic, but stainless steel is preferable for purposes of cleaning and temperature control. An electric print dryer or a hand-held hair dryer makes the entire process faster, since color and density cannot be judged accurately when prints are wet. Plastic drying screens or

film clips (or spring-type plastic clothespins) and string (or wire) can be used for air drying. A soft rubber squeegee or photo sponge may be used to remove excess water from the print surface to facilitate rapid, even drying.

A digital enlarging timer provides the most accurate exposures. Rubber or plastic gloves should be used for handling chemical solutions. A glass film carrier helps keep negatives and transparencies flat, ensuring that a print will have even sharpness overall. (Glass carriers are usually an optional accessory and must be kept scratch free and clean of smudges and dust for the best results.) Canned air or a good antistatic brush helps remove dust and loose dirt from negatives and transparencies. (Products claimed to be environmentally safe are available to accomplish this task.) A grain magnifier helps in focusing the image. A loupe helps in viewing negatives, transparencies, and prints.

For test prints, you'll need an opaque piece of cardboard that is slightly larger than the largest printing paper you intend to use. A piece of plate glass is needed to make contact prints.

Color Printing Papers

Color printing papers offer less variety than black-and-white printing papers.

Color printing papers come in a variety of types, some for printing color negatives and others for printing transparencies. The suffix -color identifies most of the negative-to-print papers (such as Kodak Ektacolor); the suffix -chrome identifies most transparency-to-print papers (such as Ilfochrome).

There are fewer choices of color printing papers than of black-and-white papers. Almost all are *resin coated (RC)*, which means they have a thin, plastic, water-resistant coating that accelerates processing and drying, and most are rated medium weight (as with black-and-white RC papers). The few exceptions have a heavy polyester base. There are no fiber-based color printing papers.

The "look" of color printing papers can vary significantly in terms of surface, contrast, and overall color. As with films, some photographers prefer one type of paper for all their work, while others use different papers for different subjects.

Paper surfaces may include matte, semimatte (also called pearl or luster), and glossy. Surface has a dramatic effect on print appearance. High-gloss papers give the greatest impression of contrast, sharpness,

Elaine Mayes, *Simpson Gardens, Cape Arago, Oregon.*

In her Flora *series, Mayes used a macro (close-up) lens to explore gardens. Her intention was to make huge, out-of-scale (35" x 50") prints to help create "abstractions out of common, ordinary subject matter." She explains that "the series came about because I wanted to hang around in nice places. The perspective was always to look at things not as subject matter, but as kind of a palette." Certainly the close view helps abstract this photograph, but the lighting is just as influential. The late afternoon sun creates strong shadows, which break up and change the shape of the subject matter, and also provides rich saturated color.*

Store color printing paper in a cool place to preserve its color balance and light sensitivity.

(Opposite)
Sheila Metzner, *Uma, Patou Dress and Hat.*

Metzner is well known for her romantic and sensual portraits, nudes, and still lifes that show up in the pages of Vogue *and other top fashion magazines as well as on the walls of major museums. Metzner is one of a very few photographers using the Fresson process, a unique and highly permanent version of carbon printing that dates from the turn of the century. (Fresson prints are made by descendants of the inventor in France, who continue to print for a very select group of photographers worldwide.) Metzner makes her photographs in a conventional manner, and the printing process provides the coarse texture and soft, impressionistic feeling. The model is the actress Uma Thurman, and the subject is lit with HMI bulbs, which are movie lights that provide continuous daylight lighting. "I used basic shapes because I was learning to light," says Metzner. "I took Bauhaus blocks and had them made into large shapes to learn to light basic forms. It was shot at night; up till then I had shot only in daylight."*

and color saturation. They also show reflections, fingerprints, and other surface marks more readily.

Color printing papers come in a very limited choice of contrast—usually a general purpose grade and a lower-contrast version (made for portraiture, but often useful for other subjects). Some brands may offer additional contrast choices, but the difference between them is not great—perhaps equal to about half a grade of black-and-white paper contrast. There are no variable-contrast color printing papers, so you must buy separate packages of paper to get different contrasts.

The color characteristics and light sensitivity of color printing papers change over time or when the papers are stored in high temperatures and humidity. You can minimize these changes by storing unused paper in a refrigerator, freezer, or other cool place (at lower than 55°F). You can place boxes of paper that have never been opened directly in a refrigerator or freezer; boxes that have been opened should be tightly sealed in a plastic storage bag before refrigerating. Make sure you take the box out of the refrigerator and let it reach room temperature before opening it (or the plastic bag). Otherwise, condensation may form on the paper and ruin it.

Color balance and light sensitivity may vary significantly from one box of paper to another, even among boxes of the same brand and type. You can achieve greater consistency by buying several boxes of paper from the same emulsion batch (see pages 37–38) and refrigerating them to keep them consistent. The emulsion batch is identified by a number on the box. (Some papers have both an emulsion batch number and a cut number from that batch, which further distinguishes one box from another. For a critical degree of consistency, use paper with the same emulsion batch and cut numbers, but for most purposes the difference between cuts is virtually unnoticeable.)

Handle color printing papers with great care, since they are delicate and crimp easily. Most types also pick up fingerprints and other blemishes, especially if they have a glossy surface. Handle paper by its edges and never touch the middle areas directly.

Color Printing Chemicals

Color printing chemicals are available in convenient kits from several different manufacturers.

Color printing papers must be matched to the paper processing chemicals. *RA-4* is the current processing system for printing color negatives (although you may still see references to *EP-2*, the previous system). For printing transparencies, you have a choice of *R-3000* and *P-30P*. RA-4 and R-3000 are Kodak designations that have been adopted as industry standards; P-30P is for processing Ilfochrome (formerly called Cibachrome) materials.

The most convenient way to buy chemicals for color processing is in kits, which include most or all of the required chemicals in safe and easy-to-mix form. Such kits are offered by several companies; you can use any brand for comparable results as long as the chemicals and papers are compatible. Specific instructions may vary somewhat from brand to brand, however, so be sure to read and follow the instructions packaged with the kit.

The keys to good color processing are cleanliness and consistency. Equipment and solutions must be kept free of the slightest contamination. Solutions must be mixed accurately and used at the recommended temperature and time and with proper agitation. Color print processing allows very little flexibility. Unlike black-and-white print processing, there is no advantage to varying or modifying developers, temperatures, or times.

Color chemicals, especially developers, have a relatively short shelf life once mixed. If you print only occasionally, you should safely dispose of all mixed chemicals after each session (see Appendix 3); used chemicals do not store well. If you print often or in large quantities, consider using *replenishers* to extend the life of the solutions. Replenishers are chemicals added to depleted solutions to revive them. Instructions may vary with different brands, so follow specific recommendations for storage and replenishment requirements.

To keep air out, store all solutions in tightly capped bottles filled to the top or in collapsible containers. Room temperature is best, as warm temperatures can cause evaporation, and cool temperatures can cause some of the chemicals to precipitate into a powdered form.

The Filter Pack

Filter packs for printing negatives generally consist of yellow and magenta filters.

A *filter pack* is a combination of filters used to produce the desired color balance when printing either negatives or transparencies. The pack can be put together from a set of CP filters for use in an enlarger's filter drawer, or it can be dialed in with a color head.

CP filters come in squares of various sizes and densities. They are sold individually and in kits containing all the needed filters. A typical kit might consist of the following densities of each color filter: .025, .05, .10, .20, .30, .40, and .50. The higher filtration numbers have the strongest effect on print color. A 30Y filter, for example, is three times stronger than a 10Y. CP filters can be combined to produce a cumulative effect (20M + 10M = 30M), but you should try to minimize the number of filters you use to keep exposure times from becoming too long.

With dichroic filters, you don't have to worry about combining filters. You simply dial in the combination you want. Changing dichroic filters has much less effect on print exposure than changing CP filters.

Both CP and dichroic filters come in yellow, magenta, and cyan. (You also can find red and sometimes green and blue CP filters, but they are rarely used.) In practice, only two filters are used to make up most filter packs—yellow and magenta when printing negatives and yellow and cyan, yellow and magenta, or cyan and magenta when printing transparencies.

(Using all three colored filters creates a situation called *neutral density,* in which the light is reduced with no practical effect on color balance. If you do end up with three filters in your filter pack, you can reduce the number to two and eliminate neutral density by subtracting the smallest filter density from each of the other two filters. For example, if your filter pack is 60Y + 10M + 30C, subtract 10 units from each to get the exact same color effect and a less dense pack: 50Y + 20C.)

Establishing a standard filter pack is critical for efficient color printing. Manufacturers usually recommend a starting pack for each of their papers (and the pack is sometimes modified for specific emulsion batches). However, you'll almost always have to modify these recommendations for your own set of variables. Besides the paper and emulsion batch, these are some of the variables that affect the filter pack: film type, subject lighting conditions, processing chemicals, processor type, enlarger (including age of bulb), and filter type (dichroic and CP filters vary somewhat in color, and CP filters fade over time).

By establishing a standard filter pack for your own set of variables, you'll be able to print and achieve good color balance with little modification to that pack most of the time. You may need to establish more than one standard pack, however, if you use different types of film, paper, and lighting conditions.

To establish your own standard filter pack, start with the manufacturer's recommended pack and make a test enlargement. The filter pack can vary widely for different papers, but you can start with the following if the manufacturer's recommendation is unavailable:

> Prints from negatives: 70Y + 40M
> Prints from transparencies (Type R): 20C + 10M
> Prints from transparencies (Ilfochrome): 35M + 30Y

For the test, use a simple, recognizable subject, preferably one with neutral gray or pastel tones (bright colors are harder to judge). Portrait, landscape, or still life subjects—or even a gray card—are good for this purpose; abstract subjects are not. Also, avoid extreme lighting conditions, such as strong, warm light at sunset.

Make the enlargement as described on pages 157–161, adjusting the filter pack until you get the desired color balance. Note the filter pack that produces this balance and make it your standard for the given variables (paper, film, and so forth). Make additional standard filter packs later when other variables come into play.

Standard filter packs may vary widely. You must establish your own filter pack for each variable that might come into play—lighting, film, paper, and so forth.

Prints from Color Negatives

Most color prints are made from negatives. Negatives are generally more suitable for printing than transparencies. They have more exposure latitude, which means that they can be a little dense or even slightly thin and still produce good prints (in fact, somewhat dense negatives often produce the best results). Also, negatives require little if any filtration when photographing. You can usually do all the filtering you need when printing (although already-filtered negatives often print more easily).

Prints from negatives are commonly called *C-prints* (also *color coupler, dye coupler,* or *chromogenic* prints). The system for processing color prints is *RA-4,* a Kodak standard that has been adopted by all manufacturers.

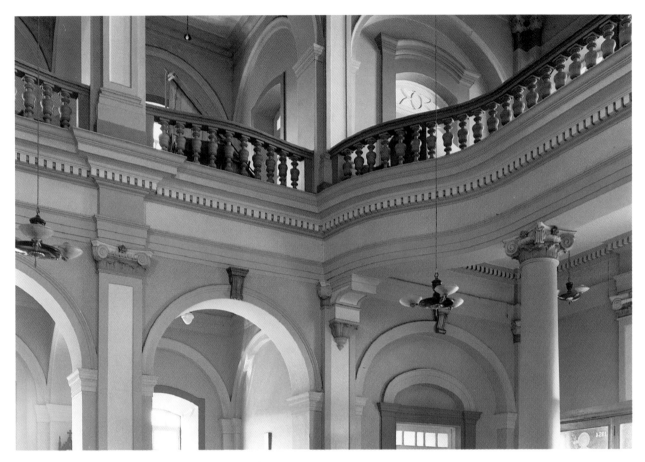

Allen Hess, *Church Interior, Diamantina, Brazil.*

Often the strength of a color photograph is in the color of the subject. Hess was sightseeing in a small Brazilian town when he stumbled onto this church. "I was blown away by the color," Hess says. "Churches in the Midwest, where I come from, were not painted pink, green, and lilac." Hess used daylight negative film and a 6cm x 9cm medium-format camera. He used no filters on his camera; all the color correcting was done by adjusting the filter pack when printing.

David Graham, *Indianapolis Backyard.*

Graham spotted this scene from an interstate highway in 1981, but was in too much of a hurry to stop. He kept the scene in mind, however, and returned two years later to make this photograph. "The weird thing was," Graham says, "when I first saw it, it had a red and white motif, and they had changed it to blue and white. Clearly the porch, yard, and house were an avenue of personal expression for these folks." Whites and other uncolored areas are good indicators when printing color. When whites print with no appreciable color cast, your filter pack is probably correct (assuming that you want neutral color).

There are several steps to making successful color prints, beginning with making contact prints. Following is a detailed explanation of the process used to make color prints from negatives. Much of the information also applies to making prints from transparencies, as covered on pages 189–197.

Contact Prints

A *contact print* is a print the same size as the negative from which it's made. A full sheet of contact prints—for example, from a roll of 35mm film—is called a *contact sheet*.

Contact prints are especially helpful when you're working with negatives, which are difficult to read without printing because they are reversed in density, complementary in color, and have an orange cast. You can make contact prints from transparencies, but there's rarely any reason to do so because transparencies can be viewed and evaluated directly.

The main reason to make a contact print is to provide a quick look at each frame before deciding which ones are worth printing. Contact prints also are useful for filing and storing negatives. Simply assign the same number to both the contact sheet and the negatives that produced that sheet (for example, 96-01 for the first roll of photographs taken in 1996, 96-02 for the second roll, and so forth). The back of the contact print also is a good place to note exact dates and provide captioning information for identifying the subject and location.

Usually there's no need to spend too much time getting contact prints to look just right. Some variation from print to print is to be expected when several negatives are printed on the same sheet—unless all negatives were originally exposed for exactly the same time in the same lighting conditions.

The exception is when contact prints are made as final prints, which sometimes happens with large-format negatives—4" x 5" and larger. (In particular, 8" x 10" negatives are often printed as contacts in their final form.) Contact prints from large negatives produce incredibly sharp and richly colored results because they aren't subject to enlargement, which is usually an image-degrading step. If you do make contact prints as final prints, treat them with as much care as you would enlargements. This means testing for correct density and color balance and burning in, dodging, or even flashing as needed (see pages 174–184).

A 35mm contact print is the size of a 35mm negative.

Contact prints are a useful reference and provide a good means of filing and storing negatives.

Don't bother to aim for exact density and color balance when making a contact print (unless the contact print is the final print).

A contact sheet generally consists of an entire roll of contact prints. Exposures and color balance often vary from print to print.

To make contact prints, use a clean, scratch-free piece of plate glass. (When contact printing large negatives as final prints, you'll need special anti–newton ring glass to prevent moiré patterns from forming in the image. Anti–newton ring glass is available at glass dealers and some camera stores that service professional photographers.) Following are some general directions for making contact prints:

1. Lift the enlarger head high enough to project a beam of light much larger than the paper size. (Use 8" x 10" or 8½" x 11" paper when contact printing a roll of 35mm or 120 film.)
2. Set up the filter pack, either by dialing it in with a color head or placing CP filters in the enlarger's filter drawer. If you haven't printed before with this combination of film and paper, use the filter pack recommended by the paper manufacturer or 70Y + 40M. If you have established a standard filter pack, use that.
3. Open the lens to its widest f-stop to allow the shortest possible exposure.

4. Set the timer at 5 seconds. This is a starting point only; you may end up with a longer or shorter time.

5. Make sure you have your negatives (filed in sheets of clear, chemically inert plastic sleeves for easy handling; see page 209–210) and box of printing paper nearby, where you can find them in the dark. Then shut off the room lights.

6. Take a fresh sheet of paper from its box and place it on the base of the enlarger, emulsion side up and positioned directly under the lens. You can use a section of a sheet of paper for the test print, but it won't provide as much information as a full sheet, and it might jam if you use a tabletop processor. Torn sections are especially likely to cause jamming; always use scissors for a clean cut.

 The paper's emulsion side is sometimes difficult to identify, especially in the required dark conditions. Some paper surfaces are easier to distinguish than others. For example, the emulsion on glossy paper should feel more slippery than the base. A more reliable clue is that most papers curl slightly toward the emulsion. Also, most printing papers come packaged emulsion side up. Whichever way the sheets face, after removing a sheet of paper be sure to keep the paper stack oriented in the same direction before closing the box. You may be able to distinguish between the white base and the tinted emulsion of some papers under a dim safelight, but be very careful not to fog the paper.

7. Place the sheet of negatives emulsion (dull) side down on the paper.

8. Place the plate glass directly on the sheet of negatives to hold the negatives tight against the paper for maximum image sharpness.

9. Now you're ready to make a test print to determine exposure. Use a piece of opaque board to cover about five-sixths of the printing paper, then expose the uncovered sixth for 5 seconds.

10. Move the board so that another sixth of the paper is uncovered and expose for 5 seconds more. The area uncovered first now has a total exposure of 10 seconds; the second area has 5 seconds.

11. Uncover still another sixth of the paper and expose for 5 seconds more, then two more sixths for 5 seconds each.

12. Remove the board entirely and expose for a final 5 seconds.

To make a test print, use a piece of opaque board to cover sections of the paper during exposure.

Print Exposure: Time versus Aperture

To adjust exposure, some printers increase or decrease the exposure time (as recommended here), and others open or close the aperture. Varying the time is simpler and more precise; it's easier to set small increments on a timer (especially a digital model) than on an lens. It also allows you to use the f-stop that will provide the best optical quality, usually 2 to 3 stops smaller than the maximum opening.

The advantage of varying the aperture rather than the time is that it allows you to avoid potential problems caused by reciprocity failure. Printing papers undergo reciprocity failure at slow and fast exposures, just as film does. The point at which they fail varies with different types of paper, but a safe exposure range for most types is about 8 to 20 seconds. Potential problems caused by reciprocity failure can be corrected in subsequent prints by adjusting the exposure time and/or filter pack. But if you want to avoid reciprocity failure, set the exposure time safely between 8 to 20 seconds and change the f-stop to adjust exposure.

For example, when making a test print, set the timer at 8 seconds, block off all but one-sixth of the test paper, and expose the paper at f/4. Then expose another sixth only at f/5.6, holding back exposure from the rest of the paper, including the section exposed at f/4. Make 8-second exposures of different sections of the paper at f/8, f/11, and f/16, then process and evaluate the results. Let's say the section of the paper exposed for 8 seconds at f/5.6 looks best, but it's a little light. You can then adjust the exposure by opening the lens slightly (or resetting the timer to 9 seconds).

This method works well enough, but it's imprecise compared to varying the exposure time. F-stops are not clearly marked for in-between settings, so any minor adjustments in f-stop are little more than a guess. You also may end up with an f-stop that's too open or too closed to provide the best image quality. Although reciprocity failure is a reasonable concern, in most cases the problems it creates (reduced sensitivity to light and altered color balance) are easily correctable by making a new print and increasing the exposure time and/or adjusting the filter pack.

13. Lift the glass and remove the exposed paper. Place it in a drum or tabletop processor, turn on the lights, and process (see pages 168–174).
14. Dry the processed sheet and evaluate it.
15. The test print should show six sections of varying density. The darkest strip received the longest exposure (30 seconds) and the lightest strip received the least exposure (5 seconds). If the test is too dark overall, repeat it using 3- or 4-second increments (or a

smaller f-stop); if it's too light overall, use 6- or 7-second increments.

16. Let's say that the 15-second section looks best. Turn off the lights, repeat steps 6 through 8, and expose the entire paper for 15 seconds to make the contact print.

17. Process and dry the paper. The results will usually be close enough for the purposes of the contact print. You can make subsequent prints, adjusting exposure and color balance if you choose, but there's no reason to spend the time and expense to do so unless you're making final prints from large-format negatives.

By standardizing important variables, you'll be able to make good contact prints most of the time without making test prints.

With experience, you'll be able to skip the test print stage and make usable contact prints most of the time in one or two tries. Standardize the important variables as much as possible (especially filter pack, film, and paper) and keep the head of the enlarger at a constant height (mark it with a piece of tape on the enlarger rail). Also, keep the focus position constant (focus doesn't matter with contact prints, but a lens focused close to the paper will produce greater exposure than a lens focused farther away).

Enlargements

Making excellent-quality enlargements requires more steps than making contact prints. First, you'll need to make a test strip, then you'll probably need to adjust the exposure and filter pack (and possibly change the paper for more or less contrast). You also may have to burn in or dodge (to adjust density or color in selected areas) or flash (to achieve detail in burned-out highlight areas or lower the overall print contrast). Following are some general steps for making good enlargements:

1. Use canned air or an antistatic brush to eliminate dust from the negative. Be careful, as color film scratches easily.
2. Put the negative in the film carrier emulsion (dull) side down.
3. Position the film carrier in the enlarger.
4. Set up the filter pack, either by dialing it in with a color head or placing CP filters in the enlarger's filter drawer. Begin with your standard filter pack (if you have established one), the pack rec-

ommended by the paper manufacturer, or a pack consisting of 70Y + 40M.

5. Set the masking blades of the easel to accommodate your paper size. For an uncropped 35mm negative on 8" x 10" paper, use about 6" x 9"; for 11" x 14" paper, use about 8½" x 12¾"; and so forth.

6. Shut off the room lights and take a fresh sheet of paper from the box for use as a focusing sheet. (You can reuse the sheet, so mark it with an *X* for identification.) Close the paper box, turn on the room lights, and place the focusing sheet in the easel to help set up the projected negative; it provides a light background to establish cropping and a slight thickness for accurate focusing. Otherwise you'll be focusing on the surface of the easel rather than on the surface of the paper. It's best to use the back of the focusing sheet since it's whiter than the front and thus provides a brighter image. (The back of a dry print also can be used.)

7. Shut off the room lights and darken the room. Now turn on the enlarger light.

8. Open the lens to its widest f-stop so that the projected image will be at its brightest for easy cropping and focusing. (If the image isn't bright enough, turn on the white light of the color head or take the CP filters out of the filter drawer.)

9. Raise or lower the enlarger head until the image fits within the blades of the easel (cropped or uncropped).

10. Focus the negative by eye or, preferably, with a grain magnifier placed on the focusing sheet. As you turn the focus knob of the enlarger, the tiny dots of grain (actually, dye clouds, see page 40) will move in and out of sharp focus. If the projected image size changes as you focus, you may have to readjust the enlarger head and refocus one or more times. When both size and focus are set, tighten the knob that locks the enlarger head to the rail.

11. Close down the lens 2 to 3 stops. If the lens has a maximum aperture of f/2.8, for example, close it to f/5.6 or f/8.

12. Turn off the enlarger and remove the focusing sheet from the easel. If you turned on the white light of the color head or removed the CP filters from the filter drawer, first turn off the light or replace the filters. Be careful not to throw off the image size or focus in the process.

13. Set the timer at 5 seconds—a time that may need adjusting when you see the first test print.
14. Turn off all the room lights. If absolutely necessary, you may use a special color printing safelight or a #13 dark amber filter in a standard safelight housing for a very brief time, but this is not recommended as a general practice.
15. Take a fresh sheet of paper from the box and place it in the easel emulsion side up (see page 155) to make a test print. (You can use a section of a full sheet of paper for the test, but it won't provide as much information, and it might jam if you use a tabletop processor.)
16. Expose six sections of the paper for the test print, following steps 9 through 12 on page 155.
17. Take the paper out of the easel and process it in a drum or table-top processor. You can turn on the room lights once the exposed paper has been placed in the processor.
18. Unless you are using a tabletop processor with a built-in dryer, you'll have to dry the processed test print with an electric print dryer or a hand-held hair dryer. Prints must be dry before they are evaluated because the density and color balance look quite different when prints are wet than when they are dry.
19. A good test print should have a range of densities from too dark to too light. (If all sections are too dark, make another test with the lens closed down 1 more stop or with 3- or 4-second exposure increments. If all sections are too light, make another test with the lens opened 1 more stop or with 7- or 8-second increments.)
20. Examine the sections for the best density. (See pages 162-163 for tips on how to evaluate print density.)
21. Let's say that 10 seconds looks best. Set the timer accordingly and turn off the lights.
22. Place a fresh sheet of paper in the easel to make your initial print. Expose, process, and dry the paper, then evaluate the print. The density should come close to matching the chosen section of the test print. It may be a little off due to resetting the timer and other factors, but don't worry about small variations, as you'll probably have to adjust the exposure for subsequent prints anyway.

When making enlargements, first establish the correct print density and contrast, then evaluate the print for color balance.

23. Examine the density carefully. (For the time being, ignore the color balance, unless it's grossly off; it's impossible to judge color balance until you get the density right.) If the print is a little dark overall, adjust the timer for a shorter exposure—perhaps 7 or 8 seconds instead of 10 seconds; if it's a little light overall, try 12 or 13 seconds. Then expose another sheet of paper for the adjusted time and process and dry it. Keep making new prints, adjusting the exposure, until you get a print with the desired overall density.

24. Now evaluate that print for overall contrast. If the contrast is too high or too low, use a higher- or lower-contrast paper, if available (see page 163). You may need to make an additional exposure adjustment when changing contrast grades.

25. Evaluate the print (with adjusted contrast if necessary) for color balance. Usually you'll need to make at least a slight change to the starting filter pack. Use one of the methods for viewing and adjusting color balance described on pages 163–169. If you're using CP filters, add or subtract filters as necessary. With dichroic filters, simply dial in any changes.

26. Make a new exposure with the adjusted filter pack. Process, dry, and evaluate the print. The new filter pack may produce a mildly lighter or darker print, especially if you're using CP filters (see the CP filter factor chart on page 167); changing dichroic filters has less effect on print exposure.

27. You may need to make a few different prints, adjusting the exposure and filter pack, until you get a print with good overall density and color balance. Sometimes this is all you'll need to do to make an excellent print. Other times you'll need to fine-tune the print, burning in or dodging to lighten or darken specific areas (or adjust the color balance in specific areas) or flashing to lower contrast. These techniques are covered later.

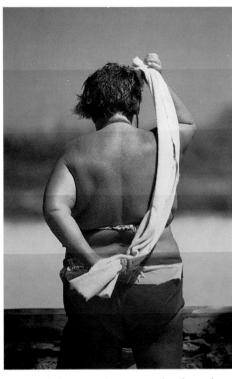

5 seconds

10 seconds

15 seconds

20 seconds

25 seconds

30 seconds

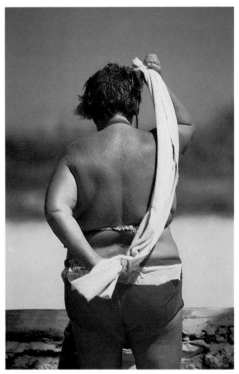

(Above, left) A good test print for this enlargement represents six different exposures, ranging from 5 to 30 seconds—all set at f/8 with a filter pack of 60Y + 40M.

(Above, right) A print made with the 15-second exposure has the best density, but the color balance is too green and cyan.

(Right) To eliminate the green, you subtract magenta. To eliminate the cyan you subtract magenta and yellow. The resulting filter pack — 50Y + 25M (subtracting more magentia than yellow) — provides good overall density and better color. The exposure had to be changed slightly—to 14 seconds—to compensate for the filter pack adjustment.

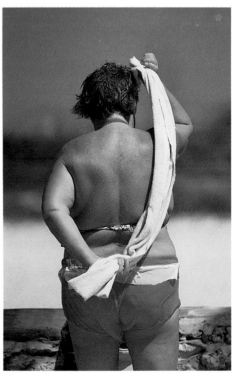

Viewing booths made for evaluating prints have lighting balanced for 5000K.

Prints must be evaluated for color balance using the appropriate light source.

Determining Density, Contrast, and Color Balance

To make good color prints, you must control these factors: density, contrast, and color balance. In general, print exposure determines density; paper contrast and various fine-tuning techniques, such as burning in and dodging, determine contrast; and the filter pack controls color balance (although balance also is affected by other factors, notably exposure).

Your ability to control these factors is largely dependent on the quality of the negative. An underexposed negative may produce a flat (low-contrast) print with muddy colors. A slightly overexposed negative should print well, but a severe overexposure may produce a print without adequate detail in its highlight areas. Subject lighting that is too high or low in contrast will lead to high- or low-contrast prints. In some cases when the film and color temperature of the light don't match up, you may have trouble finding a filter pack that will produce good overall color balance.

Personal taste inevitably plays a role in these judgments. Some individuals may prefer slightly dark prints; others may like high contrast or a strong warm cast. Subject matter also can be a factor. A cool cast might be more suitable for some scenes and a warm cast for others.

Whatever the limitations, prints should always be dried before they are evaluated, since density and color balance change as prints dry. The light used for viewing the print also is critical; density and color will look different under different types of lighting.

Ideally, a print should be evaluated under the same type of lighting it will eventually be viewed under. Realistically, prints are likely to be viewed under different types of lighting at different times. If a print is going to be used for reproduction in a book, magazine, or other printed piece, use a neutral color environment, either a 5000K fluorescent lamp or a 5000K viewing booth made specially for this purpose. If the print is for portfolio or exhibition viewing, you also can use 5000K lighting. However, galleries and museums almost always use warm light, so you may want to use tungsten or incandescent lighting for evaluating prints in this case—either alone or mixed with 5000K light. Try household bulbs or tungsten-balanced photofloods, positioned at least 3 feet away from the print to keep the print from appearing too bright.

Density. The first step in evaluating a test (or any) print is to determine the correct density, since it's impossible to judge color balance accurately in a print that's either too dark or too light. Look at each section of exposure in the test print for a good balance between light and dark values. Ignore extreme brights or darks, as these may need burning in, dodging, or flashing.

The exposure is usually correct when the light values look right.

Middle values, such as light skin, often provide a good general clue to correct print exposure. Light values also are a good indicator. They should be bright, yet they must have enough density to show detail. Even a little underexposure can cause light areas to go blank white, and a little overexposure can make them just dense enough that the overall print looks grayish.

Contrast. When the density of the light values looks right, the dark values often look good (assuming that the overall contrast is moderate). With a high-contrast negative, the dark values will be too dense when the light values are right, so use a lower grade of paper to bring down the contrast. With a low-contrast negative, the dark values will be too light with well-exposed light values, so a higher-contrast paper is needed.

Unfortunately, most color printing papers come in a limited number of contrast choices—usually two or three. If this limited contrast range isn't enough, you'll have to resort to some other method of adjusting contrast.

The best time to control contrast is actually when you're photographing your subject, by changing the lighting (if possible), moving the subject, or waiting until the natural light strikes your subject in just the right way. The film you use also is a factor; some films inherently have more contrast than others.

Refer to neutral colors when you evaluate print color balance. Ignore shadows and highly saturated colors.

Color Balance. Once the print's density and contrast are correct, you can judge its color balance. Examine areas where incorrect color balance is most likely to show up, such as light skin tones, pastel colors, and neutral (gray) tones. Ignore highly saturated colors and obvious color casts, such as strongly blue shadows.

With experience, you may learn to balance the color of a print by eye. Use your standard filter pack to make an initial print with acceptable density and contrast, then evaluate the color and make the required change to the filter pack.

When printing negatives, make changes to the filter pack in the opposite direction from the color change you need. To reduce a color

William Wegman, *Mother's Day.*

"The photo was taken in late June, 1989, on a screened-in porch in upstate New York," Wegman says. "Battina, whose head appears under Fay's elbow, is the puppy I kept." Like many of Wegman's photographs, the appealing subject matter is more striking than the color quality. Still, the muted, almost monochromatic color produces a feeling of warmth that fits the subject perfectly. Although Wegman often uses Polaroid 20" x 24" materials in a studio setting for his famous dog photographs, this one was taken with a medium-format camera and negative film on location, which may account for its relative informality.

Color Wheel

(See page 88)

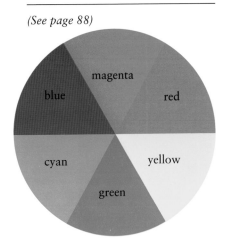

A commercially reproduced ringaround can be useful, but make your own for the best results.

from the overall print, add that color to the filter pack. To add a color, remove (subtract) it from the pack. If a print is too yellow overall, for example, add yellow to the filter pack; if a print looks too green (lacks magenta), subtract magenta (which is the complement of green, so in effect you're adding green). Use this chart as a guide:

If the Overall Color Is:	DEGREE OF ADJUSTMENT		
	Slight	Modest	Extreme
Too red	+5Y/+5M	+10Y/+10M	+20Y/+20M
Too green	−5M	−10M	−20M
Too blue	−5Y	−10Y	−20Y
Too cyan	−5Y/−5M	−10Y/−10M	−20Y/−20M
Too magenta	+5M	+10M	+20M
Too yellow	+5Y	+10Y	+20Y

These suggestions are only a starting point and can vary widely. Adding 15Y may be enough to correct a print that's too yellow with one type of paper, but another type of paper might need only +11Y or +12Y for a comparable adjustment.

Even experienced printers can use help in evaluating a print's color balance. Two common methods are the ringaround and the Kodak Color Print Viewing Filter Kit. A *ringaround* is a chart of prints showing a single subject with the same overall density but different filtration. It includes a print with neutral color balance and a series of prints with a stated number of yellow and magenta units subtracted and added.

The ringaround is best used as a reference tool. By indicating the effects of incremental changes in the filter pack, it can help you determine the amount (and direction) of adjustment you'll need to correct the color balance of a particular print.

Ringarounds may be found on a printed instruction sheet, such as the one on the next page, or they may be custom-made. A printed version is only an approximation, because color in reproduction is not exactly the same as color in a photographic print. Also, different printing films and papers may react differently to the same filter changes.

For more accuracy, make your own ringaround. Start with a print that has good overall density, contrast, and color balance; then vary the filtration to make the series of prints. Use the opposite adjustments from the ones shown on the next page to achieve the off-color results. For example, to make prints that are too cyan, add yellow and

−10Y/−10M −20Y/−20M − 40Y/− 40M

+10Y/+10M +20Y/+20M +40Y/+40M

−10M −20M − 40M

A ringaround shows how changes in filtration affect the final print. The photograph above has neutral color balance. Each smaller ringaround image shows some degree of color imbalance and is labeled with the change to the filter pack that would be required to achieve neutral color balance. Thus, if a print is slightly too cyan (top left), you would need to subtract 10Y and 10M to achieve neutral balance; if it's very cyan, you would subtract 40Y and 40M (see chart on previous page). If a print is too magenta (bottom three photographs), you'd add various amounts of magenta filtration to produce neutral color. Example by George Lange (photograph) and Jerry Vezzuso (ringaround).

+10Y +20Y +40Y

−10Y −20Y − 40Y

+10M +20M +40M

magenta to the filter pack. Also, be sure to vary the exposure from one print to the next, if necessary, to compensate for the changes in filtration.

A Kodak Color Print Viewing Filter Kit is an even more useful aid for evaluating color balance. The kit consists of six cards containing windows with different-color filters mounted in them: magenta, red, yellow, green, cyan, and blue. Each card contains three filters, repre-

How Filters Affect Exposure

Adjusting the filter pack may require changing the print exposure, especially when using CP filters. Usually the exposure adjustment is minor. You can estimate it, make new test prints, or use the following chart to determine a new exposure. Multiply the original exposure time (before the pack is adjusted) by the factor of the filter(s) you are adding, or divide the exposure time by the factor of the filter(s) you are subtracting.

Let's say you make a print with good density at 10 seconds. After evaluating the color, you decide to add a 20M CP filter. A 20M filter has a factor of 1.5x, so you multiply 10 seconds by 1.5, for a corrected exposure of 15 seconds. If you decide to subtract 30Y instead, you divide the initial exposure (10 seconds) by the 30Y factor (1.1x), for a corrected time of 9 seconds.

If you use more than one filter, multiply the individual factors together and use the results as your factor. Adding 20Y (1.1x) and 10M (1.3x) gives you an effective filter factor of 1.43x (1.1x x 1.3x).

FILTER FACTOR

Filter Density	Yellow	Red	Magenta	Green	Cyan	Blue
5	1.1	1.2	1.2	1.1	1.1	1.1
10	1.1	1.3	1.3	1.2	1.2	1.3
20	1.1	1.5	1.5	1.3	1.3	1.6
30	1.1	1.7	1.7	1.4	1.4	2.0
40	1.1	1.9	1.9	1.5	1.5	2.4
50	1.1	2.2	2.1	1.7	1.6	2.9

With dichroic filters, changing yellow in the filter pack has no appreciable effect on print exposure. Changing magenta requires a mild exposure adjustment. A general rule is to add or subtract 1 percent of the initial exposure time for every 1 unit of magenta added to or subtracted from the pack. If you add 10M and the initial exposure is 12 seconds, add 1.2 seconds (10 percent) for an adjusted exposure of 13.2 seconds. However, this is strictly an approximation and subject to variation from print to print.

Kodak Color Print Viewing filters are placed over a print as an aid to evaluating color balance.

senting different densities of that color. One side of the card is used for viewing prints made from negatives; the other side is for prints made from transparencies.

To use the viewing filters, first make a test print with acceptable density and contrast. Then dry the print and look through the filters to find the one that best corrects the color balance. Use complementary colors for viewing. For example, if the print looks too red, view it through a cyan filter; if it looks too yellow, use the blue filter.

Again, concentrate on areas of neutral or pale color, preferably grays, pastels, and light skin tones. The effect of the filters will be more apparent in middle to light tones than in the shadows. Hold the filter card about 6 to 12 inches away from the print, never directly on it. And don't hold the filter still; instead, flash it with a rapid motion back and forth between the filtered position and no filtration to keep your eyes from adjusting to one density and throwing off your judgment.

Suggested filtration changes are indicated on the card below each filter. Each viewing filter offers a choice of subtracting or adding fil-

The RA-4 Process

The instructions for RA-4 processing vary somewhat depending on the kit and the type of processing (tabletop processor or drum). The steps below are typical, but refer to the instructions packaged with your kit for specifics.

Step	Time (minutes) at 95°F*
Prewet	½
Developer	1**
Stop bath	½
Wash	½
Bleach/fix	1
Wash	1½
Drying	Varies***

*Various temperatures can be used. Warmer developing temperatures require less time; lower temperatures need more time. However, 95°F provides short enough processing for convenience and long enough for even results. (Unevenness occurs when the time is too short for adequate agitation or thorough absorption of the developer by the paper.)

**Developer temperature is critical and should be kept within plus or minus ½°F. Other solution and wash temperatures can range from about 86°F to 96°F.

***This depends on the method of drying used. Heat drying (at around 180°F) generally takes 1 minute or less; air drying (at room temperature) could take an hour or so depending on temperature and humidity.

ters to achieve the desired results. For example, a filter may show how you can make a print from a negative more magenta either by subtracting 5M, 10M, or 20M or by adding 5Y + 5C, 10Y + 10C, or 20Y + 20C. (With prints from transparencies, use the opposite side of the filter card, which recommends the opposite filter pack and twice as much filtration.)

When you hold the card away from the print, as suggested above, use only *half* of the indicated value of the filter that makes the print look best. The full values are used when the filter is placed on top of the print. You also may choose an in-between value—for example, +7M rather than +5M or +10M.

RA-4 Processing

The steps for RA-4 processing include prewet, developer, stop bath, bleach/fix (blix), wash, and drying. Here's what each one does.

Prewet. A brief water prewet softens up the emulsion so that the processing solutions will be more evenly absorbed.

Developer. Development converts exposed silver halide into metallic silver, thus creating a black-and-white image on each of the paper's three emulsion layers. This activity almost simultaneously releases dye couplers built into each layer to form the color image, leaving separate silver and dye images in each layer of the paper, as well as silver compounds from unexposed and undeveloped areas.

Development is a key factor in establishing print density, contrast, and color balance, so make sure you follow the correct time, temperature, and agitation recommendations. Consistency is very important at this stage, as are solution strength and freshness.

Stop Bath. This bath stops the development and also helps extend the useful life of the bleach/fix solution. Some kits skip the stop bath and use a water wash instead.

The developer and bleach/fix solutions must be absolutely fresh.

Bleach/Fix. This step removes all the silver left in the paper, including the metallic silver used to produce the dye image and the unexposed and undeveloped silver compounds. It does this by converting silver to a soluble silver complex, which can be easily removed in the wash, leaving only the dye image.

The bleach/fix step requires absolutely fresh solutions. Weak, contaminated, or exhausted bleach will produce a dull image color, stains, or a color cast.

Wash. The final wash step removes any remaining soluble silver complex. A thorough wash is critical for long-term print stability.

Drying. Some tabletop processors have drying modules. Otherwise, you should gently squeegee prints, then dry them using a print dryer (suitable for color prints, which are resin coated and shouldn't be subjected to temperatures higher than 180°F), or a hand-held hair dryer for quick results. You also may air dry prints by laying them faceup on a drying screen or hanging them from a string or wire with film clips or spring-type plastic clothespins. Heat drying may increase print contrast slightly and will increase the sheen of glossy surface printing papers.

Drum Processing

Using *processing drums* (or *tubes*) is the most economical way to process color prints. Drums work much like film-processing tanks except they don't use reels. They have a spout with a light trap, which is designed to let solutions in and keep light out. To use, you remove the top of the drum, place the exposed paper inside in total darkness (emulsion side facing in), close the drum, and turn on the lights. Then you pour in the solutions and drain them out until processing is complete. The top has a cap to keep solutions from dripping out during agitation.

A processing drum provides economical color print processing.

Drums come in various sizes to accommodate different-size prints; common sizes range from 8" x 10" to 16" x 20", and some drums are even larger. More than one sheet of paper can be processed in the drum at a time. For example, two sheets of 8" x 10" paper can fit in a 16" x 20" drum (as long as the sheets aren't touching each other).

One advantage of drum processing is that it requires only small quantities of each solution. Follow the manufacturer's instructions regarding the correct amount of solution for the size drum you're using. Mix enough solution for all your prints at the beginning of the printing session, use a fresh amount for each processing cycle, and dispose of the solution after each use.

Be sure to rinse and dry the drum thoroughly before inserting the paper. Leftover chemicals and moisture may contaminate processing and stain or otherwise discolor prints.

Processing temperatures vary with the brand of chemicals used, but they are almost always warmer than room temperature. You'll need a water bath system, similar to that described for film processing (see page 119), to keep solution temperatures constant. Following are instructions for processing prints in a drum:

Processing Problems: Prints from Negatives
These are some of the many problems that can occur when making prints from color negatives, with their probable causes. Specifics may vary with different papers and processing kits.

Problem	Probable Cause	Problem	Probable Cause
Red or pink marks	Hands wet with water prior to processing; skin oil or perspiration	Overall unevenness	Solution level too low
		Poor color balance	Wrong filter pack
Red, pink, or magenta stains overall	1. Exhausted developer 2. Poor wash after bleach/fix 3. No prewet step 4. Paper wet before processing, possibly because of a drum not totally dry	Cyan cast	Developer contaminated with bleach/fix
Cyan stains	1. Paper fogged 2. Prewet or developer contaminated by bleach/fix	High contrast prints with cyan stain and/or cyan shadows with pink highlights	1. Overdevelopment due to solution being too concentrated, temperature too high, too much agitation, or too much time 2. Contamination of developer or prewet by bleach/fix
Dark and light streaks	1. Processing drum not level 2. Prewet omitted 3. Not enough agitation	Low-contrast prints with green shadows and magenta highlights	Underdevelopment due to solution being too dilute, temperature being too low, not enough agitation, not enough time, or developer exhaustion
Shadows with blue cast	1. Developer solution too dilute 2. Not enough drain time after prewet 3. Developing time not long enough	Yellow or green highlights	Temperature of prewet too high
Light print	1. Underexposure 2. Underdevelopment 3. (if extreme) Paper exposed on wrong side	Black marks, streaks, or spots	Developer sludge or rusty water
		Density varies from print to print	1. Voltage fluctuations 2. Inaccurate timer
Light spots	Air bubbles formed on surface because of inadequate agitation	Cyan cast on white border of the print	Fogging due to too much safelight exposure
Mottling; whites with a yellow cast	Out-of-date or poorly stored paper	Scratches in emulsion	Physical abrasion
Cream-colored borders rather than white borders	1. Developer mixed incorrectly 2. Developer temperature too high or time too long 3. Old paper		

Processing temperatures are critical, so keep the drum in a water bath when processing.

In total darkness, load into the drum the exposed paper, which should be curled with the emulsion side facing toward the middle.

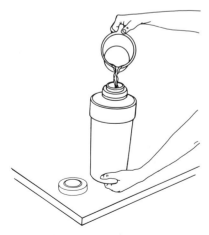

Pour solutions into the top of the drum and put the cap on.

1. Mix each solution in the processing kit in a separate beaker according to the manufacturer's instructions, which may vary with the brand of chemicals used. Wear plastic or rubber gloves to protect your skin and use very clean beakers or containers to hold the solutions. Fill one beaker with water (for a prewet) at the same temperature as the rest of the solutions.

2. Set up a water bath using a deep tray with water at a level just below that of the solutions in the beakers. Place all the beakers in the bath. Make the temperature of the bath a few degrees warmer than the recommended processing temperature; it will soon cool off to that temperature.

3. Make sure the drum is spotlessly clean (it should be washed and dried thoroughly after each use). Preheat the drum by filling it when it's empty with warm water (at the same temperature as the water bath), then immersing it in the bath. Wait a few minutes, then remove the drum from the water bath, pour out the water, and dry the inside of the drum thoroughly.

4. After exposing the paper (in total darkness), load it into the drum with the emulsion side facing toward the middle.

5. Close the drum and turn on the lights. Now you're ready to begin processing. Check the temperature of the developer solution. If it's too high, wait for it to reach the recommended temperature (or you can add cold water to the water bath or drop a plastic bag filled with ice cubes in the developer to help lower the temperature). If the temperature is too low, run hot water into the water bath to raise it.

6. Begin the processing, using the chart on page 168 as a guideline for times and temperatures with RA-4 processing. These may vary with the brand of chemicals used, so follow the kit manufacturer's recommendations.

 The first step with some kits is a water prewet. Fill the drum with water from the beaker and begin timing the process when the drum is filled. The prewet makes the temperature of the paper the same as the processing temperature. It also softens the emulsion so that it will absorb solutions more evenly.

7. Agitate the drum constantly for the entire prewet time. Good agitation technique ensures even results. Either roll the drum back and forth in a consistent motion along a surface or use a motorized unit to agitate it automatically. Motorized processors

are not too expensive, and they guarantee good agitation with minimal effort on your part.

8. Begin pouring the water out of the drum just before the time is up, making sure that it drains fully. Discard the water.

9. Immediately pour in the developer, using only the amount of solution recommended for the size drum you are using (regardless of the paper size). Start timing and agitate the drum as described in step 7.

10. Begin pouring the developer out of the drum just before the time is up and discard the solution.

11. Pour in the recommended amount of stop bath. Start timing and agitate the drum.

12. Drain the stop bath, beginning just before the time is up, and discard the solution.

13. Rinse the print with running water, dumping all the water from the drum when it fills to guarantee a fresh rinse. If you can't provide constant running water at the recommended temperature, fill a large beaker with water at that temperature and pour water from the beaker into the drum. Agitate the filled drum for about 30 seconds, drain it, then fill and drain it twice more.

14. Pour the recommended amount of bleach/fix into the drum. Start timing and agitate the drum.

15. Just before the time is up, pour out the bleach/fix, drain the drum, and dispose of the solution.

16. Open the drum and wash the print (follow washing instructions in step 13). Or remove the print from the drum and wash it in a tray with a siphon or in a print washer.

17. Dry the print. Be very careful when handling color prints, as they are delicate and damage easily, especially when wet. Place each print flat up against a piece of clean glass (or Plexiglass) hung on a wall or propped up at an angle to the counter or sink. Gently remove excess water from the back, then the front, of the print with either a squeegee or a photo sponge wet with water.

 For immediate drying, such as when you need to evaluate print density and color balance on the spot, use an electric print dryer or a hand-held hair dryer at a low temperature setting. Hold the hair dryer at least a foot away from the print and dry both sides with a steady, circular motion to ensure even results.

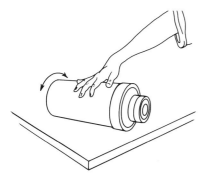

Agitate the drum manually by rolling it back and forth along a surface (or use a separate motorized unit for automatic agitation).

Wipe the print gently after washing, then use a heated dryer set at a low temperature or air dry it.

You also can air dry prints. This is usually the cleanest method of drying, since heated dryers often can become contaminated by poorly washed prints, especially in a school or other group darkroom. The major disadvantage of air drying is that it takes space and time (up to an hour or so for a fully dried print).

For basic air drying, hang squeegeed prints by one corner with film clips or spring-type plastic clothespins from a wire or string, as though you were hanging clothes to dry. Or you can use a drying screen—plastic screening stretched over a wooden, plastic, or aluminum frame. Lay the squeegeed print faceup on the screen until it dries.

Drying screens are available in some camera stores and from many mail-order sources. You can make a screen by using four pieces of 1" x 2" wood. Attach metal braces at each corner of the frame to keep it square. Then stretch fiberglass screening, which is available at hardware stores and lumberyards, across the frame and staple it taut.

18. Color-processing chemicals are especially sensitive to contamination, so wash and dry the drum and beakers completely. If possible, reserve one beaker for use with each chemical, especially for the developer and bleach/fix. Mark each beaker accordingly with a waterproof pen so you won't mix them up.

Fine-tuning the Print

Determining the correct exposure time, contrast, and filter pack are the most important steps in making a good color print. For the best results, however, you'll often need fine-tuning techniques such as burning in, dodging, and flashing.

All three techniques even out overall print density and reduce contrast by revealing detail in areas that would otherwise print too light (or sometimes even too dark). You also can burn in, dodge, or flash with filters other than those used in the filter pack to change the print color either selectively or overall.

Burning In and Dodging

Burning in when printing negatives refers to darkening selected areas of a print (while maintaining its overall density). To burn in an area, you add more light to it after making the initial exposure. (Areas can

be burned in before the initial exposure, but the results are usually better when you burn in after.)

Dodging when printing negatives is the opposite of burning in—lightening selected areas of a print. To dodge an area, you hold back the light while making the overall exposure. (Note that when printing from transparencies burning in lightens areas of the print and dodging darkens areas.)

The mechanics of burning in and dodging are similar for color and black-and-white printing. All involve waving an opaque mask in the path of the projected light. Commonly used masks include cardboard, prefabricated tools, and hands.

Prefabricated tools often don't match the shape of the area that needs burning in or dodging, so most photographers make their own tools out of pieces of cardboard. The pieces should be black or dark colored to minimize the likelihood of reflected light fogging the paper. For general use, cut several pieces of cardboard in various sizes and shapes (small and large squares, rectangles, circles, and ovals) for burning in or dodging at the corners and edges of a print. For burning in the middle of a print, cut holes of various sizes and shapes in the center of several pieces of cardboard. For dodging areas in the middle, tape suitably shaped cardboard to the end of a piece of thin, stiff wire.

For specific odd-shaped areas, you can custom-make a mask by laying cardboard on the easel, projecting the image onto the cardboard, tracing the shape, and cutting it out. Burn in or dodge by moving the cardboard very slowly just slightly above the printing paper. For burning in, the cardboard should be much bigger than the paper size, or you may inadvertently allow light in at the edges.

To decide whether burning in or dodging is required, make an initial print with good overall density, contrast, and color balance, then dry and examine it closely. Look for areas that are either too light or too dark. Follow these steps to burn in light areas:

1. Expose a fresh sheet of paper for the same time and with the same filter pack as the initial print. Let's say the correct exposure is 10 seconds at f/8.
2. Set the timer for the desired burning-in time, perhaps 20 seconds at f/8. (Tips for determining the time are provided on pages 177–178.)

When printing negatives, burning in selectively darkens areas of a print and dodging selectively lightens areas.

Burning-in and dodging tools may consist of a variety of prefabricated or handmade pieces of opaque cardboard (or some other mask) of various shapes and sizes. You also can cut board to match the shape of specific image areas.

The best way to add exposure to the middle of a print is by using an opaque piece of cardboard with a hole in it.

The best way to hold back exposure from an area in the middle of a print is by using an opaque piece of cardboard attached to the end of some thin, stiff wire.

3. Block the lens with a burning-in tool so that no light can reach the paper when the enlarger is turned on.
4. Turn on the enlarger light.
5. Carefully move the tool away from the lens to expose the areas of the paper in need of darkening. Keep the tool in motion at all times to blend the 20-second burn into the initial exposure. (A tool held steady will create a sharp line around the affected area.)
6. Repeat this procedure as often as necessary for prints that have several areas in need of darkening.

Ideally, only the burned-in areas will be affected by the additional exposure, and the overall density and color balance will remain the same as in the initial print. In practice, some extraneous light may bleed into the adjacent, blocked areas and affect the density and/or color balance of those areas.

If the initial print (with good overall density and color balance) has areas that are too dark, they can be selectively lightened by dodging. Follow these steps:

1. Expose a fresh sheet of paper for the same time and with the same filter pack as the initial print. Again, let's use 10 seconds at f/8 as an example.
2. During exposure, move a dodging tool into the path of the projected image for 2 to 3 seconds, or for whatever dodging time you determine is needed. The tool will block light from these areas and cause them to appear lighter when processed. Use the image on the easel as your guide and keep the tool in motion at all times to blend the new exposure into the initial one.

 Dodging times that are too short can cause uneven results, including obvious boundaries around the dodged areas. If this occurs, switch to a smaller aperture to increase the overall exposure and extend the dodging time. For example, if the initial exposure time is 6 seconds at f/8 with a 1-second dodge, close the lens to f/11 to allow a 12-second exposure and a 2-second dodge.
3. If more than one section of the print needs dodging, block light from different areas during the exposure. This may require fast maneuvering, especially if the exposure time is short. A longer overall exposure time will help; close the aperture and extend the time, as described in step 2.

BURNING IN

This print was exposed for 8 seconds at f/4.5 with a filter pack of 59Y + 52M. The bottom of the print has good overall density, but the area at the top is too light and needs burning in.

The final print, with even density overall, was made with the same initial exposure and filtration. The top third of the print was then burned in for 10 seconds, and the very top area (the dome—the brightest part) was burned in for 10 seconds more. Example by Jim Dow.

Burning in usually takes more time than dodging.

The amount of burning in and dodging required can vary widely, but burning in an area almost always requires more time than dodging. Sometimes a lot of extra exposure is required (especially with high-contrast subjects with bright highlights). With dodging, a relatively short time will almost always suffice.

Experienced printers often can look at the initial print and guess at how much burning in and dodging is necessary. Referring to the test print also may help if it shows a range of exposures for the areas that need burning in or dodging.

You also can make specific test prints for the areas needing attention. Let's say you make a print with good overall density using a 10-second exposure, but one corner is too light. Place a sheet of paper (or a scrap of paper if you're using a drum processor or a tabletop processor that takes scraps without jamming) in the easel at the corner that needs darkening. Make a test print in the corner only, with exposures at 15, 20, 25, and 30 seconds (or more, depending on how light the corner is). After processing, if the 30-second test exposure looks best,

make another print at 10 seconds overall, burning in the corner for an additional 20 seconds.

Rather than thinking of burning in and dodging in terms of pure exposure (number of seconds), look at it instead as a proportion of the initial exposure. Ten seconds of selectively added exposure, for example, is a 100 percent burn-in if the initial exposure is 10 seconds. However, 10 seconds represents a 200 percent burn-in with an initial exposure of 5 seconds.

Using the same reasoning, 2 seconds of dodging with a 10-second overall exposure represents a 20 percent dodge. The same 2 seconds with a 20-second overall exposure represents only a 10 percent dodge.

As mentioned previously, burning in requires more time than dodging. When burning in bright highlights or washed-out skies, for example, it's common to add 200 percent or more time to the initial exposure, whereas a 10 to 20 percent dodge will usually be enough to lighten dark areas of a print.

Dodging also has more defined limits than burning in. An area can rarely accept more than a 30 to 40 percent dodge. After that, the density differences between the overall exposure and the held-back areas become clearly visible. (For example, areas that should appear black will go gray, often with a distinct color cast.) However, light areas can usually be burned in for many times the overall exposure before such differences show up.

Reciprocity failure can have a noticeable effect on your final product, especially with burned-in areas. Printing paper's sensitivity to light slows down with long exposures, so long burning-in times have less effect proportionally than short times. For example, burning in 200 seconds with a 40-second initial exposure will darken an area significantly, but not as much as burning in for 50 seconds with a 10-second initial exposure—even though both represent a 500 percent change.

Reciprocity failure also may adversely affect the color balance in the burned-in and dodged areas. Changing the filter pack for burning in or flashing and waving filters during exposure can usually correct any such problems that might arise. These techniques are described below.

DODGING

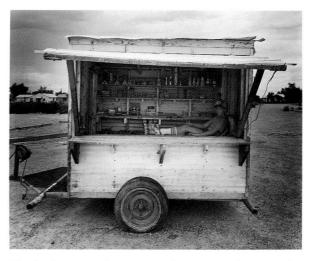

The initial print was exposed for 10 seconds at f/5.6 with a filter pack of 67Y + 66M. It has good overall density, but the inside of the cart is too dark and needs dodging.

The final print, with more even density overall, was made with the same initial exposure and filtration. However, during the exposure, the portion of projected light that exposed the cart's interior was blocked for 3 seconds to lighten that area. (There also was some burning in of the background to make these areas darker and more even.) Example by Jim Dow.

Burning In and Dodging to Change Color

The most common reasons for burning in and dodging are to darken and lighten selected areas of a print, as described. Both techniques also can be used to correct or alter color balance selectively. This may be necessary after burning in or dodging, because changes in exposure can alter color. It also may be used when the subject includes areas lit by more than one type of light source. If one part of the subject includes daylight from a window and another includes fluorescent light, for example, you can expose different sections of the paper with different filter packs to balance the overall color.

Burning in and dodging also can be used to control the color balance of selected areas of the print.

Personal taste also plays a role. Varying the filter pack allows you to alter color in selected areas simply because you prefer it that way— for example, to intensify the blue in a sky.

The procedure is similar regardless of whether you are burning in or dodging. Make the initial exposure, dodging the target area for the entire time; then change the filter pack and burn in that area. If the target area needs both darkening and a different color balance, you

can make the initial exposure without dodging, then change the filter pack and burn in.

Determining how to adjust the filter pack for burning in and dodging can be complicated and time-consuming. You may be able to estimate closely, but test prints provide a more accurate measure. Most likely you'll need a test to establish both an adjusted filter pack and an adjusted exposure time for each area in question.

Waving filters during exposure is a related technique that works a little like dodging. It involves moving a filter above the paper as it's being exposed to alter color in selected areas. (CP filters can be used for waving, but optical-quality CC filters are preferred whenever filters are placed directly in the image path.) For example, waving a blue filter across the shadow areas of the projected image will help reduce the shadow's blue cast. Waving a yellow filter in the path of projected sky areas will make the sky bluer.

As always, the denser the filter used, the stronger the effect will be. A 20Y filter will intensify a blue sky more than a 10Y filter will. In some cases, however, dense filters may hold back exposure and cause the area to print lighter. You must burn in the affected area, through the filter if necessary, to recover the lost density.

Flashing

Flashing is a technique that provides an even blanket of light over the entire print. You make the initial exposure, then remove the negative and briefly reexpose the entire sheet of paper to a burst of light. (You can reverse the order, flashing the paper first before exposing it through the negative, but the process usually works better when you flash last.)

Flashing reduces contrast throughout a print and adds tonality in highlights that are difficult to burn in.

There are two main reasons to flash a print—to reduce overall contrast and to add tonality in areas that would otherwise render too light or totally blank. Bright highlight areas with little or no detail cause the most problems. Burning in sometimes works in such areas, but it can be awkward in practice—for example, in areas that are small or irregularly shaped. It also can be time-consuming, especially if several areas of a single print need to be burned in.

Flashing accomplishes similar results by darkening highlight areas without appreciably affecting shadows. The net result is lower overall contrast—sometimes too low, so you should probably use a higher-contrast paper (if one is available) than you'd otherwise use for the flash.

BURNING IN TO CHANGE COLOR

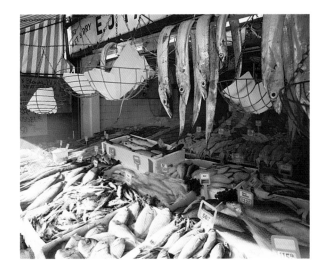

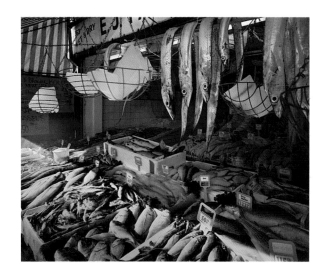

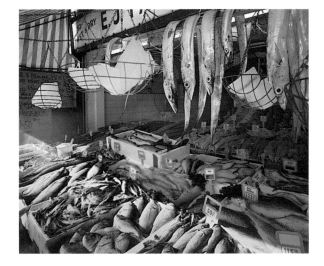

(Above, left) This print was exposed for 23 seconds at f/5.6 with a filter pack of 134Y + 74M. The top of the print has good overall density and color balance, but the area at the bottom left is too light and needs burning in.

(Above, right) A second print was made at the same exposure and filtration, and then the light area was burned in for 40 seconds more. The additional exposure produced even density overall, but the burned-in area was too yellow.

(Left) The final print, with even density and even color balance, was made with the same initial exposure and filtration. To reduce the yellow, 36Y + 16M was added to the filter pack (for a total of 170Y + 90M) when burning in. The additional filtration required a longer burning-in exposure—65 seconds rather than 40.
Example by Jim Dow.

When flashing, you should add 60Y + 40M to the filter pack to compensate for removing the orange mask of the negative, or flash with a blank orange mask, made from unexposed and processed negative film, in the film carrier.

Flashing times are generally very short, as little as 1 second or less. The exact amount of flashing is critical. Not enough exposure will have no appreciable effect, and too much will result in a dark and muddy print. Aim for the exposure that affects the highlight areas just enough to be noticeable. (See below for a test to establish that exposure.)

Closing down the lens aperture allows you to use longer flashing times, which makes the results easier to control and more repeatable. With short exposures, use a digital enlarging timer so that you can get precise increments of fractions of a second. (Nondigital timers can be used, but they aren't as accurate, especially at very short exposures.)

The negative's orange mask affects the color of light. Thus, when the negative is removed for flashing, the color equivalent of the mask must be added to the filter pack to compensate. You'll have to add approximately 60Y + 40M to the pack, although this can vary with different types of film.

For more precision, make your own blank orange mask and use it in place of the negative when flashing. To make the mask, process a roll (or sheet) of unexposed film, the same type as the negative being printed. After the initial exposure, remove the film carrier holding the negative and replace it with a film carrier holding the blank film. Throw the enlarger slightly out of focus and flash. (If you don't change the focus, scratches and dust marks on the blank film may show up on the print.)

The filtration used for flashing can be modified for effect. Adding less yellow and/or magenta to the filter pack will warm up the highlights. Adding more yellow and/or magenta will result in cooler highlights. As always, experiment for the best results. Follow these steps for flashing:

1. Make an initial print with good overall color balance and density. Let's say the exposure is 10 seconds at f/8 and the filter pack is 75Y + 30M.
2. Make a new exposure with a fresh sheet of paper. Use the same filter pack, but reduce the exposure time slightly (by about 10 percent, or 9 seconds at f/8). The reduced exposure time, which may need adjusting once you see the results, should compensate for the additional light from flashing.

FLASHING TO ADD HIGHLIGHT DETAIL

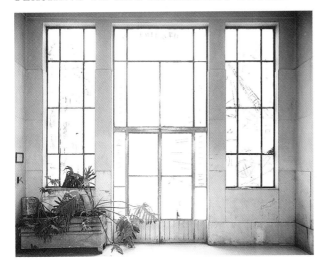 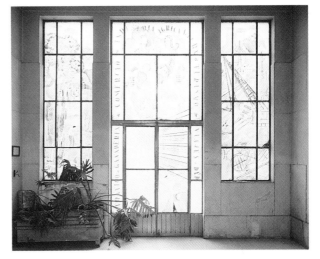

This print was exposed for 3 seconds at f/4.5 with a filter pack of 66Y + 59M. The wall has good density, but the backlit windows are much too bright. Burning in the individual windowpanes equally without darkening the molding would be extremely difficult. Flashing produces an even blanket of density over the entire area—an easier, more practical, and more repeatable option.

In the flashed print, the wall more or less retains the density of the initial print, and the window has much more density and detail. The initial exposure was the same (3 seconds at f/4.5, although slightly less exposure also could have worked), as was the initial filter pack (66Y + 59M). The negative was then removed from the enlarger, and to compensate for the lack of orange mask the filter pack was adjusted by 60Y + 40M for a final pack of 126Y + 99M. Then the lens was closed down to f/22 (to allow a longer flash) and the paper exposed for 2 seconds. Example by Jim Dow.

3. Store the exposed sheet of paper away from the light and run the following test to determine the correct flashing time.
4. Remove from the enlarger the film carrier holding the negative and close down the lens to f/16 or f/22. (Any f-stop can be used, but a small stop works best because it allows longer flashing times.) For the flashing exposure, put a film carrier holding a blank orange mask in the enlarger and throw the enlarger out of focus. (Or add 60Y + 40M to the original pack to compensate for the negative's orange mask, making the new filter pack in this example 135Y + 70M.)

.3

.6

.9

1.2

1.5

1.8

A flashing test shows several exposures. Look for the first signs of tone or color—here, at .6 seconds. The correct flashing time is the one just before that time—.3 seconds.

5. Set the timer for an initial exposure of .3 second if it's a digital model or 1 second if it's a nondigital model. These times are subject to adjustment depending on the results.

6. Do a test by placing a fresh sheet of paper (or a partial sheet if you're drum processing or if your tabletop processor allows it) in the easel and covering most of the paper with a piece of opaque cardboard.

7. Expose the uncovered portion of test paper to the light from the enlarger for the set time.

8. Move the cardboard to expose an additional section of the paper. This will give the first section twice the initial exposure.

9. Move the cardboard and expose the paper again. Now the section uncovered first will have three times the exposure, and the second section will have twice the exposure.

10. Keep uncovering and exposing the rest of the paper in sections.

11. Process and dry the paper and examine the results. The ideal flashing test will show a series of exposures from blank white to dark. If all the exposures are too dark, close down the lens and/or use a shorter time increment to make another test. If little or no exposure is produced, open up the lens and/or use longer exposure times.

 The correct flashing time is the exposure just *before* the one that shows discernible tone or color—.3 second in the accompanying example. When added to the overall exposure, this amount of flashing (though invisible here) will push the highlights of the print over the threshold of visibility.

12. Place the initially exposed paper (put away in step 3) in the easel and expose it to a flash of light for .3 second, as determined.

13. Process and dry the paper and inspect the results. A print that is too light may need a little more exposure time prior to flashing; a print that is too dark may need less time. If the print still has too much contrast or the highlight areas or shadows still have no tone, make another print with a longer flashing time. If the print is too flat and muddy, make another print with a shorter flashing time (and/or use a higher-contrast paper if available). You also may have to adjust the filter pack, since flashing can have an effect on the overall color balance, as well as on the color in the highlight areas.

Additive Printing

Almost all color printing is based on subtractive principles, with color formed by exposing a negative or transparency to light that is colored by a filter pack made up of various proportions of cyan, magenta, and/or yellow. A few color printing systems, however, use *additive* principles, which involve making three separate exposures to blue, green, and red filtered light in sequence. Additive printing is also called *tricolor printing*. (See Appendix 1 for more information on subtractive and additive principles.)

In additive printing, color balance is controlled by the relationships among the exposures of the three additive colors. For example, you might start printing a negative with exposures of 6 seconds of blue, 12 seconds of green, and 4 seconds of red. The amount of exposure and the proportions are determined by test prints, as with subtractive printing. If the resulting print is too cyan, to compensate you must decrease the amount of red (cyan's complement) exposure when printing negatives, or increase the amount of red when printing transparencies. Follow this chart:

If the print is too	With negatives	With transparencies
Red	Increase red	Decrease red
Green	Increase green	Decrease green
Blue	Increase blue	Decrease blue
Cyan	Decrease red	Increase red
Magenta	Decrease green	Increase green
Yellow	Decrease blue	Increase blue

You can use any type of enlarger for additive printing. But if you use CP filters in a filter drawer, you may inadvertently move the enlarger between exposures, which would result in blurry prints. Instead, place filters below the lens. Note that filters in the image path (below the lens) can have an adverse effect on image quality; if possible, use optical quality CC filters instead of CP filters. Also, to make exposure changes always adjust the exposure times rather than the aperture—again, by doing so you're less likely to move the enlarger during exposure.

Special additive enlargers (or additive color heads that fit onto black-and-white and modular enlargers) simplify the process considerably. Modern models are computer driven and use a strobe light source to precisely control and automate exposure through each color

"channel." They also may incorporate a color analyzer, memory functions, and other convenience features.

Additive printing is a matter of taste. It's capable of providing the same quality results as subtractive printing, no better or worse. Some printers simply prefer one system or the other—and most prefer subtractive systems.

Black-and-White Prints from Color Negatives and Papers

(Opposite)
Valorie Fisher, *Ilford Manor.*

Fisher shoots black-and-white film with a cheap plastic camera, which she modified so that all the exposures would overlap, with no lines between frames. "I wanted to be able to photograph an environment the way I experience it," she explains. "Walking through a garden, for example, I may notice the detail on a piece of stonework, and as I look up I catch a long view down a path, and following that path as it bends I discover the curve of a descending staircase. Walking through, these views present themselves, and one dissolves into another. That's what I wanted on film." Fisher prints sections of the roll, ranging from ½" to 10", using color paper and the RA-4 process. To simulate a color negative, she sandwiches the black-and-white negative with a piece of a clear orange mask made from processed, unexposed color negative film, then varies the filter pack for the desired monochromatic image color. For Ilford Manor, *Fisher used a filter pack of 64Y + 45M to produce a subtle green tint.*

There are several ways to make good black-and-white prints from color negatives. The best results usually come from special papers made for the purpose, either Kodak Ektamax RA papers (with RA-4 processing) or *panchromatic papers,* such as Kodak Panalure and Oriental Panchromatic.

Ektamax RA papers are handled like any paper for printing color negatives. You put the negative (either color or black-and-white) in the enlarger, set a filter pack (try 45Y + 45M with color negatives or 90Y + 60M with black-and-white negatives as a starting point), make a test print, and then make an enlargement, adjusting exposure and filtration as required.

Panchromatic papers are handled like any black-and-white printing paper. However, don't use a safelight unless absolutely necessary (and then only a dim one with a #13 filter for a very brief time). You can use filters when printing panchromatic papers in the same way you use camera filters when shooting black-and-white: for example, to darken skies, use a yellow, orange, or red filter in the enlarger; to lighten a blue sweater, use a blue filter. Panchromatic papers are available in more than one contrast grade.

Black-and-white prints also can be made from color negatives on standard black-and-white printing papers. You'll need long exposures and a high-contrast paper (or a high-contrast filter with variable-contrast paper). The results are generally acceptable, but you'll get some distortions because black-and-white papers have a very low sensitivity to red. As a result, red subjects may print unexpectedly dark.

You also can use RA-4–compatible color papers with black-and-white negatives to make black-and-white prints or *monochromatic* (one-color) prints with a color tint. For neutral black-and-white results, start with a filter pack of 120Y + 90M and adjust it as needed (as usual, the starting pack varies with the materials used and other factors). For a monochromatic print with a color tint, adjust the filter

pack the same way you would for color prints. To add a red tint, subtract magenta and yellow from the pack; to add a yellow tint, subtract yellow.

RA-4–compatible papers also provide an efficient way to make large black-and-white prints (16" x 20" or larger), if you have access to a tabletop processor that accommodates such sizes. Such processors are more convenient and less cumbersome than trays for processing large prints (trays being the usual method of processing black-and-white prints). Of course, you must consider the appearance of the final print; if you prefer the look of fiber-based black-and-white prints, for example, you may be disappointed, since color printing papers have RC (or polyester) bases.

Printing from Color Transparencies

Most photographers shoot negative film when they want to make prints. Negative films have more exposure latitude and less contrast than transparencies, and they are easier to color correct. However, you can get excellent prints from transparencies (assuming good exposure and close color balance) using one of two common methods. You can make an internegative from the transparency and print that, as you would print any negative. Or you can print the transparency without an intermediate step with a *reversal* process.

Internegatives

An *internegative* is a negative made from a transparency, usually by enlarging it onto a sheet of film (much the way negatives or transparencies are enlarged onto a sheet of paper). The process is complicated and requires too much experience (and equipment) for most individuals. For example, color balance, exposure, and processing must be monitored constantly. Rather than making your own internegatives, have them done at a professional lab and print them yourself (or have the lab print them for you).

One potential problem with internegatives from a lab is that they are usually made on 4" x 5" (or even 8" x 10") film, and many individuals don't have access to enlargers that handle negatives that large. Smaller internegatives are available from minilabs and labs that service convenience, department, and many camera stores, but the quality is generally second-rate. If you have internegatives made this way,

A 35mm transparency.

(Right) A 4" x 5" internegative (slightly reduced) from that transparency.

make sure you provide clean, dust-free slides, as a clean original is critical for good results. (Professional labs can generally be relied on to clean slides thoroughly before making internegatives.)

Regardless of how well they are made, internegatives are a generation removed from the original. Thus, they may produce prints with somewhat reduced sharpness and/or less accurate color. A good enlarger lens and critical focus are needed to come close to the sharpness of the original transparency. Special internegative films are designed to keep contrast under control, but a print from an internegative can rarely match the sharpness and color accuracy of a print made directly from a negative.

Reversal Printing

There are two methods for making prints directly from transparencies. One is the *Type R* (*R* for reversal) process, which is offered by various manufacturers; the other is *Ilfochrome* (formerly Cibachrome), which is a proprietary process. Both methods produce prints with notably greater sharpness than those made from internegatives.

Reversal printing is somewhat fussier than printing negatives (or internegatives). You must have excellent transparencies, with good overall density and fairly close color balance, to produce an excellent print. In particular, you can't get away with slightly dark or light originals the way you can when printing negatives. (You are a little better off with a slightly dark than a slightly light transparency, however.) Contrast also is a little harder to control with reversal printing.

Printing papers and chemicals for reversal processes (especially Ilfochrome) are generally more expensive than comparable RA-4 products. You may find printing from an internegative more economical, especially if you're making multiple prints from the same transparency.

Both Type R and Ilfochrome printing use many of the same mechanics as RA-4 printing. Basic procedures for making contact sheets, test prints, and enlargements and for burning in and dodging are similar. You also use the same type of equipment, such as a simple enlarger with CP filters or an enlarger with a color head as well as a processing drum or tabletop processor. Many enlargers offer a film carrier that takes mounted slides (or you can remove the transparency from its mount and put it in a standard film carrier). Processing drums handle papers for printing both negatives and transparencies, but most tabletop processors are made for either negative or transparency printing (although some can be set up to print either).

A number of the critical mechanical steps are reversed when printing from transparencies. For example, the longer you expose the paper, the lighter the resulting print will be. This affects both overall exposure and local changes, such as burning in and dodging. To darken an area, you dodge it; to lighten an area, you burn it in.

Adjusting color balance also is reversed. It's more logical. With transparencies, to make a print less magenta overall, you subtract magenta from the filter pack (or you add yellow and cyan). To make it more yellow, you add yellow (or subtract magenta and cyan).

Printing from transparencies also requires more exposure time and a stronger change to the filter pack than that used when printing negatives to achieve an equivalent effect. You'll often need about twice the time to get the same amount of print density and about twice the amount of filtration to adjust the color balance.

The same methods are used for evaluating the color balance of a final print whether you're printing transparencies or negatives.

Adjusting Color with Reversal Printing

If Print Is Too:	Either Subtract:	Or Add:
Blue	Magenta & cyan	Yellow
Yellow	Yellow	Magenta & cyan
Green	Yellow & cyan	Magenta
Magenta	Magenta	Yellow & cyan
Red	Yellow & magenta	Cyan
Cyan	Cyan	Magenta and yellow

Always dry a print before evaluating it and make sure the overall density and contrast are correct before trying to judge color balance. Use either experience, a ringaround, or a Kodak Color Print Viewing Filter Kit to evaluate color balance. With the viewing filters, be sure to use the side specified (the flip side of that used for evaluating prints made from negatives).

Following are general guidelines for changing the filter pack to adjust the overall color balance of a print from a transparency. Use these as starting points only and make further adjustments if necessary when you see the results. In-between units (such as 12Y or 27C) can be used, although small incremental changes probably won't have as much of an effect as they do when printing from negatives.

	DEGREE OF ADJUSTMENT		
If the Overall Color Is:	Slight	Modest	Extreme
Too red	+10C or −10M/−10Y	+20C or −20M/−20Y	+40C or −40M/−40Y
Too green	+10M or −10Y/−10C	+20M or −20Y/−20C	+40M or −40Y/−40C
Too blue	+10Y or −10M/−10C	+20Y or −20M/−20C	+40Y or −40M/−40C
Too cyan	−10C or +10M/+10Y	−20C or +20M/+20Y	−40C or +40M/+40Y
Too magenta	−10M or +10Y/+10C	−20M or +20Y/+20C	−40M or +40Y/+40C
Too yellow	−10Y or +10M/+10C	−20Y or +20M/+20C	−40Y or +40M/+40C

Type R. Type R processing for prints is similar in many ways to E-6 processing for film. It's a chromogenic process that activates dye couplers built into the paper to create the color image. The first developer creates a negative silver image, and the second developer reverses it to make a positive.

Kodak *R-3000* is the industry-standard Type R process for use by individuals. Several manufacturers offer R-3000–compatible printing papers and chemicals.

Originally, the Type R process was used to make inexpensive prints for amateurs—a quick and affordable alternative to making an internegative and a print. Early versions lacked sharpness and color quality and yielded high-contrast prints. Current Type R materials are much improved; they produce sharp prints with rich color and acceptable contrast. Still, most photographers who want to make high-quality prints from transparencies opt for making internegatives and prints or for using the Ilfochrome process.

Type R printing requires these basic steps: prewet, first developer, color developer, bleach/fix, and periodic water washes.

The R-3000 Process

Instructions for different R-3000 and compatible processing kits vary somewhat, but these are typical. For the best results, follow the instructions packaged with the specific kit you are using.

Step	Time (minutes)* at 100°F**
Prewet	1½
First developer	1½***
Wash	1¾
Color developer	2***
Wash	¾
Bleach/fix	1½***
Wash	2½
Drying	Varies****

*Includes the time it takes to drain the tank of solution.
**This temperature is recommended, but others can be used. Increase the time for lower temperatures and decrease it for higher temperatures. Instructions packaged with the processing chemicals provide the specific changes required for different solution temperatures.
***These steps are critical, and temperature should be varied no more than 1°F from that specified. Other solutions can have temperatures in a wider range (about 90°F to 100°F).
****This depends on the method of drying used. Heat drying generally takes 1 minute or so; air drying takes an hour or two depending on temperature and humidity.

Summary: Printing Transparencies versus Printing Negatives

Goal	Printing from Negatives RA-4 (C-print)	Printing from Transparencies R-3000 (Type R) P-30P (Ilfochrome)
For an excellent print	Negative density can be slightly off; often best when a little dense	Transparency density must be close to perfect; better slightly dark than light
To lighten a print overall	Decrease exposure	Increase exposure
To darken a print overall	Increase exposure	Decrease exposure
To darken a specific area	Burn in (add light to) the targeted area	Dodge (hold back light from) the targeted area
To lighten a specific area	Dodge (hold back light from) the targeted area	Burn in (add light to) the targeted area
To add a color overall	Subtract that color from the filter pack (or add its complement)	Add that color to the filter pack (or subtract its complement)
To reduce a color overall	Add that color to the filter pack (or subtract its complement)	Subtract that color from the filter pack (or add its complement)
To adjust the filter pack	Small changes are visible	Stronger changes are needed; about twice as much

Prewet. This is a brief water bath that softens the paper's emulsion so that it will absorb subsequent solutions more quickly and evenly.

First developer. This step converts exposed silver halide in each of the paper's three emulsion layers to metallic silver. Unexposed and undeveloped silver halide and color dye couplers are left untouched.

Color developer. An additional development chemically fogs (exposes) the remaining unexposed silver in the paper and simultaneously activates dye couplers built into each of the film's layers. It's the couplers that form the positive color image.

Bleach/fix. Here, the silver is converted to a soluble silver complex that can easily be washed from the paper, leaving only the color dye image. The bleach/fix requires absolutely fresh solutions. If it's weak, contaminated, or exhausted, it will produce a dull image color, stains, and/or a color cast.

Wash. The final wash step removes any remaining soluble silver complex. A thorough wash is critical for long-term print stability.

Ilfochrome (formerly called *Cibachrome*). Ilfochrome materials produce prints from transparencies with great sharpness and rich

color saturation. Two types are widely used for printing; one is a resin-coated paper, and the other has a polyester base. The resin-coated version closely resembles RA-4 and Type R papers in physical appearance. The polyester material is heavyweight and more expensive, and it has superior archival characteristics.

Surface and contrast choices vary with the base material. Generally, you have a choice of a glossy or pearl surface, with the glossy having more sharpness and color saturation. Contrast choices include normal, medium, and low, depending on whether you use the resin-coated or polyester version. Ilfochrome materials have a tendency to be high in contrast, so often you'll need to use a low-contrast material to achieve normal contrast.

It can be difficult to distinguish the emulsion side of Ilfochrome materials from the base side in the dark. With experience, you'll probably be able to identify which side is which by feel. But one certain way is to notice that the emulsion faces the information label located on the lighttight bag that holds the material inside its outer envelope

How Ilfochrome Forms Color

The method by which Ilfochrome materials form color is called *silver dye-bleach*. It differs markedly from chromogenic color, the method used by almost all other color films and papers.

The silver dye-bleach system uses an emulsion with three basic dye layers of complementary colors built in (one each of cyan, magenta, and yellow). During processing, the dyes that aren't needed are bleached away, leaving the desired positive color image. As with chromogenic processing, which produces its dyes during development, silver plays an intermediary role. Each emulsion layer contains silver halides in addition to a dye. Each silver layer is sensitive to one of the primary additive colors (blue, green, or red), which is linked to the appropriate complementary dye. Thus, the blue-sensitive layer contains yellow dye, the green-sensitive layer contains magenta dye, and the red-sensitive layer contains cyan dye.

Upon exposure, the silver in each layer responds to the amount of blue, green, and red light it receives from the projected transparency. The red-sensitive layer, for example, is highly affected by red light (and to a lesser degree magenta and yellow, the colors next to it on the color wheel); it is unaffected by cyan.

During development, the exposed silver in each layer is converted to a black metallic silver negative image (similar to what happens during black-and-white development). The amount of silver that builds up depends on the layer's color sensitivity. Thus, in the red-sensitive layer, a lot of density will build up in the areas where red light hits (magenta and yellow light will produce proportionally less density, and cyan will produce none).

Bleaching, the next step, removes color dyes in proportion to the silver density. Areas with a lot of density are bleached more heavily, leaving dyes that match the color of the transparency when the three layers are superimposed.

Bleaching also converts all the silver (developed and undeveloped) to silver halide for removal in the fixer, which is the final critical step.

Processing Problems: Ilfochrome Process

Following are some of the many problems that can occur with the Ilfochrome process, with their probable causes:

Problem	Probable Cause	Problem	Probable Cause
Black print but subtle image	No bleach used	Edges of print yellow	1. Inadequate agitation 2. Insufficient intermediate or final wash 3. Not enough solution used
Flat, yellowish print	No fixer used		
Flat, dark print	Underdevelopment		
Light print overall	1. Overdevelopment 2. Overexposure	Brown/red borders	1. Fixing time too short 2. Fixer contaminated by bleach 3. Insufficient wash
Dark print overall; fogged and flat	Fixed before bleached		
Light print overall; bluish cast	1. Developer too concentrated 2. Contaminated by fixer	Green borders	Paper expired or damaged by poor storage conditions
Orange cast overall; black areas seem blue	Developer contaminated by fixer	Arbitrary color streaks	1. Processing drum wet 2. Not enough solution used 3. Inadequate chemical coverage
Dark print overall with orange/red cast and backward image	Wrong side of paper exposed		
Flare; light marks	Paper fogged by stray light	Blue/white streaks across the print	Light entering processor
Gray areas; unevenly developed and bleached; streaks	Too little processing solution used		

or box. Another method is to cut off a small piece of the unexposed paper and look at it in the light; the emulsion side will appear brown or green and the base side white.

Ilfochrome is a relatively slow material, requiring at least 2 stops more exposure than RA-4 papers. This may make it easier for you to hold back light when adding density to an area, but it also may make exposures longer than you'd like them to be. One way around this is to use a brighter enlarger bulb, if available.

The Ilfochrome process requires only three steps (developer, bleach, and fixer). You can process Ilfochrome at a wide range of temperatures, including room temperature (or a little warmer), if you choose. This makes it easy to keep the solutions at an accurate and consistent temperature.

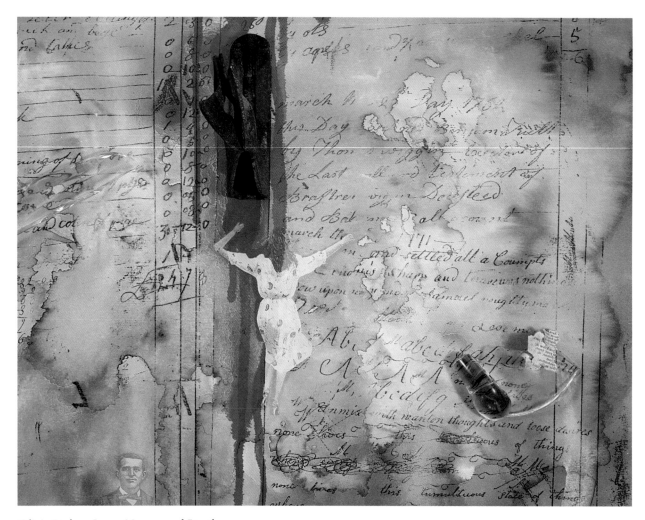

Olivia Parker, *Love, Money, and Death.*

Parker used reversal paper (Cibachrome, now called Ilfochrome) directly in her camera, rather than film, to make this photograph. The exposure was about 4 minutes, because of the paper's very low sensitivity to light. She used a yellow filter on the lens and a combination of yellow, orange, red, and blue gels on the three quartz lamps lighting the subject. "I like to combine text and images," she says. "Words add a dimension to it, yet it's important that the picture makes an impression before you start trying to read the words. We're such verbal creatures . . . we go right to the words. I hope in this case you see the picture as a whole, first."

P-30P Process for Ilfochrome

The *P-30P* process is standard for Ilfochrome materials. You can use a drum processor over a range of temperatures, as long as you adjust the timing of the main steps (developer, bleach, and fixer), or you can use a tabletop processor at 86°F for 2 minutes in each bath. As always, read the manufacturer's instructions carefully before proceeding. Following are times for drum processing.

Step	Time (minutes)* at 75°F**
Prewet	½
Developer	3
Wash	½
Bleach	3
Fixer	3
Wash	3
Drying	Varies***

*Includes the time it takes to drain the tank of solution.
**Temperatures are plus or minus 2°F.
***This depends on the method of drying used. Heat drying generally takes 3 minutes or so; air drying takes an hour or two depending on temperature and humidity.

Other solution temperatures can be used by changing the time of the developer, bleach, and fixer according to this chart (prewet and wash times are unaffected by varying the temperature).

Step	Time (minutes) At 68°F	At 71.5°F	At 79°F	At 84°F
Developer	4	3.5	2.5	2
Bleach	4	3.5	2.5	2
Fixer	4	3.5	2.5	2

Ilfochrome P-30P solutions can be used one time and thrown out or partially reused after each use (during a single session only). Reusing will approximately double the capacity of the solutions, but you must be very careful to follow the directions packaged with the chemicals. Poor reuse methods can lead to inconsistent results and print staining.

Never pour used Ilfochrome solutions directly down the drain. The P-30P bleach is corrosive and must be neutralized with the developer for safe disposal. See Appendix 3 for information on neutralizing the solutions.

Spotting Prints

Finished prints may contain blemishes such as scratches, dust marks, and fine lines due to imperfections in the negative or transparency. These can be covered up by *spotting* them with a fine-point brush and dye. (You also can use colored pencils for spotting. These do a good job of eliminating blemishes, but pencil marks may sit on the surface of the print and not blend in as seamlessly as dyes.)

Blemishes may show up even if you're extremely careful. However, you can minimize the amount of spotting needed by taking extra precautions to keep negatives and transparencies clean and scratch free. Treat them delicately during processing, store them safely in a closed container after processing, and touch them only by the edges or mounts (with slides). Always brush or blow off surface dust or dirt before printing.

Several types of dyes are available. Some come in dry form, for mixing with water, and others come as liquid solutions. Some are water soluble, and others are permanent. Most dyes can be used with any type of printing paper, even though some paper manufacturers may specify a particular dye (such as for Ilfochrome).

Dyes made for black-and-white prints can be used for much of the work in color print spotting. Use them to darken the area in need of spotting (and even add faint color with the green-gray, brown-gray, or blue-gray tints that come with black-and-white spotting kits). Sometimes the added density will be enough to hide the imperfection. At other times, it will add a base so that you'll need only a dab of color dye to finish the job.

Color spotting dyes are more expensive than black-and-white dyes, but both types will last for many years. They generally come in sets. Basic sets offer only a few colors, such as red, yellow, and blue, which can be mixed to produce virtually any other color. More elaborate sets offer many more dyes, making color mixing a little easier; they also may contain flesh tones and/or a variety of grays (which some spotters prefer to the grays in black-and-white spotting kits).

You'll need several tools for spotting. Working with dyes requires a fine-point brush, preferably one made of a high-quality material such as sable. Brushes come in numbered sizes; the finer the point, the lower the number. Thus, a #0 brush has a finer point than a #3. A #000 or #0000 is even finer; the finer points are recommended for spotting, especially for very small dust spots.

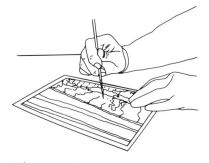

When spotting, put a scrap of test paper next to the areas needing attention and test the density and/or color of the dye on the scrap before applying dye to the print.

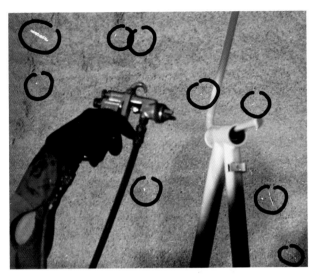

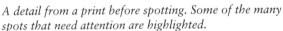

A detail from a print before spotting. Some of the many spots that need attention are highlighted.

Same detail after spotting.

A camel hair brush that is 2 inches wide or wider is useful in wiping dust off the delicate surface of color prints; an antistatic cloth also works well for this purpose. Use either the brush or the cloth gently, however, since the surface of the print scratches easily. To keep skin oils from staining the print surface, wear white cotton gloves (available in most camera stores) when handling prints. Dyes should be mixed in a white vessel, such as an art palette or a small ceramic or plastic plate.

A scrap of test paper will help you match the mixed dye to the blemish. For accurate color matching, use a piece from the white border of a previously processed print of the same paper type. A cup of water is needed for mixing the dyes. Soft tissues or disposable Photo Wipes (also available in most camera stores) can be used to blot the brush and protect the print surface.

Some blemishes are easier to spot than others. Small, round dust marks, for example, fill in without much trouble, but long, thin scratches are quite difficult. It's easier to spot when the image is grainy and a little soft than when it is fine grained and dead sharp. Areas with flat and even density, such as blue or light gray skies, can be particularly difficult to match. Probably the most common spotting problem occurs when the dye dries too dark. To avoid this problem,

Start spotting with a tone or color a little lighter than you need and build up the density and color until you get it right.

don't try for a match immediately; instead, start light and build to the needed density and color.

Spotting can be tedious. You have to be very patient, as rushing the process almost always leads to sloppy results. Specific techniques vary somewhat, but you can use the following steps as a guide:

1. Clean off a tabletop or counter in a well-lit area.
2. If you're using liquid dyes, pour a very small amount of each color into its own cup in the palette (or on a white plate) and wait until the dyes dry. (In dry form, dyes can be saved and reused for future spotting sessions.)
3. Mix the desired gray tone or color by wetting the spotting brush with a small amount of water and the appropriate dye(s). Never lick the brush with your tongue.
4. Test the mixed color on the test paper, positioned on the print next to the blemish. Begin with a density that's a little lighter than required and build up a gray density or color as you spot, blotting the brush as you go with tissues or Photo Wipes. Keep the brush from getting too wet; a dry brush helps the dye blend into the print surface and not spread beyond the targeted area. It also helps keep the spot from drying too dark.

 When applying the dye, gently touch the tip of the brush to the border of the test paper. Since dyes change color as they dry, wait a couple of minutes before comparing colors. Let dyes dry naturally, as blotting them may leave a noticeable mark.

 Fill in blemishes with tiny spots of dye from the tip of the brush; never try to fill them in with brush strokes.
5. If either density or color doesn't match, go back to the palette, remix the dye, and test again. When the density appears close but a little light on the test paper, you're ready to begin spotting the print.
6. Fill in the blemished area with the tip of the brush, using as many tiny spots as needed. Never use brush strokes. If the image has visible grain, try to imitate the grain pattern with the spots. Remember to keep the brush relatively dry at all times.
7. To build up the dye density, blot the brush and spot again. Or use a neutral gray (or green-gray or brown-gray tint) alone or mixed with the colored dye.

8. If the spotted areas look too dark or off-color, act fast to remove the dye and try again. Sometimes you can remove dried dyes by diluting the spotted area with a relatively dry brush (wet only with water) or by rewashing the entire print (only for water-soluble dyes). If all else fails, try applying a weak (5 percent) solution of nondetergent (no suds) ammonia to the area with a clean brush. This should lighten the spot or make it disappear in a minute or so. You'll have to wait until the ammonia dries before respotting. (You can buy ammonia at a drugstore and mix it with water to make the 5 percent solution.) Ammonia should not be used on Ilfochrome materials.

Spotting glossy surfaces is usually more difficult than spotting semimatte surfaces, since the dyes aren't absorbed as easily, and they may leave a dull spot when dry. Mixing the dyes with stabilizer solution may help them dry to a glossier finish. (The dullness won't show if the print is put under glass or plexiglass.)

With prints made from transparencies, blemishes often appear as black marks instead of white. Use white spotting dye or opaque, available at art supply stores, to whiten these areas. Then spot them in by building up the color and density as described.

Color Theory

Color originates in light, which is one of several types of energy. (Other types include heat, sound, and electricity.) Energy is described graphically along the *electromagnetic spectrum,* which charts the response of various sensory organs (in the case of photography, the eye), as well as photographic materials (films and papers) and other measuring devices. Most other forms of energy represented on the spectrum, such as gamma rays, microwaves, and television signals, have no direct bearing on photography.

Energy moves three-dimensionally, in an oscillating line, somewhat like waves on water. The distance from one crest to the next is described as a *wavelength.* Some wave crests are far apart—low-frequency radio waves, for example, are miles long—while others are extremely close. The entire span of visible light on the electromagnetic spectrum is tiny, measuring only 300 nanometers. A *nanometer* (nm) is 1 millionth of a millimeter (mm), and it takes 25mm to make an inch.

Different colors fall at different points along the visible-light portion of the electromagnetic spectrum. Cool colors, such as violet and blue, are on the lower end (measured at about 400 to 450 nanometers). Warm colors, such as yellow, orange, and red, are on the higher end (around 650 to 700 nanometers).

"Invisible" light also is represented on the electromagnetic spectrum by ultraviolet and infrared wavelengths. Both border visible light on the spectrum, and both have photographic applications and implications (actually all films are somewhat sensitive to UV light). On the short wavelength side of visible light is *ultraviolet (UV),* which sometimes produces a blue cast with color materials. Excess exposure to ultraviolet rays also may cause processed color materials to fade. On the long wavelength side of visible light is *infrared.* Special films that record infrared have long been used for scientific and creative purposes.

Light travels in the form of rays in a straight line through space. When it meets up with an object, several things might happen. It may bounce off that object; it may be absorbed; or it may be transmitted through the object itself. Most of the time, some combination of these events occurs.

Color is perceived according to the wavelengths that reflect off a material (or the wavelengths that are transmitted if the material is transparent). The rest of the wavelengths will be absorbed. Thus, in simple terms, a shirt is blue because it reflects blue wavelengths and absorbs other colors. An object that absorbs all wavelengths is seen as black; an object that reflects all wavelengths is white.

Forming Color: Additive and Subtractive

For photographic purposes, color can be formed by either adding or subtracting various wavelengths of

The Electromagnetic Spectrum

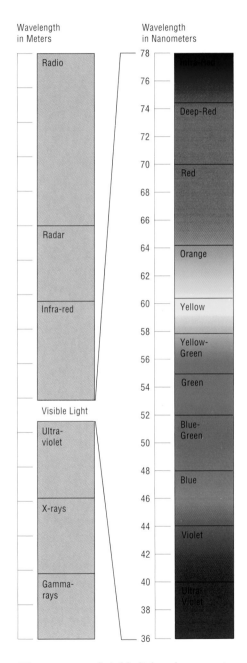

The spectrum of visible light takes up a tiny section of the total electromagnetic spectrum.

light. Blue, green, and red light, each representing about one-third of the visible spectrum, make up white light. Virtually any other color can be produced by combining (or adding) various proportions of these basic colors. Blue, green, and red light are called the *additive primaries*. Combining equal amounts of any two additive primaries produces the *subtractive primaries,* which are cyan (blue and green), yellow (green and red), and magenta (red and blue).

(The term *primary* shouldn't be confused with primary colors in pigments—for example, as they relate to painting—which are red, blue, and yellow and create color by subtractive means.)

A color wheel represents this relationship by sandwiching subtractive primaries between the additive colors that form them. *Complementary colors* are opposite each other on the color wheel. With additive color, mixing complementary colors in equal proportions produces white light; with subtractive mixing, equal proportions of complementary colors produce gray. Yellow is complementary to blue; magenta is complementary to green; and cyan is complementary to red.

To form color by subtractive means, you use filters to mix various proportions of the subtractive primaries. This has the effect of absorbing (subtracting) the complementary additive primary wavelengths from white light, leaving the desired color.

Subtractive primaries absorb one-third of the light spectrum and allow the other two-thirds to pass. For example, yellow absorbs blue and transmits red and green. Mixed in equal proportions, the subtractive primaries create black, because they absorb all the color of the spectrum. In varying amounts, they can create all colors.

For practical purposes, the net effect of the additive or subtractive methods of forming color is

Photographic color can be created according to additive or subtractive principles. The practical effect of either is similar, but the methods are very different. In additive color systems, various proportions of blue, green, and red (the additive primaries) light are mixed together to form any other color. Mixing any two of these colors in equal amounts produces a subtractive primary (cyan, yellow, or magenta). Mixing equal parts of all three additive primaries produces white light.

In subtractive color systems, cyan, yellow, and magenta (the subtractive primaries) filtration is mixed in various proportions to create any other color. The filters form color by absorbing (subtracting) complementary colors from white light. Mixing equal parts of all three subtractive primaries creates gray or black.

the same. Both mix disparate proportions of color together to create a similar choice of colors. One does so by adding color together, the other by subtracting colors from white light. The earliest color photography systems were based on additive principles. However, almost all modern color photography is based on subtractive principles.

Hue, Saturation, and Value

Several terms are used to describe the characteristics of a color. Hue, saturation, and brightness are the most common.

Hue is essentially a technical term for color. For example, a red object is said to be red in hue. Red, yellow, green, and blue are common hues, but there are many more combinations of these colors and tints. White, gray, and black have no hue.

Saturation (also called *chroma* or *intensity*) refers to color purity. The higher the saturation, the stronger and richer the color. The lower the saturation, the grayer it is.

Value (also called *brightness*) describes a color's overall lightness or darkness. It follows that light colors are naturally brighter than dark colors. Sometimes value is confused with saturation, but the qualities are actually quite different. Light hues can be high or low in saturation; the same goes for dark hues. For example, a highly saturated yellow has a much lighter value than a highly saturated blue.

Chromogenic Films

Virtually all modern color films are *chromogenic*. They are made up of three black-and-white emulsion layers with chemical agents called dye couplers built into each. (There are actually several layers, but three basic ones form the color.) Each layer

This "cross-cut" view of an Agfa color negative film was taken with an electron micrograph. It shows the three main dye layers of the film (cyan, magenta, and yellow) with interlayers in between. Modern color films actually have multiple layers. This film uses two dye layers to record each of the three primary colors. Courtesy Agfa-Gevaert AG, Leverkusen, Germany.

responds to part (about one-third) of the light spectrum. Typically the top layer is sensitive to blue light; the middle layer to green light; and the bottom to red.

In the first processing stage, the film turns into a three-layered black-and-white negative with silver built up according to the proportionate amount of exposure. For example, a "pure" red subject is recorded as dense silver in the red-sensitive layer, but with no density in the blue- or green-sensitive layers. Virtually all colors are made up of more than one of the three primary colors, so they cause a build-up of some density on the other layers as well.

As the developer oxidizes, the dye couplers in each layer are released to form dyes complementary to the color that layer is sensitive to. Thus, in the blue layer the coupler releases a yellow dye; in the green layer, a magenta dye; and in the red layer, cyan. The amount of dye formed depends on how much silver was developed in that layer; thus, the most dye forms on the red-sensitive layer in areas represented by strongly red areas of the subject. After the film has been developed and the color formed, the black-and-white emulsion is bleached away, leaving only the color dyes.

Archival Color

In time, all photographic images, especially those in color, are subject to fading and staining. They also may become brittle or suffer other forms of physical deterioration. *Archival* is a term often used to describe the long-term stability of photographic materials and processes. The goal is to produce film and prints with good archival qualities so they will last for a long time in their original state without noticeable deterioration.

In recent years, issues of image stability have become more pressing, driven in large part by the emergence of photography as collectible art. Anyone who buys art is likely to want assurance that what he or she collects will not disappear in a few years. For many years, most color photographs were considered too unstable to collect. Happily, this has changed. Modern color materials last much longer than materials available just a few years ago.

The archival characteristics of color transparencies, negatives, and prints are a function of many factors. These include the inherent stability of the materials used, the processing methods, and how they are displayed and stored. (Pages 216-217 list sources that offer products for archival display and storage. Also, the bibliography on pages 218-220 lists books with more information on this subject.)

Color photographs often fade over time. After approximately 25 years, this transparency has lost all of its cyan and yellow dye, leaving magenta only. Fortunately, most modern color films have improved longevity, although this varies considerably from film to film. Courtesy James Reilly/Image Permanence Institute, Rochester Institute of Technology.

Material Stability

The way that film and paper are made has a lot to do with how long an image will last. Some materials are intrinsically more stable than others; this is particularly so with color materials.

Film and paper consist of a light-sensitive emulsion layered on a base (or support) material. The base of most films is made of triacetate or polyester, both of which are considered quite stable. Most color papers have a resin-coated fiber base, which also is fairly stable but somewhat less so than a film base.

When problems arise, they are often due to deterioration in the emulsion, not in the base. The emulsion is usually a mixture of organic dyes, dye-producing agents, and silver halides. After the dyes are processed, they may undergo changes over time that can lead to fading and other forms of deterioration. Color materials have three (or more) dye-forming layers, and these usually fade at different rates, often causing a color shift as the overall relationship of one layer to another changes.

The dyes in some films and papers are inherently more stable than those in others, but it may be difficult to pin down specifics. Tests rating the archival quality of available films and papers are occasionally published in magazines and books. Although these ratings can be a useful guide, they aren't definitive and may become obsolete whenever new generations of films or papers become available.

Another factor is whether film and prints are stored in light or dark conditions. A film or print that keeps well in dark storage may deteriorate rapidly when displayed in the light, such as when laid out on a light table or projected, and a print with good light-storage characteristics may fade in dark storage.

Although you should be aware of these issues, you shouldn't base your choice of a particular film or paper on the supposed inherent stability of the product. When handled, displayed, and stored carefully, most modern color materials have very good to excellent archival characteristics, and future generations of materials should improve. When choosing a film or paper, first weigh characteristics such as speed, sharpness, and, most of all, color quality; then factor in archival concerns. If a photograph doesn't have the quality you want, there's little consolation in knowing that it will last a long time.

Processing

Processing procedures, such as an adequate wash, are critical to color image stability. You must monitor time and temperature carefully and keep the chemicals fresh and the processing equipment clean. Since so many photographers use professional labs to process color film and prints, however, these factors may be difficult for individuals to control.

Display and Storage

What happens to films and papers after processing is at least as important as their stability characteristics. Fortunately, this is a factor over which individual users have a lot of control. The following display and storage factors have the greatest effect on image stability: temperature, humidity, light, storage materials, and environment. Different films and papers can react to these factors in different ways.

Temperature

Temperature is a primary cause of the fading and staining of most color materials. High temperatures speed up detrimental chemical reactions, while low temperatures have the opposite effect. As a general rule, try to store processed film and prints in condi-

tions no warmer than 60°F to 70°F. This is not always possible, of course, but do keep storage conditions as cool as possible.

Some photographers protect their processed film and prints by freezing them in a sealed enclosure. Color materials can last indefinitely when frozen in conditions of low relative humidity (for example, in a frost-free freezer). You can use a heavy plastic bag made for this purpose or special vapor-seal envelopes (see pages 216-217 for sources). Insert one sheet of film or one print per bag or sleeve. (Some sources suggest using two bags for each sheet.) You'll also need some backing, such as thin (1- or 2-ply) mat board, for support, because film and paper can become brittle when frozen. Make sure the humidity is low (25 to 50 percent) when you put the package together, and squeeze out the air as you fold and seal the opening. Then place the bag or sleeve in the freezer. Let the package reach room temperature before removing frozen film or prints.

Humidity

High humidity accelerates harmful chemical reactions, which can lead to fading and staining. It also can cultivate the growth of fungi and cause gelatin in film and prints to soften and become vulnerable to physical damage. Low humidity can cause color materials to become brittle and possibly cause cracking and peeling.

Temperature and humidity are often linked, though not invariably. Hot days may bring high humidity; cold days may bring low humidity.

Storage conditions with a relative humidity of 25 to 50 percent are generally considered safe. Many museums and archives have humidity-controlled vaults to achieve this level. Individuals should use common sense. Don't display or store photographic materials in damp conditions, such

as most basements or on a bathroom wall (even an exterior bathroom wall).

Whatever the storage temperature and humidity, both should be kept as constant as possible. Fluctuations can cause damaging expansion and contraction of the emulsion.

Light

Exposure to light can cause color materials to deteriorate rapidly. As with heat and humidity, light accelerates chemical activity, which quickens the degradation process. The worst problems happen when slides are projected and prints are displayed. However, inadvertent exposure also can cause deterioration, such as when you leave unprotected transparencies, negatives, and prints around for several days without filing them away.

When projected, slides are especially subject to fading. A slide may show deterioration after only an hour or two of accumulated exposure, depending on the inherent stability of the film and the intensity of the light.

To be safe, use duplicate slides for projection and store the originals in the dark. Use a low-wattage bulb or the low-light setting on the projector. Also, keep exposure times short, preferably under 30 seconds. Slides are more likely to show deterioration when subjected to a constant amount of light than when projected for short periods of time, even if the accumulated exposure is the same.

When color prints are displayed, they are subject to damage from the light source. Both visible light and ultraviolet (UV) radiation are dangerous. Damage is cumulative; small amounts of exposure are usually not harmful, but deterioration will occur with time. Prolonged exposure to dim light may be more damaging than short exposure to bright light.

The best storage enclosures for negatives and transparencies are chemically inert, clear plastic envelopes and sleeves.

Different brands and types of color print materials vary widely, but most can last 20 years or longer under proper display conditions. Some materials are considerably more permanent.

UV is a prime culprit. Modern print materials have built-in UV filter layers for protection, but you still have to be careful. Sunlight and fluorescent light both have UV components. Tungsten light has much less UV. Whatever the light source, always use the dimmest amount that will adequately illuminate the print.

Prints lit by sunlight or fluorescent light should be protected behind UV-filtering Plexiglas. You can even put UV-filtering sleeves around fluorescent tubes to minimize UV exposure further. These products are available at some framing and hardware stores or through some of the mail-order suppliers listed on pages 216-217.

For further protection, make multiple copies of each print you plan to display and store them safely away. That way you can replace the original if and when it deteriorates.

Storage Materials

Processed film and prints should be stored in envelopes, sleeves, boxes, or other enclosures to keep them clean, away from physical harm, and in total darkness. For safest storage, use enclosures made of materials that won't react with photographic materials. Clear, chemically inert plastic envelopes or sleeves made of polyester, polypropylene, triacetate, or polyethylene are recommended for transparencies and negatives. Avoid glassine envelopes and clear polyvinyl chloride (PVC) sleeves; both can be damaging to their contents.

Clear plastic sleeves have other advantages. They allow you to edit and contact print without actually touching slides and negatives directly, making physical damage less likely. The openings in plastic sleeves also allow potentially harmful moisture to escape.

Some photographers store their slides in boxed Carousel trays. Although this doesn't allow for easy editing, it does provide a nonreactive storage container and good venting of moisture. Just be sure the Carousel box is made of nonreactive materials.

Prints should be stored in an opaque envelope or box that keeps out light and is made of material with a pH that is neutral or higher. The pH scale, a measurement of the relative acidity or alkalinity of a material, goes from 0 to 14. Zero is highly acidic, 7 is neutral, and 14 is highly alkaline. For archival storage, it's critical that the enclosure—and the mat board, if the print is stored with one—be acid free.

Some envelopes, boxes, and mat boards have alkaline buffering chemicals added to neutralize acidity or protect against acids that may material-

ize in otherwise acid-free mat board. Although buffered materials are acceptable for black-and-white print storage, only nonbuffered, acid-free enclosures should be used for color.

Many companies specialize in archival print envelopes and boxes. These materials also are useful for storing clear slide and negative sleeves; they help keep the slides and negatives organized and keep out light.

In general, envelopes, sleeves, boxes, and other storage containers made of the following materials are considered archivally safe for color film and prints:

> baked enamel on steel
> nonbuffered acid-free mat board or paper
> polyester
> polyethylene
> polypropylene
> triacetate

Avoid the following items and containers that include or are made of these materials:

buffered mat board or paper
oil-based paint
ordinary pulp board and paper
paper clips
polyvinyl chloride (PVC)
pressure-sensitive tape or other
 tacky adhesives
rubber bands
rubber cement
wood

Environment

Photographic materials can be damaged by polluted air and other environmental factors, particularly in urban areas. For protection, keep film and prints in closed but porous, archivally safe containers and away from fresh paint and other gaseous fumes. Particle matter, airborne grit, mold, smoke, and even insects can cause problems.

Institutions that collect photographs often use an air purifier or filtering system to protect against environmental hazards. Unfortunately, these precautions are beyond the means of most individuals.

Health and Environmental Hazards

Improperly handled photographic chemicals, especially those for color processing, can pose a threat to the health of darkroom workers and to the environment. Sometimes a chemical causes an immediate and identifiable effect, such as a burn from concentrated acetic acid. But often the effect may take years to develop, as with a skin allergy.

Good health today is no guarantee for the future. A single exposure or repeated exposures over a long period of time may be required for a chemical to have a harmful effect. Some chemicals may never cause harmful effects, even at high exposures.

Some of the milder acute health complaints associated with photographic chemicals include skin rashes, headaches, coughing, burning eyes, fatigue, and dizziness. Long-term and far more serious chronic damage to kidneys, liver, lungs, spleen, central nervous system, and other body parts also has been blamed on exposure to photographic chemicals, although responsible sources differ on the likelihood of normal darkroom use's causing such problems.

In fact, the long-term safety of some of the newer (and even some older) chemicals may not be adequately documented. It seems certain, however, that photographic chemicals have become somewhat safer in recent years. Manufacturers are using less-toxic chemicals and distributing more information about safe handling of their products. And individuals are more aware of potential problems and are taking more steps to behave safely.

Fortunately, there are many ways to minimize potential health and environmental risks. Some require only common sense; others call for more specific information and action. See pages 216-217 for a list of suppliers of safety and related equipment and the bibliography for sources and literature on health hazards.

Identifying Risk

Some individuals are more susceptible than others to the hazards of photographic chemicals. Those generally believed to be at higher risk include children, the elderly, smokers, heavy drinkers, and those with chronic diseases, such as lung, kidney, or heart disease. Allergy sufferers (especially asthmatics) and those with sensitivity to eye irritations or allergic skin reactions also may need to take special precautions. The same goes for pregnant women, especially those in their first trimester, and mothers who are breast-feeding; they should check with their physicians before working with any chemicals.

Individual susceptibility aside, risk depends on the relative toxicity of the chemical used and the total amount of exposure to it—how much of the chemical, how often, and for how long. Your goal should be to use the least-toxic chemicals

available and to minimize your cumulative exposure to them.

Some processing chemicals are more toxic than others. Two of the most toxic are a derivative of para-phenylenediamene, which is found in some color developers, and formaldehyde (or derivatives), which is found in stabilizers.

Chemical exposure can occur through inhalation, skin contact, and ingestion. The most commonly identifiable problems are from skin contact. However, vapors and gases from liquids and dust from powders can harm the respiratory system.

Minimizing Risk

Following are some specific suggestions for minimizing the risk of problems resulting from exposure to photographic chemicals. Most of these suggestions are just good common sense and can be applied to any chemicals with which you might come in contact, even those outside the darkroom.

Learn About Risks

You should get material safety data sheets (MSDSs) on all chemical products. These sheets provide health, safe handling, and first aid information in great detail. Manufacturers will supply you with MSDSs for their products on request.

Read all instructions and warnings on product labels and in MSDSs before mixing or using any photographic materials. If you have a specific health concern, such as an allergy, ask your doctor or the manufacturer. Many manufacturers have physicians or toxicologists on staff to answer questions from customers.

Store Chemicals Safely

Keep concentrated solutions stored in a cool, dry place and in their original containers. With diluted solutions, properly label the storage containers and keep them closed between uses.

To avoid confusion and accidental ingestion, never store the chemicals in containers previously used to store food or beverages, and never store chemicals in the refrigerator—unless the refrigerator is used solely for photographic materials. Also, store chemicals that react with each other in separate areas. (MSDSs include information on the reactivity and incompatibility of various chemicals.)

Chemically resistant plastic containers are the safest type for storage, since they won't break if dropped. If you do use glass containers, store them on low shelves, never above eye level or where you have to stretch to reach them.

If you have small children or pets, keep a lock on the darkroom or any areas where you store chemicals.

Housekeeping

Clean up chemical spills immediately. When they dry, spilled solutions containing dissolved solids may form airborne dust.

When mixing dry chemicals, empty containers gently to keep chemical dust from getting into the air. Also, wipe tabletops, benches, and shelves frequently to prevent the dust from building up. Chemicals in liquid form are generally safer to handle than chemicals in powder form, although many new powders are relatively dust free.

Never overheat solutions, as this can increase the release of toxic gases and vapors. Some primitive heating methods, such as aquarium heaters and hot plates, are unsafe because they can cause overheating or electric shock.

Skin Contact

Your skin acts as a protective barrier to prevent the absorption of many, but not all, harmful chemicals. Skin breaks such as cuts, sores, and abrasions result in less protection.

Some chemicals can cause allergic skin reactions similar to those caused by poison ivy, or they can cause irritations or burns at the point of contact. Some chemicals may even be absorbed by the skin and transported by the bloodstream to other parts of the body.

To prevent these problems, wear impervious gloves and clothing when mixing and handling chemicals. Single-use latex or plastic gloves, though better than nothing, usually don't provide adequate protection. Skin barrier creams are even less effective.

If skin contact does occur, wash skin thoroughly with soap and water and remove contaminated clothing and shoes. Wash and clean clothing and shoes before reusing them. Consult your doctor or get other medical attention if you notice any symptoms, such as a burn or rash.

Eye Contact

Wear eye protection when mixing or handling solutions or dry chemicals. Safety glasses with side shields, goggles, or goggles with a face shield may be best depending on the chemicals you're using. (MSDSs contain this information.)

In case of an eye splash, immediately flush your eye with water for at least 15 minutes. Again, consult your doctor or get medical attention if symptoms occur.

Some people believe that contact lenses absorb or trap airborne chemicals and shouldn't be worn in the darkroom. However, recent studies suggest that contact lenses may actually provide some protection. Certainly contact lenses alone aren't enough to protect your eyes from exposure to most photographic chemicals. Always wear them in conjunction with recommended eye protection.

Accidental Ingestion

Swallowed chemicals may be absorbed by the digestive tract. Nail biters and thumb suckers may inadvertently swallow solutions they've touched. The same goes for those who smoke, eat, or drink in the darkroom or where chemicals are stored; cigarettes, foods, and liquids can absorb chemical vapors or dust. Don't mix or use chemicals in the kitchen (or other food preparation areas), bathroom, or other high-traffic areas.

Handle retouching dyes with care. Never put a brush containing dye in your mouth or on your tongue.

Inhalation

Never process color materials in open trays. Use processing drums or tabletop processors and cover solutions when they aren't being used.

Masks or other respiratory protection are no substitute for proper ventilation. Disposable dust masks provide no protection from exposure to vapors or gases, and cartridge-type respirators can be uncomfortable and stressful to wear for extended periods of time. People with respiratory diseases, such as asthmatics, may even find that respirators make breathing more difficult. If you are considering using a respirator, check first with a physician. To ensure that a respirator will function properly, it should be fitted by a qualified professional. If you must wear a respirator, check the MSDS or contact the manufacturer to make sure you're wearing the right type for the chemicals you are using. The wrong respirator may actually do more harm than good.

Ventilation

Work only in darkrooms that are well ventilated. Adequate ventilation reduces the buildup of harmful gases and vapors so they are less likely to irritate the eyes and respiratory tract.

A darkroom should be a separate, dedicated room with windows or other openings to the outside to allow for ventilation. Makeshift arrangements in kitchens, bathrooms, bedrooms, and closets are inadequate for safe handling of photographic chemicals.

Air conditioners don't provide adequate ventilation. They are designed to remove humidity and recirculate the air rather than exchange it with a fresh supply. Bathroom fans may exhaust air, but not at a sufficient rate for darkroom use.

You'll need an exhaust fan to remove air contaminants, as well as an intake duct or louver to bring in fresh air. (Both the fan and intake vent must be lighttight.) Exhaust fans are rated in cubic feet per minute (cfm), according to their ability to remove air. A 1,000-cubic-foot room will need a fan rated at a minimum of 167 cfm for removal of air every 6 minutes. Air exhaust should be at a higher rate than air intake to prevent vapors or gases from escaping back into the room.

The amount of ventilation required depends on room conditions and what chemicals are in the air. Check the MSDSs or contact the manufacturers for recommended ventilation guidelines for the chemicals you are using.

These ratings assume maximum efficiency—well-placed and efficient fans and intake ducts. In practice, it's usually not possible to change the air in a room completely, so the efficiency of the ventilation system may be more important than the total number of changes. You may even need supplementary ventilation, such as an exhaust hood, for mixing or working with certain chemicals.

An efficient ventilation system brings fresh air into your working environment and draws fumes and dust away. The exhaust should be vented to the outside of the building and away from any air intakes.

Hot Lines

Keep these health, safety, and environmental hot line numbers on your darkroom wall in case of questions or a health emergency. Many hospitals and community health agencies also have medical hot lines. Consult your local telephone directory.

Agfa: (303) 623-5716
Ilford: (800) 535-9205; (800) 842-9660 (emergency)
Kodak: (716) 477-3194
Polaroid: (800) 225-1618; (617) 386-4846 (emergency)

Safe Waste Disposal

Some of the chemicals used in photographic processes are potentially hazardous to the environment. Waste-control systems are usually too expensive or impractical for individuals, so for the safest waste disposal you should use commercial labs for processing whenever possible. Labs are generally well equipped to dispose of materials safely.

Fortunately, most individuals use small quantities of solutions. Still, if you process film and prints yourself, you can take some precautions to minimize the impact of disposal, regardless of the volume. (Many communities have laws about hazardous-waste disposal for even small users. Check with your local authorities for specifics.)

Don't drain chemicals into a septic tank without the approval of the appropriate state or local agency. Never drain solutions into a natural water source, such as a pond or lake. Check with authorities for local guidelines when discharging into a sanitary sewer system. Some localities have hazardous-waste disposal sites, which may be appropriate for certain photographic chemicals.

When disposing of chemicals, don't discharge large amounts at any one time. To clear traps and local plumbing lines, run water into the drain for several minutes after slowly discharging each used solution. With Ilfochrome P-30P materials, neutralize the bleach before disposal by mixing the used developer in equal amounts with the used bleach, then mixing that solution in equal amounts with the used fixer that has had the silver removed.

Don't throw away any bottled chemicals in the household trash or at local dump sites without checking with waste officials. Also, rinse empty chemical containers thoroughly before throwing them away.

Silver Recovery

With color-processing materials, silver from film and paper accumulates in the bleach/fix. Pouring these solutions down the drain without silver recovery puts possibly valuable and harmful amounts of silver in the sewer system.

A silver recovery unit can prevent this loss. Commercial labs use large silver recovery systems that also may allow for recycling. The silver can then be sold and the fixer reused. The silver recovered from small amounts of fixer is minuscule, but large-volume users can sometimes realize cost savings from silver recovery.

A typical silver recovery unit consists of a holding tank with a steel wool or iron wire cartridge at the outlet. As used fixer is drained from the tank, it comes in contact with the cartridge, allowing silver to replace the iron, which ends up in the solution.

You can buy a small, inexpensive silver recovery unit or contact a service company to collect your used fixer for recovery. Check the yellow pages or a local lab to find out whether there is a recovery source in your area. Or ask the lab if it will accept used fixer for its own recovery system.

Resources

The following lists of mail and telephone sources for products, services, and information may be useful to anyone photographing or printing in color. For products and service, you can usually call or write for a free catalogue. Other information sources often have written materials they will send you for free or for a nominal price.

Products for archival storage, slide presentation, and framing
*Archival storage **Slide presentation ***Framing

Conservation Resources *
8000-H Forbes Place
Springfield, VA 22151
(800) 634-6932
(703) 321-7730
(703) 321-0629 fax

Gaylord Brothers *
Box 4901
Syracuse, NY 13221
(800) 634-6307
(800) 448-6160
(800) 272-3412 fax

Graphik Dimensions Ltd. ***
2103 Brentwood Street
High Point, NC 27263
(800) 221-0262
(910) 887-3700
(910) 887-3773 fax

The Hollinger Corporation *
Box 8360
Fredericksburg, VA 22404
(800) 634-0491
(703) 898-7300
(800) 947-8814 fax
(703) 898-8073 fax

Light Impressions */**/***
439 Monroe Avenue
Rochester, NY 14607
Box 940
Rochester, NY 14603
(800) 828-6216
(800) 828-9859
(800) 828-5539 fax

Pohlig Bros, Inc. *
Century Division
2419 East Franklin Street
Richmond, VA 23223-0069
Box 8069
Richmond, VA 23223-0069
(804) 644-7824
(804) 343-7530 fax

University Products *
517 Main Street
Holyoke, MA 01041
Box 101
Holyoke, MA 01041
(800) 628-1912
(800) 762-1165
(413) 532-9431
(800) 532-9281 fax

Wess Plastic **
70 Commerce Drive
Hauppauge, NY 11788
(800) 487-9377
(516) 231-0608 fax

Westfall Framing ***
Box 13524
2860 Industrial Plaza Drive
Tallahassee, FL 32317
(800) 874-3164
(800) 334-1652 in Florida
(904) 942-4935 fax

Mail-order books
*New **Used

Helix*
310 South Racine Avenue
Chicago, IL 60607
(800) 334-3549
(800) 621-6471
(312) 421-6000
(312) 421-1586 fax

Image Products*
7 East 17th Street
New York, NY 10003
(800) 367-4854
(212) 243-2306
(212) 243-2308 fax

International Center of
Photography*
1130 Fifth Avenue
New York, NY 10128
(212) 860-1751
(212) 360-6490 fax

The Maine Photographic Resource
2 Central Street
Rockport, ME 04856
(800) 227-1541
(207) 236-4788
(207) 236-8581
(207) 236-2558 fax

Photo-Eye */**
376 Garcia Street
Santa Fe, NM 87501
(505) 988-5152
(505) 988-4955 voice fax

Photographers Place */**
Box 274
Prince Street Station
New York, NY 10012
(212) 966 2356
(212) 941 7920

*Labs that offer processing for
out-of-production films*

HAS Images, Inc.
136 North St. Clair Street
Suite 300
Dayton, OH 45402
(513) 222-3856

Johns Hopkins University
School of Medicine,
Room 1–Pathology
Monument & Wolfe Street
Baltimore, MD 21205
(410) 955-3843

Pinkey's Photo Service
P.O. Box 1087
Little Rock, AR 72203
(501) 375-6409

Precision Photo Lab
5758 North Webster Street
P.O. Box 14595
Dayton, OH 45414
(513) 898-7450

Qualex, Inc.
220 Graceland
Des Plaines, IL 60016
(708) 827-6141

Rocky Mountain Film Lab
145 Madison Street*
Denver, CO 80206
(303) 399-6444

Sundance Photo, Inc.
Industrial Drive
Jackson, WI 53037
(800) 558-7818
(414) 677-2233
(414) 677-4801 fax

*Sources for health and safety
products and information*

Arts, Crafts, and Theater Safety
181 Thompson Street, #23
New York, NY 10012-2586
(212) 777-0062
(212) 673 4403

Best's Safety Directory
A. M. Best Company
A. M. Best Road
Oldwick, NJ 08858
(908) 439-2200
(908) 439-3296 fax

Center for Safety in the Arts
5 Beekman Street, Room 820
New York, NY 10038
(212) 227-6220
(212) 233-3846 fax

Fisher Scientific
711 Forbes Avenue
Pittsburgh, PA 15238
(800) 926-8999
(412) 562-8300
(412) 562-2675 fax

Lab Safety Supply
Box 1368
Janesville, WI 53547

(800) 356-2501
(800) 356-0783
(800) 356-0722
(800) 543-9910 fax

The Photographer's Catalog
890 Supreme Drive
Bensenville, IL 60106
(800) 225-8638
(708) 860-7105 fax

Wilson Safety Products
Box 622
Reading, PA 19603
(800) 345-4112
(215) 376-6161
(610) 371-7725 fax

*Manufacturer's technical and
professional product information*

Agfa
100 Challenger Road
Richfield Park, NJ 07660
(201) 440-2500

Fuji
514 South River Street
Hackensack, NJ 07601
(800) 669-3854 technical
(800) 385-3854 product

Ilford Photography
West 70 Century Road
Paramus, NJ 07653
(201) 265-6000 technical/product
(201) 599-4348 fax

Kodak Information Center
Department 841
R2-Riverwood
Rochester, NY 14650
(800) 242-2424 technical/product
(716) 724-5199 fax

Polaroid Corporation
784 Memorial Drive
Cambridge, MA 02139
(800) 225-1618 technical/product
(617) 577-3888 fax

Bibliography

Photography books can be difficult to find. Once they go out of stock, they often are not reprinted. Many of the best books are especially hard to find because they're published by small presses. Also, only the most well-stocked bookstores carry a good selection of photography books. (See pages 216-217 for a list of mail-order book firms that specialize in used and new photographic books.)

Photographic manufacturers publish many of the most useful books on craft and technique. Kodak is especially active in publishing, and many of its books and pamphlets address specific technical issues that are not well covered in general trade publications. For information about Kodak's publications, call the company's professional products information line: (800) 242-2424.

Most photographic magazines also cover product and technical information, as well publish portfolios, that may interest photographers working in color. Notable examples include *AmericanPhoto, Camera and Darkroom, Darkroom and Creative Camera Techniques, Petersen's Photographic, Photo District News, Popular Photography, Outdoor Photographer, View Camera,* and *Zoom.* Visually driven mass-market publications, such as *Harper's Bazaar, National Geographic, Rolling Stone, Sports Illustrated, Vanity Fair,* and *Vogue* also publish good color photography on a regular basis.

Because the technology changes constantly, many books on the techniques of color photography become partially dated soon after they're published. However, out-of-date books may still contain valuable information and remain useful, as long as you refer to product literature for current details.

Viewing photographs is one of the best ways to learn how to make them yourself. Go to museum and gallery shows whenever possible, and look at books of photography. Although there are too many to list them all, a selection of monographs by photographers whose work appears in this book is included in the monograph section that follows.

Craft and Technique

Current, Ira. *Photographic Color Printing: Theory and Technique.* Boston: Focal Press, 1987.

Eastman Kodak Co. *Basic Developing, Printing, Enlarging in Color.* Kodak Publication AE-13. Rochester, NY: Eastman Kodak, 1984.

———. *Color as Seen and Photographed.* Kodak Publication E 74. Rochester, NY: Eastman Kodak, 1991.

———. *Color Darkroom Dataguide.* Kodak Publication R-19. Rochester, NY: Eastman Kodak, 1994.

———. *Color Print Viewing Filter Kit.* Kodak Publication R-25. Rochester, NY: Eastman Kodak, 1994.

———. *Kodak Photographic Filters Handbook.* Kodak Publication B-3. Rochester, NY: Eastman Kodak, 1992.

———. *Photographic Retouching.* Kodak Publication E-97. Rochester, NY: Eastman Kodak, 1987.

Eckstein, Helene W. *Color in the 21st Century: A Practical Guide for Graphic Designers, Photographers, Printers, Separators, and Anyone Involved in Color Printing.* New York: Watson Guptill, 1991.

Evans, Ralph M., W. T. Hanson, and W. Lyle Brewer. *Principles of Color Photography.* New York: Wiley, 1953.

Evans, Ralph. *Eye, Film and Camera in Color Photography.* Melbourne, FL: Robert E. Krieger Publishing Co., 1979.

Feininger, Andreas. *Basic Color Photography.* Englewood Cliffs, NJ: Prentice-Hall, 1972.

———. *Successful Color Photography.* Englewood Cliffs, NJ: Prentice-Hall, 1975.

Gasson, Arnold. *The Color Print Book: A Survey of Contemporary Color Photographic Printmaking Methods for the Creative Photographer.* Rochester, NY: Light Impressions, 1980.

Glendinning, Peter. *Color Photography: History, Theory, and Darkroom Technique.* Englewood Cliffs, NJ: Prentice-Hall, 1985.

Hattersley, Ralph. *Beginner's Guide to Color Photography.* New York: Doubleday, 1979.

Hedgecoe, John. *The Art of Color Photography.* New York: Fireside Books, 1990.

Hirsch, Robert. *Exploring Color Photography* (second edition). Madison, WI: Brown & Benchmark, 1993.

Hunt, Robert William Gainer. *The Reproduction of Color.* New York: Wiley, 1967.

Liberman, Alexander. *The Art and Technique of Color Photography.* New York: Simon & Schuster, 1951.

Marvullo, Joe. *Color Vision: A Photographer's Guide to Understanding and Using Color.* New York: Watson-Guptill, 1989.

Mason, Robert G. *Color.* New York: Life Library of Photography, Time/Life Books, 1970.

Spencer, D. A. *Colour Photography in Practice.* New York: Amphoto, 1975.

Wall, E. J. *Practical Color Photography.* Boston: American Photographic Publishing Co., 1928.

Zakia, Richard, and Hollis N. Todd. *Color Primer 1 and 2.* Dobbs Ferry, NY: Morgan & Morgan, 1991.

History and Collections

Coe, Brian. *Colour Photography: The First Hundred Years.* London, U. K.: Ash & Grant, 1978.

Coote, Jack H. *The Illustrated History of Colour Photography.* Surrey, U.K.: Fountain Press, 1993.

Eauclair, Sally. *American Independents: Eighteen Color Photographers.* New York: Abbeville Press, 1987.

Friedman, Joseph S. *History of Color Photography.* London, U.K.: Focal Press, 1968.

Mees, C. E. Kenneth. *From Dry Plates to Ektachrome Film: A Story of Photographic Research.* New York: Ziff-Davis, 1961.

Sipley, Louis W. *A Half Century of Color.* New York: Macmillan, 1951.

Sobieszek, Robert A. *Color as Form: A History of Color Photography.* Rochester, NY: International Museum of Photography at George Eastman House, 1982.

———. *The Art of Persuasion: A History of Advertising Photography.* New York: Abrams, 1988.

Wall, E. J. *The History of Three-Color Photography.* Boston: Focal Press, 1970.

Wood, John. *The Art of the Autochrome: The Birth of Color Photography.* Iowa City, IA: University of Iowa Press, 1993.

Monographs

Callahan, Harry. *New Color: Photographs 1978–1987.* Kansas City, MO: Hallmark Cards/University of New Mexico Press, 1988.

Dow, Jim. *Dream Fields* (calendar). San Francisco: Chronicle Books, 1994.

Fellman, Sandi. *The Japanese Tattoo.* New York: Abbeville Press, 1986.

Goldin, Nan. *The Ballad of Sexual Dependency.* New York: Aperture, 1986.

Graham, David. *Only in America: Some Unexpected Scenery.* New York: Alfred A. Knopf, 1991.

Groover, Jan. *Photographs.* Boston: Bulfinch Press, 1993.

Grossfeld, Stan. *The Whisper of Stars: A Siberian Journey.* Boston: Globe Pequot Press, 1988.

Haas, Ernst. *Ernst Haas: Color Photography.* New York: Abrams, 1989.

Harris, Alex. *Red, White, and Blue and God Bless You: A Portrait of Northern New Mexico.* Albuquerque: Center for Documentary Studies/University of Mexico Press, 1992.

Horenstein, Henry. *Baseball Days.* Boston: Bulfinch Press, 1993.

Jacobson, Jeff. *My Fellow Americans....* Albuquerque: Picture Project/University of New Mexico Press, 1991.

Leibovitz, Annie. *Photographs: Annie Leibovitz: 1970–1990.* New York: HarperCollins, 1991.

Demarchelier, Patrick. *Fashion Photography.* Boston: Bulfinch Press, 1989.

MacLean, Alex. *Look at the Land: Aerial Reflections on America.* New York: Rizzoli, 1993.

Maisel, Jay. *On Assignment.* Washington, DC : Smithsonian Institution Press, 1990.

Mapplethorpe, Robert. *Flowers.* Boston: Bulfinch Press, 1990 .

Mark, Mary Ellen. *Falkland Road: Prostitutes of Bombay.* New York: Alfred A. Knopf, 1981.

Metzner, Sheila. *Color.* Altadena, CA: Twin Palms, 1991.

Misrach, Richard. *Desert Cantos.* Albuquerque: University of New Mexico Press, 1987.

Parker, Olivia. *Under the Looking Glass.* Boston: New York Graphic Society, 1983.

Porter, Eliot. *Eliot Porter.* Boston: New York Graphic Society, 1987.

Slavin, Neal. *When Two or More Are Gathered Together.* New York: Farrar, Straus, Giroux, 1976.

Staller, Jan. *Frontier New York.* New York: Hudson Hills Press, 1988.

Tenneson, Joyce. *Transformations.* Boston: Little, Brown, 1993.

Wegman, William. *Man's Best Friend.* New York: Harry N. Abrams, 1982.

Wolfe, Art. *The Kingdom.* San Francisco: Sierra Club Books, 1990.

Archival

Appelbaum, Barbara. *Guide to Environmental Protection of Collections.* Madison, CT: Sound View Press, 1991.

Eaton, George T. *Conservation of Photographs.* Kodak Publication F-40. Rochester, NY: Eastman Kodak, 1985.

Image Permanence Institute's Storage Guide for Acetate Film. Rochester, NY: Image Permanence Institute, 1993.

Keefe, Laurence E., and Dennis Inch. *The Life of a Photograph: Archival Processing, Matting, Framing, Storage.* Boston: Focal Press, 1990.

National Committee to Save America's Cultural Collections. *Caring for Your Collections.* New York: Abrams, 1992.

Polaroid Corp. *Storing, Handling, and Preserving Polaroid Photographs: A Guide.* Boston: Focal Press, 1983.

Reilly, James M. *Care and Identification of 19th-Century Photographic Prints.* Kodak Publication G-2S. Rochester, NY: Eastman Kodak, 1986.

Rempel, Siegfried, *The Care of Photographs.* New York: Lyons and Burford, 1987.

Wilhelm, Henry, and Carol Brower. *The Permanence and Care of Color Photographs: Traditional and Digital Color Prints, Color Negatives, Slides, and Motion Pictures.* Grinnell, IA: Preservation Publishing Co., 1993.

Health, Safety, and Environment

Clark, N., T. Cutter., and J. A. McGrane. *Ventilation: A Practical Guide.* New York: Nick Lyons Books, 1987.

Eastman Kodak Co. *Photolab Design.* Kodak Publication K-13. Rochester, NY: Eastman Kodak, 1989.

———. *Safe Handling of Photographic Chemicals.* Kodak Publication J-4. Rochester, NY: Eastman Kodak, 1979.

Freeman, Victoria, and Charles G. Humble. *Prevalence of Illness and Chemical Exposure in Professional Photographers.* Durham, NC: National Press Photographers Association, 1989.

Ilford Corp. *Disposal of Photoprocessing Wastes.* Paramus, NJ: Ilford, 1992.

———. *Procedure for Neutralizing Ilford, Ilfochrome Classic and Ilfochrome Rapid Bleach Solutions.* Paramus, NJ: Ilford, 1994.

McCann, Michael. *Artist Beware.* New York: Lyons & Burford, 1992.

Seeger, Nancy. *A Photographer's Guide to the Safe Use of Materials.* Chicago: The Art Institute of Chicago, 1984.

Shaw, Susan D., and Monona Rossol. *Overexposure: Health Hazards in Photography.* New York: Allworth Press, 1991.

Tell, Judy (ed). *Making Darkrooms Saferooms.* Durham, NC: National Press Photographers Association, 1988.

Color Theory

Albers, Josef. *Interaction of Color.* New Haven: Yale University Press, 1975. *(Also available on CD-Rom)*

Arnheim, Rudolf. *Art and Visual Perception: A Psychology of the Creative Eye.* Berkeley: University of California Press, 1993.

von Goethe, Johann Wolfgang. *Theory of Colours.* Cambridge: M. I. T. Press, 1970.

Glossary

1A filter. See skylight filter.

additive. Method of reproducing color by mixing various proportions of blue, green, and red light.

additive primaries. Blue, green, and red as they relate to light and photography; typically, dyes in layers of negatives, transparencies, and prints that form color.

additive screen. Method of producing color photographs using a screen of microscopic lines or particles of translucent blue, green, and red dyes.

AE. Autoexposure (automatic exposure).

air bells. Unwanted dark or light spots that form in negatives or transparencies during processing due to air bubbles on the film's surface.

analyzer. Instrument that reads the density and color of the negative or transparency and recommends a workable print exposure and filter pack.

AP4. Agfa designation for its version of the industry-standard color transparency process—Kodak E-6.

AP-70. Agfa designation for its version of the industry-standard color negative process—Kodak C-41.

aperture. Opening formed by an adjustable diaphragm inside a photographic lens, controlling exposure and depth of field.

aperture priority. Autoexposure mode available on many cameras with built-in meters. The photographer sets the aperture (f-stop), and the camera chooses the shutter speed needed for the correct exposure.

archival. Used to describe the long-term stability of photographic materials and processes.

automatic exposure (AE). Exposure mode available on many types of cameras in which aperture, shutter speed, or both are automatically set by the camera.

averaging meter. Meter that averages all the light values it reads to determine exposure.

bicolor polarizing filter. Type of camera filter used to tint the entire image by blending the two colors of the filter to create a variety of colors in between.

bleach/fix. Solution used in color film and print processing. The bleach/fix removes all the silver left in the film or paper, including the metallic silver used to produce the dye image and the unexposed and undeveloped silver compounds, leaving only the dye image. Bleach/fix also is called blix.

blix. *See* bleach/fix.

bracketing. Technique of shooting different exposures of the same subject to help guarantee the best possible results. To bracket, you make an initial exposure based on the suggested meter reading (and any necessary adjustments), then make additional exposures allowing in more and less light while using the exact same framing.

brightness. A color's overall lightness or darkness. Brightness is sometimes referred to as value.

burning in. Darkening selected areas of a print (or lightening in the case of reversal printing) while maintaining its overall density. Burning in is the opposite of dodging.

C-41. Kodak designation for its industry-standard color negative process.

C-print. Print made from a negative.

CC filter. See color compensating filter.

center-weighted averaging meter. In-camera meter that measures light across the entire viewfinder area, giving more weight to the center portion when suggesting or setting exposure.

changing bag. Lighttight sack or flexible enclosure that holds film, reel, and tank and provides sleeves to put your hands in. Changing bags allow film to be loaded for processing in room light. A changing bag also may be used for loading sheet film into film holders in room light.

chroma. *See* saturation.

chrome. Slang for a processed transparency of any format.

-chrome. Suffix attached to trade names of transparency films and transparency-to-print papers.

chromogenic. Process of creating color with dye couplers in layers of films and papers that are released during processing.

Cibachrome. Reversal printing material based on dye-destruction principles. Introduced in 1962, Cibachrome is now known as Ilfochrome.

circular polarizer. Type of polarizing filter needed for correct operation of certain types of through-the-lens metering and autofocusing systems.

clip test. Technique of cutting a small section from the beginning of a roll, processing that section, examining the results, and adjusting the developing time, when necessary, to obtain correct density for the rest of the roll (or rolls). Sometimes referred to as a snip test.

CN-16. Fuji designation for its version of the industry-standard color negative process—Kodak C-41.

cold-light head. Enlarger head that uses fluorescent tubes as a light source. Cold-light heads are used mostly in black-and-white photography.

-color. Suffix attached to trade names of negative films and negative-to-print papers.

color cast. Shift of the overall image color from neutral toward warm, cool, or any specific color.

color compensating filter. Type of camera filter used to control the balance of specific colors in the final transparency or negative. Color compensating filters also are known as CC filters.

color conversion filter. Type of camera filter that produces strong changes in the color temperature of light. There are two types of conversion filters—the 85 series (orange) and the 80 series (blue).

color coupler. *See* dye coupler.

color crossover. Condition that occurs when contrast among the three processed dye layers is inconsistent to the point where corrective filtration can't produce neutral color.

color head. Enlarger head that contains a quartz-halogen lamp; built-in cyan, magenta, and yellow dichroic filters; and a diffusion chamber to mix the filtered light.

color meter. Meter that measures the color temperature of the light and recommends filtration to match the light source with the type of film being used.

color polarizing filter. Type of camera filter used to tint the entire image with the filter color. The tint becomes more or less intense as the filter is turned.

color printing filter. Printing filter that is similar in effect to a color compensating filter but lower in quality. Color printing filters also are known as CP filters.

color temperature. Numerical description of the color of light. Color temperature is measured on the Kelvin scale.

color wheel. Circular representation of additive (blue, green, red) and subtractive (cyan, magenta, yellow) primary colors.

complementary colors. Colors that create neutral density when mixed in equal proportions. Magenta is complementary to green, yellow is complementary to blue, and cyan is complementary to red.

condenser. Simple, convex lens used in condenser enlargers to direct and even out light. Condenser enlargers are usually used for black-and-white printing, although they can be used for color as well.

contact print. Print that is the same size as the negative from which it's made. Contact prints are made by sandwiching a negative or transparency between a sheet of printing paper and a piece of glass, then exposing the paper to light and processing it.

contact sheet. Full sheet of contact prints—for example, from a roll of 35mm negatives.

contrast. Difference in brightness or density between dark and light values in a subject, transparency, negative, or print.

CP filter. *See* color printing filter.

CR-56. Fuji designation for its version of the industry-standard color transparency process—Kodak E-6.

cross processing. Processing transparency film in C-41 chemicals to produce negatives or processing negative film in E-6 to produce transparencies for special effects.

cyan. Blue-green; one of the subtractive primary colors.

daylight balance. Film and lighting are matched for 5500K, the color temperature of an average sunny day at noon.

density. Description of the degree to which silver or dye deposits transmit or reflect light. A dark print, for example, is denser than a light print.

depth of field. Depth of the zone of sharpness in an image from front to back.

dichroic filter. Type of filter that comes with color heads. Dichroic filters are easy to use and less liable to fade than CP filters.

diffraction filter. Type of special-effects camera filter with surface ridges that diffract light to create patterns of rainbow-colored bands.

diffusion enlarger. Type of enlarger that evens out the light passing through the negative or transparency with a translucent screen or mixing chamber. A form of diffusion system is used in color heads and is generally preferred for color printing.

dip-and-dunk. Method of processing used by professional labs in which film is loaded on reels or hung on racks, then lowered into a succession of open tanks of solution. Agitation is achieved either manually or with jets of gas.

discontinuous light. Light source with missing wavelengths that is likely to produce strong and unpredictable color casts. Common discontinuous light sources include fluorescent, mercury vapor, and sodium vapor lamps.

dodging. Lightening selected areas of a print (or darkening in the case of reversal printing). To dodge an area, you hold back light during the overall exposure. Dodging is the opposite of burning in.

drum. Lighttight plastic cylinder that holds paper (or film) and allows processing solutions to be added and drained out in room light. Drum processing is the most affordable method for most individuals to print color.

dupes. Duplicate transparencies.

dye clouds. Pattern of dyes that materialize around the silver particles in color films during processing. Dye clouds remain after the silver is gone, "remembering" its grain pattern. They create the grain effect in a color negative or transparency.

dye coupler. Chemical that forms a color complementary to the color of the light striking the film or paper layer. Dye couplers are created during processing and also are called color couplers.

dye transfer. Obsolete Kodak process for making color prints that provided excellent color fidelity and image stability.

DX. Bar code indicating film speed imprinted on the film cassette, allowing cameras with a DX-code reader to set the speed automatically.

E-6. Kodak designation for its industry-standard color transparency process. Almost all modern transparency films are processed in E-6 or compatible chemicals.

EI. *See* exposure index.

electromagnetic spectrum. Representation of various forms of energy in wavelengths, such as light, gamma rays, microwaves, and television signals.

emulsion batch. Specific lot in which a film emulsion is manufactured. Each batch is subject to minor variations in color, speed, and contrast.

EP-2. Kodak designation for discontinued industry-standard color negative printing process. The EP-2 process was replaced by RA-4.

evaluative meter. *See* multisegment meter.

exposure compensation. Option on many cameras that allows adjustment of overall exposure in autoexposure mode. A setting of +1, for example, adds 1 stop of exposure to the camera-selected exposure, and a setting of –1 reduces exposure by 1 stop.

exposure index (EI). Film speed rating that varies from the manufacturer's recommended setting, as when push- or pull-processing.

exposure latitude. Margin for error in film exposure. Exposure latitude varies with film type and lighting conditions.

f-stop. Measurement of lens aperture. The larger the f-number, the smaller the lens opening.

filter. Sheet of glass, gelatin, or plastic that is usually tinted and may be used when photographing and printing, usually to adjust color or exposure or to create special effects.

filter factor. Numerical value indicating how much additional exposure is needed when using a particular filter.

filter pack. Combination of filters that allows you to adjust the color balance of a print (or, when used on the camera, to adjust the color balance of the film).

flashing. Technique in which the entire print is given a slight overall exposure in addition to the initial image-forming exposure to light to add detail to highlights, reduce contrast, or control color.

gel. *See* gelatin filter.

gelatin filter. Type of nonthreaded filter made of flexible gelatin that comes in individual square sheets of various colors, types, and sizes. Gelatin filters are excellent optically, but they are thin and fragile and must be handled with care. Gelatin filters also are called gels.

graduated filter. Type of filter that is half clear and half colored, with the colored half gradually becoming less dense as it meets the clear half. Graduated neutral-density filters work in a similar way, but they selectively reduce exposure in their portion of the picture rather than add color.

grain. Clusters of silver crystals created by development from light-sensitive silver compounds. Grain in color film shows up as dye clouds, which are left when silver is removed during processing.

gray card. Medium-gray card designed for determining exposure that reflects 18 percent of the light that strikes it. In most cases, meter readings from a gray card held in the

same light as the subject should produce correct film exposure.

hand-coloring. Creating color by applying pigments, oils, watercolors, and other substances to the surface of a monochromatic print.

HMI. Daylight-balanced hot light.

hot light. Studio light that remains on during setup and exposure (as opposed to strobes, which go off for a brief interval). Hot lights are usually photofloods, quartz, or HMI lights.

hue. Scientific term for color.

Ilfochrome. Printing material based on dye-destruction principles; formerly called Cibachrome.

incident meter. Meter designed to read light falling on the subject rather than reflected by it.

Instant 35mm Slide Film. Polaroid 35mm film that can be processed within minutes using an AutoProcessor or PowerProcessor.

integral film. Self-developing Polaroid film that requires no peeling apart. Popular integral films past and present include SX-70, Time-Zero, Type 600, Spectra, and Captiva.

interference principle. Production of color through the chemical response of a silver chloride emulsion to reflected light waves.

internegative. Negative generally made from a transparency.

K-14. Kodak designation for Kodachrome processing.

Kelvin. Scale used to measure color temperature. Warm light has a low Kelvin temperature, and cool light has a high temperature.

Kodachrome. Pioneering color transparency film (1935). Kodachrome is the only contemporary film that has no inherent dye-forming ability. Instead, its color is added during processing.

light-balancing filter. Type of camera filter that produces mild to moderate incremental changes in the color temperature of light. There are two types of light-balancing filters—the 81 series (amber) and the 82 series (blue).

light meter. Instrument that measures light and recommends an f-stop–shutter speed combination that will produce correct exposure. Light meters may be stand-alone units or built into the camera.

linear polarizer. Standard type of polarizing filter.

magenta. Purplish-pink hue; one of three subtractive primary colors.

manual exposure. When the photographer sets both the shutter speed and the f-stop, using the meter's suggestions as a guide.

matrix meter. *See* multisegment meter.

minilab. Lab that provides quick 35mm color negative processing, complete with snapshot-size prints. Minilabs are sometimes called 1-hour labs and may be stand-alone retail businesses or part of a camera store or other business.

monochromatic. One-color print, either black-and-white or with a color tint.

multipattern meter. *See* multisegment meter.

multiple-image filter. Type of camera filter used to create repeated prismatic effects in a variety of patterns.

multisegment meter. In-camera meter that divides the viewfinder into several sections, using computer algorithms to analyze each section individually to come up with an exposure reading. Multisegment meters also may be called matrix, evaluative, or multipattern meters.

nanometer (nm). One millionth of a millimeter (mm). Nanometers are used to measure wavelengths.

neutral density. Situation that occurs in printing (and when photographing) when complementary colors are present in a filter pack, causing light to be reduced with no practical effect on color balance.

neutral-density (ND) filter. Grayish filter that reduces the amount of light reaching the film, with no effect on color.

optical plastic filter. Nonthreaded filter made of resin, polyester, or other material. Plastic filters are sturdy, easy to clean, and good to excellent optically, depending on the grade of plastic.

P-30P. Ilfochrome printing process.

panchromatic paper. Paper for making black-and-white prints from color negatives with black-and-white processing chemicals.

pearl. Semimatte paper surface.

peel-apart film. Any of a family of Polaroid films that develop within a minute or two after the negative and receiving sheet are sandwiched together with the developer.

pixel. Short for picture element; pixels are units of information that make up a digital image.

polarizing filter. Type of camera filter that contains a microscopic screen to reduce or eliminate polarized light. Polarizing filters have three main uses when photographing in color: to darken blue skies, to increase color saturation, and to reduce or eliminate reflections and glare from smooth nonmetallic surfaces.

Polaroid transfer. Technique of transferring dyes from a Polaroid peel-apart color negative to a sheet of watercolor paper or some other receiving material.

primary colors. Colors as they relate to light and photography. Blue, green, and red are additive primaries; cyan, magenta, and yellow are subtractive primaries.

professional film. Premium film that is shipped from the manufacturer to the camera store when it reaches its peak criteria in terms of color balance, speed, and contrast.

program. Autoexposure mode available on many types of cameras. The camera automatically sets both shutter speed and f-stop for you. Some programs are general purpose; others favor high shutter speeds or small apertures or are designed for specific types of subject matter, such as portraiture.

pulling. Overexposing and underdeveloping film to maintain the correct density. Pulling is usually used to decrease contrast and/or to adjust for film that has been inadvertently overexposed.

pushing. Underexposing and overdeveloping film to maintain the correct density. Pushing is usually used to get good film density in low-light conditions, to increase contrast, to achieve smaller apertures or faster shutter speeds, and/or to adjust for film that has been inadvertently underexposed.

R-3000. Kodak designation for its industry-standard color transparency printing process.

RA-4. Kodak designation for its industry-standard color negative printing process.

reciprocity failure. Breakdown in the reciprocity law caused by especially long or short exposures. The primary symptoms of reciprocity failure with color films and papers are underexposure and color shifts.

reciprocity law. Photographic principle stating that light intensity (f-stop) and time (shutter speed) can be adjusted in inverse proportions to provide constant exposure. Thus, film exposed at 1/60 at f/11 should have the same density as film exposed at 1/125 at f/8 or 1/250 at f/5.6.

reflected light. Light that bounces off the subject.

replenisher. Chemical added to depleted processing solutions to revive them.

resin-coated (RC) paper. Color (or black-and-white) printing paper that has a thin, plastic water-resistant layer.

reversal print. Print made directly from a transparency without an internegative.

ringaround. Chart of prints showing a single subject with the same overall density but different filtration.

roller transport. Method of processing used by minilabs and some professional labs in which film (or paper) is carried through the necessary solutions by a series of rollers in an automated processor.

saturation. Color intensity. The higher the saturation, the stronger and richer the color. Saturation is sometimes referred to as chroma or intensity.

series filters. Glass, nonthreaded filters that are classified numerically, as in Series 5, Series 6, and Series 7.

shutter priority. Autoexposure mode available on many types of cameras. The photographer sets the shutter speed, and the camera chooses the aperture needed for correct exposure.

shutter speed. Interval of time for which film is exposed.

skylight filter. Camera filter, usually pale pink, used primarily to help protect the front of the lens from moisture, scratching, and other damage. Skylight filters filter out some ultraviolet radiation and may also be called 1A filters.

slide. Transparency framed in a cardboard or plastic mount; usually 35mm.

snip test. *See* clip test.

split-field filter. Camera filter with two distinct (nongraduated) halves. Usually one half is a color of even density, and the other half is either clear or a different color.

spot meter. Meter that reads a very narrow angle of light from a limited area of the subject, usually represented by a small circle in the center of the viewfinder of either a camera or hand-held meter.

spotting. Covering up print blemishes such as scratches, dust marks, and fine lines using a fine-point brush and dye or a pencil.

stacking. Combining two or more filters.

step-up ring. Adapter that fits on the front of a lens to hold a larger filter.

stop. General term describing a doubling or halving of exposure or light level.

subtractive. Method of creating color by mixing proportions of cyan, magenta, and yellow—complements of the additive primaries (blue, green, and red).

subtractive primaries. Cyan, magenta, and yellow as they relate to light and photography; typically, dyes in layers of negatives, transparencies, and prints that form color.

SX-70. Brand name of the first Polaroid integral film and camera.

tabletop processor. Stand-alone machine for processing film and prints. Most models automatically maintain solutions at a constant temperature and provide consistent agitation.

Some models provide automatic solution replenishment and washing and drying cycles.

transparency. Film positive in any format. Processed transparencies also may be called chromes and slides (when mounted).

tungsten balance. Film and lighting are matched for 3200K or 3400K, the color temperature of most photographic photofloods and quartz lamps.

Type A. Film balanced for 3400K, which matches the color temperature of some photofloods or quartz lights.

Type L. Tungsten-balanced (3200K) negative film, which is available only in medium and large formats and is mostly used when photographing with hot lights to allow long exposures without reciprocity failure.

Type R. Chromogenic reversal print.

ultraviolet (UV) filter. Almost clear camera filter used primarily to help protect the front of the lens from moisture, scratching, and other damage. UV filters also may cut down on blue casts due to UV rays and eliminate haze that the eye can't see.

value. *See* brightness.

viewing booth. Industry-standard lighting environment (5000K) for viewing color prints.

voltage stabilizer. Instrument that detects changes in electric current and adjusts for them.

water bath. Deep tray filled with water, which is used to keep processing solutions at a constant temperature. Some water bath units incorporate temperature control and/or automated agitation.

Wratten. Classification of filters that uses a numerical designation usually followed by a letter, such as the Wratten 81A filter.

Index

89–91, 96; preservation of materials and, 207–208; printing, 170; processing, 117–118, 119, 125

Tenneson, Joyce, *107*

test(s): clip, 63, 65–67; color film, 37–38, 63; exposure, 48; filters, 97–99; prints, 82, 137, 143, 144, 154–157, *161;* shots (proofing), 76

Thurber, Shellburne, *111*

transfers: diffusion, 21; dye, 5, *15, 18, 21, 53;* enlargements, 80–82; paper for, 82, 83

tripods, 47, 61

tungsten balanced. *See* color films; film; lighting

Type A film, 32

Type L film, 32, *46,* 67–69, *92, 130*

ultraviolet (UV) light, 202, 209; filters, 99–100, 138

viewfinder, 44, 49

voltage stabilizer, 140

wash-off relief process, 18

Wegman, William, *164*

Wittmer, Albert, *17*

Wolcott, Marion Post, *14*

Wolfe, Art, *106*

X rays, 43

Young, Thomas, 4

Zoller, Charles C., *10*